Monet at Argenteuil

MONET
at Argenteuil

PAUL HAYES TUCKER

Yale University Press
New Haven and London
1982

For Maggie

Designed by Faith Brabenec Hart.
Filmsetting and monochrome origination by
Jolly & Barber Limited, Rugby.
Printed in Italy by
Amilcare Pizzi s.p.a., Milan.

Published in Great Britain, Europe, Africa,
and Asia (except Japan) by Yale University Press,
Limited, London. Distributed in Australia and
New Zealand by Book & Film Services, Artarmon,
N.S.W., Australia; and in Japan by Harper & Row,
Publishers, Tokyo Office.

Library of Congress Cataloging in Publication Data

Tucker, Paul Hayes, 1950-
 Monet at Argenteuil.

 Bibliography: p.
 Includes index.
 1. Monet, Claude, 1840–1926. 2. Argenteuil
(France) in art. I. Monet, Claude, 1840–1926.
II. Title.
ND553.M7T8 759.4 81-12994
ISBN 0-300-02577-7 AACR2

Acknowledgments

IT IS A PLEASURE to be able to thank the many people and institutions who have assisted me in the writing of this book. I am grateful to the University of Massachusetts at Boston for a Faculty Development Grant in 1980–81 and to the Samuel H. Kress Foundation for their support during the summers of 1975 and 1976 and during the year 1976–77 when I was researching and writing my doctoral dissertation on which this book is based.

The cooperation of the many private collectors who generously allowed me to study their Monets and provided illustrations has been invaluable. Among colleagues in Paris, I would like to pay particular thanks to M. and Mme. Jean Adhémar, Georges Poisson, Claude Richebé, France Daguet, Anne Distel, Marie Berhaut, Pierre Michel, Robert Schmit, and le comte René du Chambrun.

I owe a special debt of thanks to Messrs. Daniel Wildenstein and Charles Durand-Ruel for their invaluable assistance with photographs. M. Wildenstein was especially kind in giving me photographs of two unpublished drawings from the Monet sketchbooks. In addition, his monumental catalogue raisonné was an essential aid throughout my work.

In Argenteuil, I happily thank M. Lherault, M. Medici, and most warmly Mme. Lucienne Legrand-Dreher, whose wit, energy, and innumerable gestures of kindness will always be remembered with the greatest appreciation.

In London, I received invaluable assistance in gathering photographs from Desmond Corcoran and Daphne R. Boyce at The Lefevre Gallery, Thomas Gibson at Thomas Gibson Fine Art, Ltd., S. Lawson Baker at Christie's, Gillian Abel at Sotheby's, J. M. F. Baer at Hazlitt, Gooden & Fox, Ltd., V. Beston at Marlborough, and, most particularly, Gabriel Naughton at Thomas Agnew and Sons, Ltd.

I was aided in like manner by many dealers in New York: William Acquavella and Joan H. Buck at Acquavella Galleries, Inc., Nancy C. Little at M. Knoedler & Co., Inc., F. L. Schoneman at Schoneman Galleries, Inc., and Ay-Whang Hsia at Wildenstein & Co., Inc., were very helpful. I also owe thanks to Jane Fluegel and Claudia Bismark at the Museum of Modern Art, Richard Brettell at the Art Institute of Chicago, and Beverly Carter at the Paul Mellon Collection. My thanks, finally, to Alan L. Gilbert, Cultural Affairs Officer at the American Embassy in Cairo; to John Earl, Jim, Abate, Walter Dräyer

Eric Pollitzer, Sharon Courage, Nancy Lutz, and Helen Chilman for their photographic work; and to John Rewald, Pat Rubin, Michael Brenson, George Shackleford, and Roger Ward.

Many friends and colleagues assisted me at different stages in the preparation of the manuscript: William Olander, my sister Mary Evelyn Tucker-Grim, Ruth Heuberger, Barry Kaplan, and Beth Chiquoine, all of whom read parts of the text in dissertation form. Ruth also proofread the book, for which I am very grateful. Ken Silver contributed greatly to my thinking, while Steven Frankel's wise and sensitive editorial pen improved the manuscript immeasurably. Without him, I might still be struggling. A heartfelt thanks also to Marie B. Etienne, a tireless, dependable letter writer, typist, and interlocutor.

I would like to recognize my former professors at Williams College, S. Lane Faison and Whitney Stoddard, who first introduced me to art history and to Monet. And I would like to express my gratitude to my art history and studio colleagues in the Art Department of the University of Massachusetts at Boston, particularly Ruth Butler, Frances Fergusson, and Renee Arb who provided constant support and Susan Bigger and Kelly Worrall for numerous clerical tasks. I would also like to thank my students, especially Sharon Courage for her identification of flowers in Monet's paintings.

I owe special thanks to Anne Coffin Hanson, Vincent Scully, and Joel Isaacson, all of whom read the manuscript as a dissertation in 1979. Anne must be thanked in particular for her many conversations and insightful criticisms. My sincere thanks too to John Nicoll and Faith Hart of Yale University Press, John for his trust and encouragement, Faith for her sensitivity and patience.

There are four people finally who receive my deepest gratitude. First are my parents, whose understanding and support have made my task much easier; there are no two better. My greatest and most treasured intellectual debt is to Robert L. Herbert. It was on his recommendation that I pursued this topic and under his sagacious eye that it was brought to a finish as a dissertation. If this book has merit, it is in large part due to his training and friendship.

I reserve my final thanks for my wife. She is my best critic, supporter, and friend. It is with pleasure and admiration, therefore, that I dedicate this book to her.

UNIVERSITY OF MASSACHUSETTS/BOSTON PAUL HAYES TUCKER
JULY 1981

Contents

List of Illustrations

Black and White Illustrations

Introduction

MONET'S VIEWS of sun-dappled waters and flowering fields executed at Argenteuil in the 1870s have long been seen as constituting a classic phase of Impressionism, a period in which Monet developed a formal vocabulary of heightened color and broken brushwork which he wedded with dynamic compositions and modern subjects. While maintaining his concerns of the 1860s as a modern landscape painter, Monet pursued with even greater vigor the fleeting effects of nature and the vagaries of visual sensation. Together with his friends and fellow painters Pissarro, Renoir, Degas, Sisley, and others, he also organized the first Impressionist exhibition in 1874 and participated in the three other independent shows during the decade, demonstrating his defiance of tradition and his unwavering belief in his art. For most students of the period, all of this is quite familiar. So, one might ask, why another book on the subject?

The answer is fairly simple: most studies of Monet tell the same story. Hard-pressed for funds yet committed to forging a new art, Monet, we learn, lived in relative poverty working incessantly to reveal the instantaneous quality of vision, the beauties of nature and the expressive possibilities of paint. Beginning canvases at certain moments of the day, abandoning them when light or weather conditions changed, returning to them only when similar effects reappeared, all the time working out of doors, Monet, they say, painted without care for content or meaning, literary associations, or salon conventions. He was, in the end, interested not in ideas, but only in the delights of nature, asserting pleasure as a legitimate goal and function of art.

While Monet's works are indeed about pleasure, nature, and the moment, they are by no means restricted to these concerns. Emile Zola, writing about Monet in 1868, made this clear:

> Among the painters of the first rank, I will cite Claude Monet. He has sucked the milk of our age; he has grown and will continue to grow in his admiration of that which surrounds him. He loves the horizons of our cities; he loves the busy people in the streets who run about in topcoats, . . . he loves our women, their umbrellas, their gloves, their ribbons, their wigs, and their face powder, everything that makes them

daughters of our civilization. In the fields, Claude Monet prefers an English park to a corner of the forest. He is pleased to discover man's trace everywhere; he wants to live among us forever. As a true Parisian, he brings Paris to the country; he cannot paint a landscape without including well-dressed men and women. Nature seems to lose its interest for him as soon as it does not bear the stamp of our customs. . . . Claude Monet loves with a particular affection nature that man makes modern. . . . Certainly, I would not admire his works much if he were not a true painter. I simply want to verify the sympathy that sweeps him toward modern subjects.[1]

It was the modernity of Monet's subjects that Zola found so new.

Another critic, Frédéric Chevalier, writing in 1877 about the third Impressionist exhibition, in which Monet had the largest number of works, made equally penetrating remarks:

The disturbing ensemble of contradictory qualities . . . which distinguish . . . the Impressionists, . . . the crude application of paint, the down to earth subjects, . . . the appearance of spontaneity, . . . the conscious incoherence, the bold colors, the contempt for form, the childish naïveté that they mix heedlessly with exquisite refinements, . . . all of this is not without analogy to the chaos of contradictory forces that trouble our era.[2]

Clearly, these two critics saw more in these works than we have. But while Zola, Chevalier, and other critics can provide an essential contemporary perspective, Monet and his associates unfortunately cannot.[3] During the 1870s Monet did not write or speak about his art, and when he did so later in his life, he was not the kind of guide a historian would like to have. Forgetful, defiant, or contradictory, he either reaffirmed common ideas about instantaneity and the primacy of visual sensation or avoided the issue. His friends for the most part did the same.

If we are to seek through this study of Monet's work at Argenteuil more meaning in Monet's paintings, what can we call upon to help us? First and most important, the paintings—there are over one hundred and seventy from these years. The majority of these works, surprisingly enough, are still in private hands, which poses obvious problems. But recently through publications, museum exhibitions, and gallery shows many have been brought out into the public light—a welcome development, for it is only through the study of the works themselves that conclusions can be made.

Historical information is, of course, an essential complement to the pictures. But here again there are difficulties. We do not know, for example, exactly when every work was done, down to the precise month; we do not know the first owner of each work or his expectations or intentions. We also do not know enough about certain issues raised by some of the paintings—the status of seventeenth-century Dutch art during this period, for example, or the place of the rococo.

On the positive side, there is a wealth of information about two crucial factors that affected Monet's art during the decade of the 1870s: general developments in France and suburban changes in Argenteuil. The most important force behind the former was the continuing belief in the economic, social, and political advancement of the country—that is to say, in progress.

2

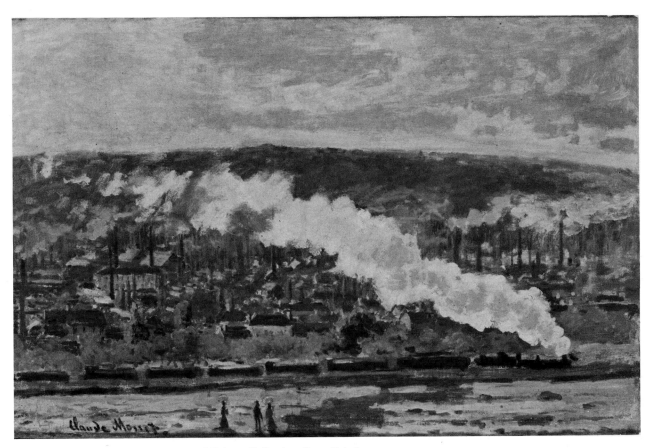

1. Claude Monet, *The Train*, 1872. 48 × 76. Private Collection, Great Britain.

In his *Dictionary of Received Ideas*, Flaubert called progress "headlong" and "ill-advised," but in his *Balance Sheet of the World for Ten Years, 1870–1880*, the noted economist Michael Mulhall asserted, "The period of ten years which has just come to a close has been one of marvelous industrial activity, of unprecedented increase in population . . . and an almost unchequered . . . prosperity and growing wealth,"[4] this despite a worldwide depression that began in 1873. France shared in this prosperity. While forced to pay a staggering indemnity and to give up two major manufacturing areas, Alsace and Lorraine, after her disastrous defeat at the hands of the Prussians, the country saw its industrial production increase by more than eleven percent during the decade and the earnings of the average Frenchman rise by more than fifteen percent, all of which meant a higher standard of living. One French economist in 1879 actually felt that "progress would never be as rapid or as marvelous as it has been up until now."[5]

Monet was no economist, but the subjects he painted were drawn from that progressive world. And the people we know who bought his paintings, like the opera singer Faure, the banker Hecht, or the department store owner Hoschedé, were immersed in it. Monet was able to profit from many people's patronage, for he made a considerable amount of money during these years, far more than earlier historians ever imagined. He was doing so well that two years after he left Paris for Argenteuil—a flight to the suburbs that was typical of his time—he was able to move into a bigger, more expensive house.

3

Argenteuil was extremely important for Monet. It was both home and subject, an ideal combination, the fulfillment of his aspirations for his life and his art. Others who moved there in the 1860s and the 1870s also felt content, for, like many suburban developments of the twentieth century, Argenteuil was a restful retreat from the capital. By Monet's time, however, Argenteuil was becoming highly industrialized.

Yet for someone who believed in progress, factories were essential. Although they had their unpleasant side, they were the ultimate source of wealth and opportunity. Monet must have felt this way; one of his earliest paintings was of factories (Wildenstein catalogue no. 5). In 1872 he painted no fewer than four views of the industries in Robec and Déville, near Rouen, the most striking of which is *The Train* (fig. 1). The factory-covered hill and smoke-filled sky are more reminiscent of modern-day sprawls around industrial cities like Pittsburgh or Liverpool than picturesque sites like Rouen, Paris, or Argenteuil. Despite its apparent grittiness, however, the picture was bought that same year by Durand-Ruel. Obviously, he felt it could sell.

Perhaps he and Monet saw it as a homage to their time. In addition to the factories which represent technological prowess, the picture includes the railroad, the contemporary symbol par excellence of progress. And in the foreground, gazing at the sight, are three people, surrogates for Monet and his countrymen. France was well on its way to recovering the glory of the Second Empire only a year after it had signed the armistice with the Prussians. And, as it had proven before, industry was the means to that new and better future. What better subject, then, for modern landscape painting? Not surprisingly, Durand-Ruel bought not only *The Train* but also two of Monet's other industrial pictures from the same year (*Factories at Déville*, W.214, and *Déville Valley*, W.215).

What is surprising, however, is that Monet did not paint similar pictures in Argenteuil, or at least not with the same directness. From documents in the town archives and elsewhere, we know that factories existed there, albeit smaller and fewer than in *The Train*. And we know through the letters from local residents, the mayor, and the department prefect, all in the same town repository, as well as from the minutes of the town meetings of the period, what the public reaction was to the presence of industry in the town and to its expansion.

Why Monet did not paint such subjects is only one question among many that should be raised. What was Argenteuil really like before and during the time Monet spent there? What did it offer him? Why did he choose to paint certain subjects? What did those subjects mean to him and to his time? Were there relationships between his sites and subjects and the way he painted them? Did his choice of subjects change over the years and, if so, why?

Only when these and other questions are posed will we begin to suspect that Monet's paintings at Argenteuil were more than just impressions of changing light and color in a suburban town. And only when we attempt to answer them—as we will in this book—will we see that they are actually profound expressions of his struggle to create a modern landscape art in a rapidly changing, industrialized world.

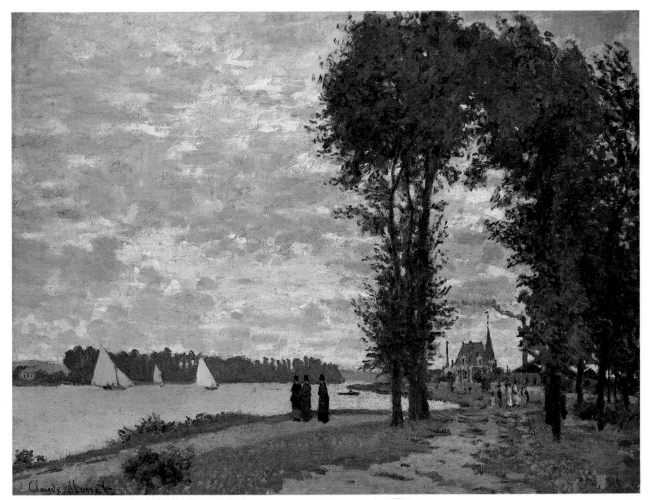

I. Claude Monet, *The Promenade along the Seine*, 1872. 53 × 71. Private Collection, London.

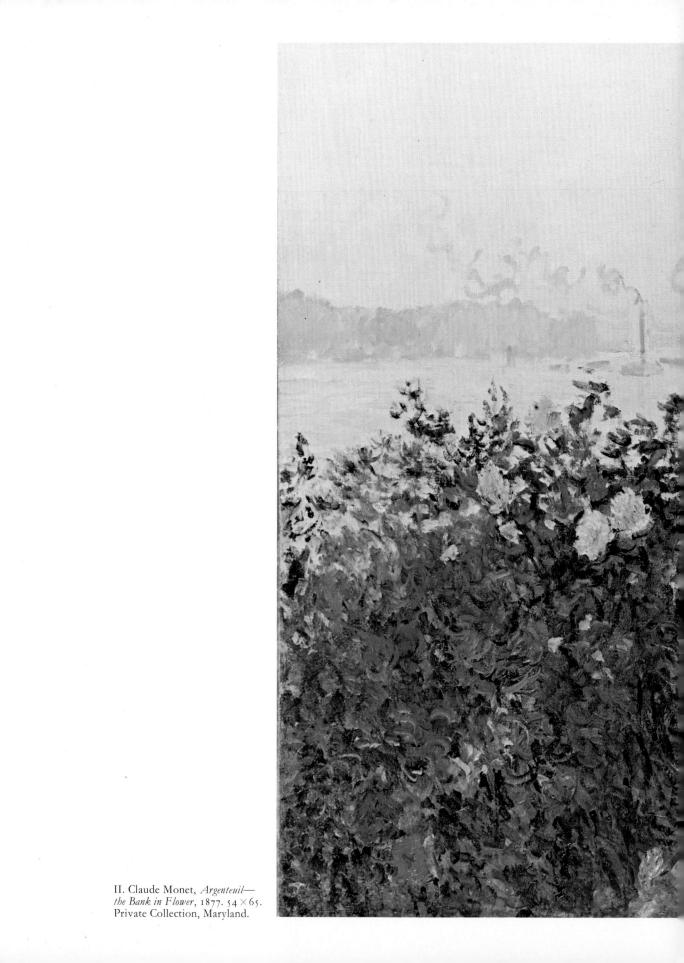

II. Claude Monet, *Argenteuil—
the Bank in Flower*, 1877. 54 × 65.
Private Collection, Maryland.

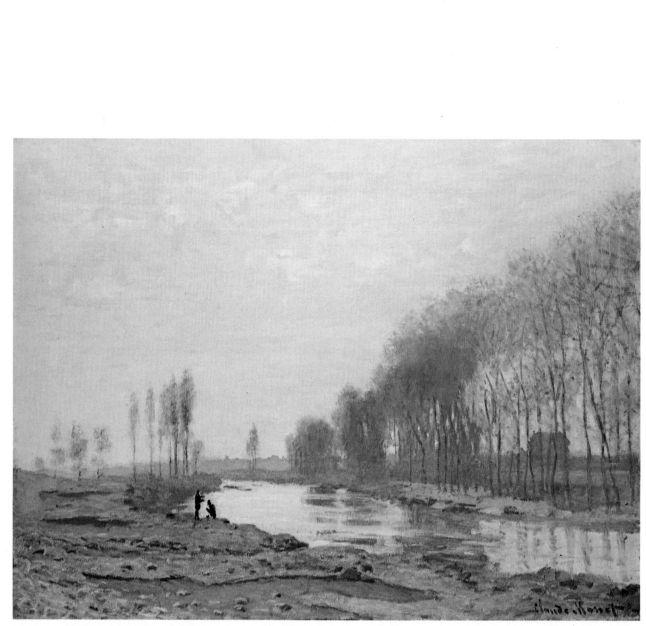

III. Claude Monet, *The Petit Bras of the Seine*, 1872. 53 × 73. National Gallery, London.

1. Monet and Argenteuil

CLAUDE MONET spent most of his mature years in Giverny and much of his youth between Paris and the Norman coast. During his middle years (1870–90) he was an indefatigable traveler seeking inspiration in more than twenty different locations in his native France, from the shimmering Côte d'Azur to the chilling cliffs of Belle Isle in the Atlantic off Brittany. Most of these excursions took place during the 1880s; he spent the greater part of the previous decade (from 1871 to 1878) in one place—Argenteuil. Located just down the Seine from Saint-Denis, where the river loops for a second time on its course north from Paris to the Channel, Argenteuil was a picturesque, historic, and progressive suburban town. It was twenty-seven kilometers by water from the capital but only eleven kilometers by railroad, a fifteen-minute trip. Well known in the nineteenth century as an *agréable petite ville*, it was for some an unrivaled spot for Sunday outings and pleasure boating. For the historical-minded or devout it was a treasure trove of archeological finds and religious relics, and for the families of local workers and landowners it was a town that was destined to be an important and populated city. For nearly everyone it was a place, as one contemporary journalist noted, that had "flowers, large trees, green grass, and a breeze; isn't that enough to make us forget everything?"[1]

Stretching along the right bank of the river on a site that gradually slopes up to meet a series of rolling hills to the north, the gracious little town was crisscrossed by numerous winding streets, encircled by fields and promenades, and crowned by the spire of the parish church. It was bordered on the south by the river and linked to the village of Gennevilliers and to Paris by two bridges, one for coaches and pedestrians and another for the railroad. From the highway bridge, one had a marvelous view of the area, as Peter Worms, a local resident, described it in an article written shortly before Monet arrived:

> The town of Argenteuil lies in front of you with its quays bordering its entire length. Right away, you notice the magnificent basin of the Seine, where in the summer season, the happy boaters come to indulge in their nautical pastime; then you notice some small houses serving as *pieds à terre* for their owners in the pleasant parts of the year. Then further, a magnificent promenade shaded by majestic trees. Then another rather large promenade where the town fête is held, a celebration that is very popular

9

among the neighboring towns and even frequented by Parisians. Right next to that is a huge expanse of green grass encircled by trees which would serve perfectly as a place for a tennis game.

Turn your eyes to the right and you see the railroad bridge being built which will link the western line with that of the north. . . . A little bit further lies an immense slope covered with vineyards and fig trees. Follow this and you come to the Orgemont windmill formerly known as the Moulin de la Galette; in order to get there you have to climb, but you are rewarded for your efforts by a magnificent panorama. . . . Descending by another road you cross the huge gypsum mines that Argenteuil possesses which are not the least interesting thing to see in the area.[2]

It was near the northern end of the railroad bridge, at 2 rue Pierre Guienne, that Monet rented a house in December 1871. And it was in this house and later in a new one just around the corner on the boulevard Saint-Denis that he lived until January 1878. Although he would occasionally leave to paint sites in other Paris suburbs, and in Normandy and Holland, Argenteuil was where he had settled to live, work, and raise a family.

This town was, in fact, the first place that Monet could call home since he had moved from his parents' house in Le Havre in 1862. During the nine years before he settled in Argenteuil, he lived in no fewer than eleven different places.[3] His bohemian existence, although bourgeois in many of its particulars, was frequently characterized by poverty and despair. In 1868, while in Bougival, a popular pleasure spot that rivaled Argenteuil, he was so badly off that Renoir, who was living with his family in nearby Voisins, often came to his aid with food and encouragement. Monet was not living alone at that time. In 1866 he had met Camille Doncieux, the nineteen-year-old daughter of a businessman who had moved from Lyon to Paris. Sometime during that year, despite the objections of both sets of parents, they began living together, and a year later, on 8 August 1867, Camille gave birth to their first son, Jean. It was this "bonne petite famille"—as he referred to them in a letter to his friend Frédéric Bazille—that Monet had to support during the difficult later years of the 1860s.

Their move to Argenteuil in December of 1871, just a month after Monet had turned thirty-one, marked a turning point in his success at selling his work and being a provider. Although it has long been believed that the family was destitute during the 1870s at Argenteuil, they actually lived quite well. Monet made, on the average, more than 14,000 francs per year, a large sum considering that a professional man in Paris earned only 9–10,000 and workers in Argenteuil a mere 2,000. Judging from his earnings the first year after moving—Monet sold thirty-eight paintings in 1872 for a total of 12,100 francs—the change in the family's life style was immediate. Although he was always short of ready cash and constantly writing to his friends for loans, he was hardly starving.[4]

Monet's output, like his fortunes, increased substantially, especially during the first year. The town must have incited him to work for he painted almost as many pictures there in 1872 as he had in three years at Bougival, Trouville, London, and Holland combined. During the six years he spent in Argenteuil, he painted nearly as many pictures as he had since he first picked up a paintbrush thirteen years earlier. Almost all of these, however, were actually painted between 1872 and 1876; in 1877, his last year in Argenteuil,

10

he painted only four. The change is as significant as it is substantial. If forty-six paintings in the first year indicate initial enthusiasm, four at the end imply a drastically revised opinion.

These last four paintings are views of the same site that Monet rendered when he first arrived—the promenade along the Seine. By juxtaposing two of the more telling canvases, one from 1872 and one from 1877, we can immediately see what has happened (figs. I, II). In *The Promenade along the Seine* a well-trod path invites us into the scene, gently leading us along the bank and through the arch of the trees to the Louis XIII–style house in the background. On either side of the house, factory chimneys break the horizon; the chimney on the right, emerging from behind a row of sheds, emits a stream of smoke that drifts lazily toward the river before dissipating in the cloudy sky. Below, people walk along the promenade while to the left sailboats dance on the water. Everything is peaceful, calm, and harmonious. In *Argenteuil—the Bank in Flower*, the same turreted house and factory chimneys are visible in the background; to the left, instead of the sailboats, there is a single steamboat whose smokestack parallels the chimneys and spouts a trail of exhaust. To the right, in the middleground, there are two boaters on the water while above them on the promenade there are three people under the trees. In the fiction of the picture, however, because there is no path to bring us into the scene, all of this is inaccessible. Indeed, the flowers in the foreground rise halfway up the canvas and completely block our entry. At the same time, they divide the view into two parts, adding a distinct note of tension to the scene. Clearly something has changed in Monet's relationship to either the site or the town since he painted the earlier picture. Before we can trace or interpret these changes, we must know what kind of town Argenteuil was and why Monet came to settle there.

In his *Histoire des environs de Paris* of 1850, G. Lafosse describes Argenteuil in the following words: "Seated on a slope, surrounded by vineyards, and dotted with gardens and orchards, this town offers travelers a varied and picturesque appearance. Here and there, through the vines and shrubbery of the hill, one discovers grayish vestiges of the ancient abbey. The parish church of imposing size crowns the mélange of greenery and houses well. . . . A cheerful village, Argenteuil is full of life and rich features."[5] Almost twenty years later, in 1869, in an article about Argenteuil in the popular weekly magazine *L'Illustration*, the town was described in much the same manner.[6] Accompanying the article was an engraved view of the area seen from Gennevilliers across the river (fig. 2). The town aptly fits its idyllic description. Although the foliage is perhaps overly thick, the banks excessively rustic, and the bridge reduced to make the scene more intimate, the view as a whole is fairly accurate, as a photograph of the site taken in the 1870s bears out (fig. 3).

But Argenteuil was not only an idyllic *petite ville*; it was one that was rich in history. In the nineteenth century historians of the suburbs and authors of guidebooks devoted considerable space to retelling the town's long and distinctive past—and with justification, for Argenteuil was one of the oldest towns in the Paris region. The first mention of it is found around A.D. 655 when the wealthy Seigneur Ermanric and his wife received permission from Childebert III to establish a nunnery in the place called "Argentoïalium." The nunnery built on the present rue Notre-Dame became the focal point of the town

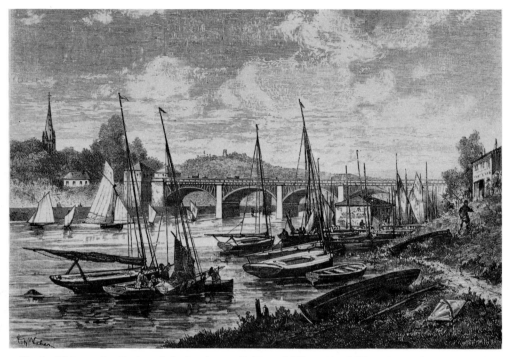

2. Charles Webster, *Les Environs de Paris: Argenteuil*. (From *L'Illustration*, LIV, 25 September 1869, 208.)

and its life. In the ninth century Charlemagne placed it under the direction of his daughter Theodrade and gave it one of the most venerated relics of the time—what was said to be the tunic of Christ. The tunic, formerly in the possession of the Holy Roman Empress Irene, was a great attraction, drawing pilgrims from all over Europe for centuries, even down to our own. From the eighteenth century onward it was the focus of the religious festival celebrated by the town on the days surrounding the Pentecost, an occasion that Monet would paint when he first arrived.

In the twelfth century the nunnery was taken over by its protectorate, the Benedictine monastery at Saint-Denis then under the famous Abbot Suger. Several years earlier, in 1118, the niece of the Parisian canon Fulbert, Heloise, had retired to the nunnery, and had soon become its prioress, after the scandal of her romance with the rising theologian Peter Abelard, who had been her tutor in Paris. At its transformation to a monastery, Heloise left, with Abelard's help, for the Paraclete near Nogent-sur-Seine, where she established her own order. The Argenteuil building was destroyed during the years after the revolution of 1789, but the town preserved the memory of this passionate though chastened woman by renaming its main street the boulevard Héloïse in the 1850s.

Although the town over the centuries remained a typical village, surrounded by fields and crowned by the church spire, one public undertaking in the mid-sixteenth century did alter its appearance for more than two hundred years. In 1544, after having been ransacked several times by the rival factions in the continuing wars of religion, the town received permission from François I to construct a stone wall around its perimeter. When

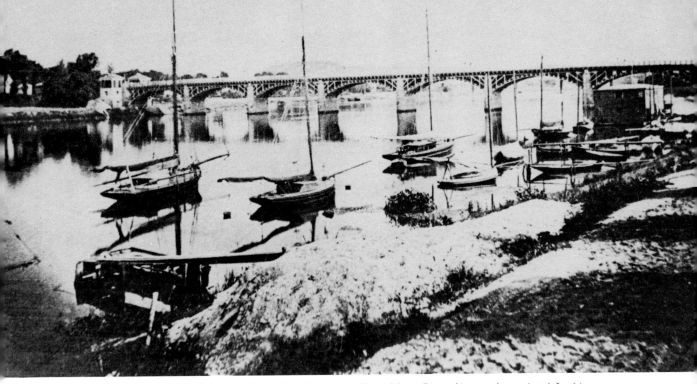

3. Photograph of the Argenteuil basin, 1870s. (From D. Wildenstein, *Claude Monet: Biographie et catalogue raisonné*, I, 76.)

work was completed five years later, Argenteuil had become a typical fortified medieval village, as can be seen in a seventeenth-century engraving (fig. 4). These walls remained intact until the late eighteenth century when another public project was initiated. Around 1790 the town was hit by the most severe in a series of malaria epidemics. The municipal authorities at the time believed that the breeding ground for the deadly mosquitoes was the sluggish waters of a small arm of the Seine that formed an island which stretched the length of the town. The town fathers decided, therefore, to fill in the arm with the stones from the medieval walls. The work took more than twenty years, but in 1818, when the island was finally attached to the town, Argenteuil had gained as much in physical size, potential for growth, and security against disease as it had lost in public outlay. Malaria never again plagued the town. Moreover, after its annexation the island provided residents with several new acres of wooded park land and with direct access to the Seine. And since it was shaded by tall trees and washed by the river, it quickly became a promenaders' paradise and one of the town's most picturesque attractions. (Monet painted it several times; in fact, it was from a spot along the island's path by the Seine that he painted *The Promenade along the Seine* and *Argenteuil—the Bank in Flower*.) All remnants of the ancient ramparts had vanished by the time the work was completed except for one, a tower called Tour Billy, which stood through the nineteenth century and was illustrated in several guidebooks as a reminder of days gone by (fig. 5).

Without its walls, the town looked directly out onto the surrounding fields and, just beyond them, the slopes covered with vineyards. Stretching two kilòmeters eastward to

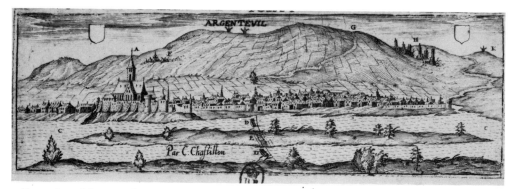

4. Engraving of Argenteuil in 1610. Musée du Vieil Argenteuil.

Epinay, two kilometers westward to Bezons and Sartrouville, and approximately two and a half kilometers toward Sannois and the hills that shielded the town to the north, this land was Argenteuil's livelihood. It had been cultivated by the town's farmers for generations and had yielded fruits, grains, vegetables, and potatoes which were sold in the weekly market or in Paris. It had also yielded grapes, which were turned into wine, Argenteuil's most important agricultural product. Picked by migrant workers as well as townspeople, the grapes were processed and bottled locally and then sold in the capital and its suburbs. The wine was hailed for centuries as a *vin supérieur* and had been the primary source of the town's renown since the later Middle Ages. It was still consumed throughout the nineteenth century, although by then it was widely known as a *vin ordinaire* of questionable quality; its low price had become its main attraction.

A sizable part of Argenteuil's population around 1800 worked to produce plaster, another well-known and much-used town commodity. The hills to the north behind the town held rich deposits of gypsum which had been discovered in the Middle Ages and subsequently exploited. In the sixteenth century François I had used it in his vast building campaigns, and in the nineteenth century many entrepreneurs relied on it when rebuilding Paris during the reign of Napoleon III. Together with that from the mines at Saint-Denis and Montmartre, Argenteuil's plaster was what generally became known as "plaster of Paris."

Like most of the other suburbs in the region, Argenteuil retained its rustic charm despite the presence of local industries, of which mining was the most substantial. Between 1800 and 1850 the mines were more extensively developed and, with the aid of steam-powered machines, their yield gradually increased. They were some distance from the town and thus not a pressing presence. More visible were several distilleries, a tannery, a tallow shop, and an iron forge, all of which were located in the town itself. Most of these were small operations, the forge run by Pierre Joly being the largest, employing ten to fifteen people in the 1840s. More important at the time was a silk factory that opened on the rue Lévêque in the 1830s. The first real factory in Argenteuil, it proved to be quite successful, and by 1844 it employed almost one hundred people.[7] Despite its size and location, it did not provoke complaints. Other businesses were less fortunate. In 1834, after being accused of running an unsanitary, dangerous, and in-

cessantly noisy operation, one distillery owner went so far as to claim that people in Argenteuil were carrying out a popular campaign against the industrialists.[8] Undoubtedly he was exaggerating, but the fact was that industry did exist in Argenteuil and that it gave rise to conflict between residential and industrial interests.

In 1850 Argenteuil was still very much the same as it had been in the eighteenth or even the seventeenth century. Although a number of Parisians had adopted the town as a principal or secondary residence because of its proximity to Paris and its pleasant setting, the majority of townfolk worked as farmers, field hands, or miners, just as they always had. In 1817 the population had stood at 4,175, only 600 more than in 1600; in 1851 it had merely inched up to 4,757.[9]

In 1851, however, an event took place that transformed the country town and its peaceful way of life. In April of that year the railroad from Paris to Argenteuil was inaugurated, providing a new and efficient link with the capital.[10] Parisians were soon enticed to leave the city and to build their homes and factories on Argenteuil's pleasant, inexpensive countryside. In the next two decades, the population almost doubled, rising to 8,046, and the number of industries multiplied. To the tannery, tallow shop, and distilleries were added a factory that produced phosphate extracts, a dye factory, a starch factory, a machine-made-lace factory, a gas works, a large saw mill and construction operation, a chemical plant that produced potassium chromate, a factory that made artificial mineral and carbonated water, a carton factory, and finally a crystal factory. The silk factory had closed some time in the late 1840s, but it was bought in the early 1850s and converted into a toy factory, sold again in the 1860s and changed into a distillery.[11] The Joly iron forge remained in the same family but it grew from a small workshop to one of the largest iron works in France, employing at different times anywhere from three hundred and fifty to five hundred workers. Instead of horseshoes and iron railings, it turned to producing monumental metal bridges, flat-bottomed iron boats, and iron market structures. While it exported the bridges and boats throughout Europe, and the latter even to Africa, the company was best known in the Paris region for having built all the markets in the capital and, above all, for having constructed the most renowned iron structure in France, Les Halles.[12]

5. *La Tour Billy*. (From Adolphe Joanne, *Les Environs de Paris*, Paris, 1870, 374.)

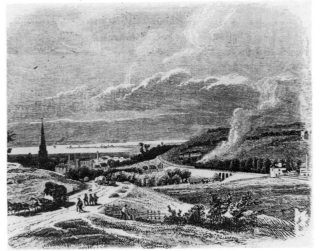

6. Charles Daubigny, *Harfleur*. (From Jules Janin, *De Paris au Havre*, Paris, 1853, 96.)

Surprisingly, perhaps, the Joly iron works, like the silk factory earlier, did not prompt public criticism whereas the chemical factory, the distilleries, and the tannery were all strongly attacked several times. The tallow factory opposite the church in the middle of town became the object of so much public protest in 1868 that it was finally forced to close the following year. And a proposed oil depot and refinery was prevented from opening in 1869 on the grounds that it presented "two of the most serious inconveniencies: the danger of explosion and fire, and the danger of unhealthy and unpleasant smells."[13] Both would have been undesirable for its projected location—the neighborhood of the railroad station, which was considered one of the most picturesque parts of Argenteuil.

Most of the time, however, the municipal and departmental authorities overrode residents' objections and permitted businesses to build their factories even if they were destined for picturesque areas. Already constructed in the neighborhood of the station were the chemical factory, the lace factory, and the dye factory.

With the influx of industry and the rise in population, the town obviously could not remain the same; something had to be sacrificed. The first thing to go was, of course, land. It was needed for the factories, the country houses, and for the houses for factory workers. As there was plenty of it surrounding the town, the need was easily met. In 1858 one resident of the western part of Argenteuil could state that "in the past six or seven years, forty houses were built in my neighborhood and twenty-five meters from here two cities of 25 to 30 houses are in the process of construction."[14] But the development was not limited to a single part of town; as an Argenteuil journalist noted in 1862, "new constructions were going up on all sides."[15] The land they were using was once farmland or vineyards. As this land changed hands it was clear that Argenteuil was not losing just open acreage but also its long-standing agrarian traditions. For generations, the wine-growers, farmers, and miners had worked the fields and quarries. They had been proud of the land for its beauty and for the products it yielded and they had held the most respected positions in the community. But as the new houses and factories were going up, all of that was becoming history.

The municipal government, with the mandate of the public, had invited and indeed encouraged this change. They had fought for the railroad since 1836, recognizing that it would help the town's economy. In 1845, when the proposals were still being made, one official noted at a municipal council meeting that,

In the past, the fortunes of Argenteuil increased at the same time as its roads. Let's hope now that the new railroad will come, because it will cut the time it takes to get to Paris . . . to a quarter of an hour . . . and time is man's most precious jewel. The railroad will also increase the plaster business which would be good for Argenteuil and for the country. . . . The railroad will likewise help Argenteuil's wine business. Developed property will gain as well since Parisians will come more willingly, knowing that living in Argenteuil will not disrupt their daily business in the capital.[16]

They not only hoped that all this might come true, they made every effort to insure it, even down to improving the physical appearance of the town. As one resident remarked in that same meeting, "The goal of all your efforts . . . to straighten up all the streets of the

16

town, to pave those that need it, to maintain the others, to embellish and enlarge the promenades, to fix up the rural roads, is to attract visitors and to induce them to stay."[17]

The emergence of industry and the arrival of Parisians meant prosperity to the town, and how was that to be refused? It also meant progress, the advance of the town from its sleepy confinement in the past into the energized, mechanized, forward-looking present. Thus in 1862, in reference to the Joly iron works, Monsieur Chevalier could ask, with complete confidence about the answer, "Is not . . . this immense factory where copper, iron, and wood are transformed into gigantic works of art which the capital is proud of, or, which crossing the seas are going to make the antique minarets of our African cities seem pale, is it not progress and one of the most remarkable examples of it?" Of course it was, as Chevalier answered with another question, "Does the factory not distribute the comforts of life all around it while at the same time immortalize the name of the creator?"[18] As this comfort-distributing factory was joined by the ten others listed above and as the population grew, together with the number of houses, streets, and promenades, a prediction that an Argenteuil journalist had made in 1862 was becoming a reality. Writing in the *Journal d'Argenteuil*, Monsieur Lebeuf observed that "if we do not paralyze its tendencies and direction, Argenteuil, by its situation and proximity to Paris, should become a populated and important city."[19]

Argenteuil's growth was, of course, only a part of a larger social and historical phenomenon: the growth of Paris, the expansion of the urban population into the suburbs, and the industrial and residential development of those once rural areas. Hailed by many as a positive good, this growth and development brought significant changes to the traditional patterns of life in the suburbs. In 1862 Monsieur E. Bonnevalle, an Argenteuil writer, reflecting on this fact while attending the wedding of a friend, observed that indeed "the suburban communities of Paris have habits and traditions that are disappearing every day, fading in the face of modern civilization which approaches."[20] By the 1860s that approaching civilization had already made itself felt. Between 1831 and 1851 the population of the department of the Seine, which encompassed Paris and its suburbs, almost doubled after having increased by only one and a half percent over the preceding forty years. Between 1851 and 1871 it rose again by nearly thirty percent.[21] This phenomenal growth, caused by rural laborers leaving their farms and villages for the opportunities offered in urban areas, provoked real fears about the depopulation of the countryside as fifty-four out of the eighty-three departments in France lost residents to the urban centers, most notably to Paris. Government studies were conducted, and as early as 1853 the minister of the interior recommended that passports for Paris be issued to rural workers only if they could prove that they had a job waiting for them in the city.[22]

Not unexpectedly, this growth caused tremendous health, housing, and security problems, for the physical space and facilities in mid-nineteenth-century Paris were insufficient to accommodate this flood of humanity. In old neighborhoods such as Les Halles and Saint-Honoré, there were more than one thousand inhabitants per hectare ($2\frac{1}{2}$ acres).[23] It was partially in response to this that between 1853 and 1870 Napoleon III and Baron Haussmann laid down more than forty kilometers of new streets in the capital and demolished 24,000 houses to build 100,000 new ones.[24] As this renovation raced to keep

up with the demand, people such as Maxime DuCamp became worried about the future. "In forty years," he wrote in *Paris: Ses organes, sa fonction et sa vie dans la seconde moitié du XIX^e siècle*, "if the influx continues Paris will have three million inhabitants. Where are they going to live? . . . What will become of the Champs-Elysées, the Bois de Boulogne, and the race course? There will be five-story houses there; Paris and Saint-Cloud will join hands across the Seine."[25] In 1869, however, when DuCamp voiced these fears, Paris and Saint-Cloud were already linked by railroad and stagecoach and by necessity—the need to escape the crowded, impersonal city and to breathe *l'air pur de la campagne*.[26]

Fresh air was certainly available in the suburbs of the capital, but it was not always so pure, because in most towns, pasture land and poppy fields flourished alongside smoking factories and smelly sewage. From mid-century on, large businesses, faced with rising costs inside the *octroi* walls of Paris, moved to establish their factories in the outlying areas. Where once the rural horizon was broken only by steeples of town churches, it now was punctured by thirty-meter-high chimneys. As one writer put it in 1856:

> When you leave Paris and make an excursion into the suburbs, aggressive, industrial, and bourgeois all at the same time, you find the most astonishing contrasts . . . trees, fields, and grass clash with plots of arid earth, bald like the head of an old man. . . . One also finds factories here and there, establishments of a totally modern kind. Chimneys poking up like obelisks from the street which is covered with their black smoke make you stop in more places than you know what to do.[27]

To the north, where this growth was most extensive owing to the development of the railroad in that direction, the smoke of the factories joined with the sewage in the Seine to create a terrible gaseous stench. In addition to the industries that dumped waste into the river, Haussmann in the early 1860s placed the mouths of his new Paris sewer system at Asnières and Saint-Denis and flushed 450,000 kilograms of sewage daily from the bowels of the capital into the Seine.[28] All of this soon gave rise to serious health and environmental problems and to confrontations between Paris and the towns along the river to the north, Argenteuil included.

Again, this is not to say that rural nature and pure country air were nonexistent; Argenteuil and many towns like it in the suburbs were still *riant*, a word used by many guidebooks of the time to describe the pleasant rustic quality of small country villages. But the suburban towns had all been discovered by mid-century or shortly thereafter, and most had lost their rural virginity. So when the urban dweller left his steaming city for the pleasures of the cool countryside, he was greeted in Argenteuil as well as else-where by constant socio-economic reminders of his era—factories, new houses, even other pleasure-seekers. The latter were unavoidable since the ever-expanding railroad system provided increasing accessibility to the area around Paris. Ironically, therefore, not only did pleasure-seekers begin to flood the suburbs and change what they themselves hoped to find, but the country pleasures that kept a town like Argenteuil "provincial" were the same ones that were turning it into its antithesis, a Parisian playground.

When Monet moved to Argenteuil in the winter of 1871, he probably was not aware of the specific changes the town had experienced. He had had no ties to the area; he had not even visited there when he lived down the Seine in Bougival in 1868 and 1869. Most

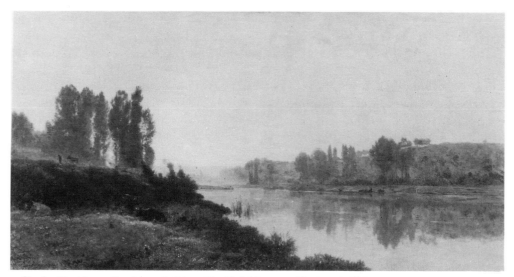

7. Charles Daubigny, *Evening on the Oise*, 1863. Taft Museum, Cincinnati, Ohio.

likely, he chose it on the recommendation of Manet, whose family had been long-time residents of Gennevilliers across the river. Manet knew people in the town and may have put Monet in touch with Madame Aubry-Villet, who became his first landlady.[29]

Monet had seen the town many times from the train on his way from Paris to Bougival and Le Havre, so it would not have been unfamiliar. He would have known from its widespread reputation that it was the sailing center of the Paris region, and, because it was so frequented by Parisians on Sunday outings, he must have recognized that it offered him the opportunity to paint modern life in a landscape setting.

This would have been an important consideration because, as he had demonstrated in his work of the later 1860s—and as Emile Zola had noted—Monet was very much interested in painting the contemporary scene. In 1866 Zola had placed him at the head of a group of painters he called "Les Actualists," men "who try above all to penetrate the sense of things; they are not content with *trompe l'oeil* tricks. They interpret their epoch as men who live in it. Their works are alive because their subjects are taken from life and are painted with all the love that the artists have for modernity."[30]

From Monet's first paintings in Argenteuil, such as *The Promenade along the Seine*, it is apparent that he was still committed to those concerns. In fact, while Monet might not have known the town was heavily industrialized before he came, he indicates in this picture—by the presence of the factory sheds and smoking chimneys—that industry was a welcome element in the landscape. Indeed, the archway of trees that frames the little chateau and factories is like that in Constable's *Salisbury Cathedral from the Bishop's Grounds*. Instead of the wonders of God and man, however, Monet is celebrating progress, the new religion, where man and industry work with nature for the greater good of humanity and where labor and leisure go hand in hand in the same environment. Although Monet never expressed these sentiments himself, they were those of his era. Furthermore, Monet's picture is so close to popular prints that illustrate these ideas—

19

Daubigny's view of Harfleur (fig. 6) being just one example of many—that his alliance with this spirit cannot be doubted.

This is only one side of Monet, however, and only one side of Argenteuil. At the same time as Zola was writing his praises, Monet was enjoying the pleasures of rural Normandy, far from the Parisian crowd. And, as he described to his friend Bazille, the tranquillity of untouched nature was indeed inspiring.

> Thanks to this man from Le Havre who has come to my aid, I am enjoying the most perfect tranquillity. . . . my desire would be to remain forever in a nice quiet corner of nature like this one. I assure you that I do not envy you being in Paris and I hardly miss the get-togethers at the Café Guerbois although it would be nice to see some of the regulars. But frankly, I think that one cannot work so well in that kind of milieu. Don't you think that by oneself, alone in nature, one does better? Personally, I am sure of it. Moreover, I have always thought that and what I have done under those conditions has always been better.[31]

This love of quiet corners persisted in the 1870s, as another painting from the first year at Argenteuil bears out, *The Petit Bras of the Seine* (fig. III). In contrast to *The Promenade along the Seine*, it shows a site where the march of progress has not yet left a footprint. There are no boats, no factories, and no well-dressed urban strollers. Two men stand on the banks of the river, but they are subordinated to the broad expanse of flat and otherwise deserted countryside. The poplars screen an isolated house to the right, but like the river they wind into the background and contribute to the rustic quality of the scene. Nothing disturbs the site's pervasive silence and nothing lets us know that it is Argenteuil in 1872. It is as if Monet has retreated into the untrammeled rural past as Barbizon artists before him had done. The picture, not surprisingly, is similar to Charles Daubigny's *Evening on the Oise* of a decade earlier (fig. 7). Even Monet's color scheme of earthy tones recalls that of the older artist.

Monet's picture actually shows not Argenteuil itself but an area across the river from the town. To the left are the plains of Colombes and Gennevilliers and to the right, encircled by the arm of the river, is the Ile Marante. But the area is totally different from that in *The Promenade along the Seine*. One is a place where the mysteries of the natural world are untapped; the other is a site where man has made nature modern. One is more private; the other, more public. One is countrified; the other, urbanized. In terms of the paintings, *The Petit Bras of the Seine* is an elegy to former times; and *The Promenade along the Seine* is an ode to the present.

Argenteuil offered Monet both kinds of subjects, a fact which he must have found appealing. From one day to the next, he could be either the painter of modern life in landscape or the painter of Barbizon updated. For most of his six years there, he chose the former. But the desire to paint those quiet corners of nature remained. While he always fought to render his impressions accurately, regardless of the subject, he also continually struggled to satisfy these two demands. They were conflicting demands and, just as *The Petit Bras of the Seine* differs from *The Promenade along the Seine*, they caused Monet to paint pictures of striking contrast. Ultimately, they also caused him to reevaluate his aims as an artist.

20

2. Views of the Town

IN 1876, IN A LETTER to Doctor Georges de Bellio, one of his newly found patrons, Monet despairingly pleaded for support. "The creditors are proving to be obstinate; unless some rich amateurs suddenly appear, we are going to be thrown out of this nice little house where I have been able to live modestly and work so well."[1] This was just one of dozens of such pleas that Monet made during his years at Argenteuil, but it was the only time during the period that he assessed his life and work. Although the modesty of his living habits could be questioned, the fact that he worked well certainly cannot. Monet painted over one hundred and seventy canvases in Argenteuil—more than he had in all of the 1860s. This extraordinary productivity was the result perhaps of his growing success, his settling down, and, not least important, his enthusiasm for the town.

As an ensemble, Monet's paintings of Argenteuil and its environs are remarkably varied in style as well as subject. In fact, diversity is perhaps their most significant characteristic; never again was Monet quite so versatile. The logic to that diversity is revealed in a pattern of formal developments: a flat, unmodulated application of paint evident in the earlier works gives way to a looser, more complex fracture; quiet, matte colors disappear in favor of pastels and vivid hues. And the range of subjects, initially quite wide, narrows considerably.

The paintings that concentrate on the town itself—its houses, streets, fields, and festivals—exhibit these developments most dramatically. During the first year, they comprised the largest and most varied group, suggesting that Monet found the town to be La Fosse's cheerful village; they even read like a tourist's promenade. Over the next few years the town does not feature as largely, but in 1874 and early 1875 it reemerges as a focus of attention. By then, however, Monet's tourist enthusiasm had long since worn off and his art was beginning to change, so much so that only two years later his views of the town would constitute the smallest and most repetitive group of paintings he produced.

Monet's initial attraction to Argenteuil is evident not only in the number of paintings from the first year but also in the fact that he chose sites and subjects that he would never paint again. One of these was the hills of Sannois. Part of a range that began at Saint-

Denis and continued north to Pontoise, the hills rose up behind the town, giving it a protective barrier and a picturesque backdrop. At Argenteuil, where they gained their greatest altitude, 168 meters, they were a scenic attraction, providing all who climbed them with a magnificent view of the surrounding area. They were some distance from the center of Argenteuil, but that did not discourage people from making the ascent. As early as 1863 the *Journal d'Argenteuil* could declare, "The hills of Sannois, which were almost deserted a little while ago, are frequented today by a considerable number of people; it seems as if everyone meets there; one encounters promenaders, artists, travelers, and even tourists."[3]

Looking at Monet's *View from Sannois* (fig. 8) one might think that he was rendering the pre-1860 days. Two small figures appear in the distance, but they are submerged in the vegetation that covers the hill and are subordinated to the view beyond. It is as if Monet were the sole visitor, playing the roles of promenader, artist, traveler, and tourist. He paints what all of them desire—a country path that leads through tall grass and plowed fields, a sky that hangs limpid over the terrain, a panorama that reaches over houses, and a church steeple that touches the horizon. Monet also composes it as everyone would like to see it: the earth and the sky meet at the midpoint of the canvas, the path

8. Claude Monet, *View from Sannois*, 1872. 53 × 72. Musée du Louvre, Paris.

winds through two counterbalancing groves of trees to end up at the midpoint of the picture's base, and the town in the distance sits just slightly off center, balanced by the tiny figures and the larger trees to the right.

What is uncharacteristic of tourist views, however, is Monet's manner of rendering the scene. Elements are differentiated only by color; there is almost no variation in brushwork and thus no change in the paint surface. Calling attention to the flatness of the canvas, the matte texture of the paint also emphasizes the general character of the view. In fact, the panorama is so innocuous that we could be standing at any point along the range. Monet, although traveling the tourist trail, obviously concentrated not on the tourist attractions but on the simple evocation of vast distance and soft atmosphere.

Monet's deviation from the promenader's norm is even more evident in his other view from Sannois, *The Path through the Vineyards* (fig. IV). Standing closer to the base of the hills, Monet looks down a path that occupies most of the foreground. Again, the town is barely visible in the distance but it is more distinguishable than in the first view, and the particular features of the site are given more definition. The generalized fields of figure 8 here are recognizable vineyards complete with stakes and vines. The bushes beyond are rendered in some detail while in the background several white houses stand out clearly against the dark green foliage. The colors throughout are richer and the paint more manipulated. The contrasts of Argenteuil likewise are more evident. Factory smoke-stacks and the church tower puncture the horizon while, deep in the distance, the skyline is broken by the buildings of the capital.

The care with which Monet selected his subject is apparent when his picture is compared with Peter Worms's contemporary description of the view from the top of the Sannois hills: "At your feet, you see the Seine which snakes its way from Saint-Denis to Saint-Cloud, then all of the city of Argenteuil which seems to await your visit; and the Pantheon in the distance like an advance guard seems to say to you in its grandiose majesty, 'I dominate all the other monuments of the big city by my height and the thought that created me.'"[3] Obviously, Monet did not paint the tourist view. His scene appears quite ordinary. What it does include, however, is revealing.

The path does not wind through fields but through vineyards. Argenteuil's most important product, indeed the source of its renown since the Middle Ages, was its wine. The Abbé de Marolles under Louis XIII had listed it with those of Suresnes and Saint-Cloud as the best in the Ile de France, while the town's first historian, the Abbé Lebeuf, writing a century later, in 1749, had said that of the two things that made Argenteuil memorable, one was its terrain known for its full-spirited wine.[4] The vineyards in Monet's painting, therefore, are not accidental, picturesque additions; they are symbols of Argenteuil itself.

But the town in 1872 was not just an agrarian community; it was also a manufacturing center that produced and exported embroidery throughout the capital region, plaster to Normandy, crystal to England, and iron bridges throughout Europe. The chimneys in the background bear witness to that fact. To emphasize it, Monet places them in the center of the picture at the vanishing point of the path. While the fields lie dormant, the chimneys spout trails of smoke, painterly intermediaries between the more carefully rendered fields and the impastoed sky. The chimneys do not appear to be foreign or

undesirable elements in the landscape; on the contrary, they complement the church tower, balance its verticality, and fill what would otherwise be a void in the middle of the scene. Their smoke is as wistful as the clouds above, their forms as permanent and monumental as the traditional spire. They also imitate the vineyard stakes in the foreground, and not by chance, for Monet is presenting the town's progression from the traditional cultivation of the soil to the new mechanized production of goods. And with the path leading so naturally from the foreground to the background, from the vineyards to the factories, it appears that for Monet in 1872, the two, industry and agriculture, city and country, coexist in Argenteuil in perfect harmony. Four years later, this would no longer be the case.

Monet's initial perception of Argenteuil as an idyllic town was quite understandable, for its suburban offerings were indeed enticing. The chimneys could spout their smoke and the machinery could make its noise, but the town was still a charming place. Besides the surrounding fields that offered the visitor the highly desirable *air pur de la campagne* and the broad river basin that gave him the opportunity to engage in boating, Argenteuil also had many quaint winding streets that could lead the city dweller—accustomed to the broad open boulevards of modern Paris—from the present to the past.

One such street was the rue de la Chaussée. It led up from the Seine and the Champs de Mars to the center of town. At its halfway point, it was joined by the rue des Saints-Pères and the rue Notre-Dame, which caused it to open slightly and to form a little square. It was this street and square that Monet chose to paint in one of his first views of the town, *Rue de la Chaussée* (fig. 9). The street was unpaved, so its brown sunbaked surface joins with the tan stucco of the houses to establish the unified earthy texture and overall color scheme of the painting. The street was not perfectly straight; after the square, it bent to the right and narrowed considerably. Monet uses this effectively to add variety to the view.

More important, however, in contrasting the open foreground and the narrow background, he emphasizes the street's rustic qualities. The houses contribute to this effect also. Each rises to a different height and few are properly aligned. As their facades and roofs move in and out, causing slight changes in color, we are reassured that the street is indeed simple and unplanned, all of which suggests the human scale and values of an old way of life. The light that bathes the buildings in the foreground adds a warmth to the whole, while the shadows in the square and on the building to the right enclose the space and provide the final picturesque touch to this unassuming remnant of the past.

The rue de la Chaussée did have the appearance and the spirit of a bygone age, as a postcard from the end of the century shows (fig. 10). So crooked and narrow was it that in 1868 the biweekly market that had been held there for centuries was moved to the boulevard Héloïse because, as the municipal council declared, "the town and its population, having grown considerably, need a larger place."[5]

The rue de la Chaussée, however, was not just *an* old street in Argenteuil; it was *the* oldest, dating back to the seventh century when Ermanric and his wife established their nunnery.[6] Built on the present rue Notre-Dame, the nunnery bordered the Seine. Because they traveled frequently to and from the capital, Ermanric and his followers created the rue de la Chaussée for easier access to the river ferry. The name "Chaussée," which

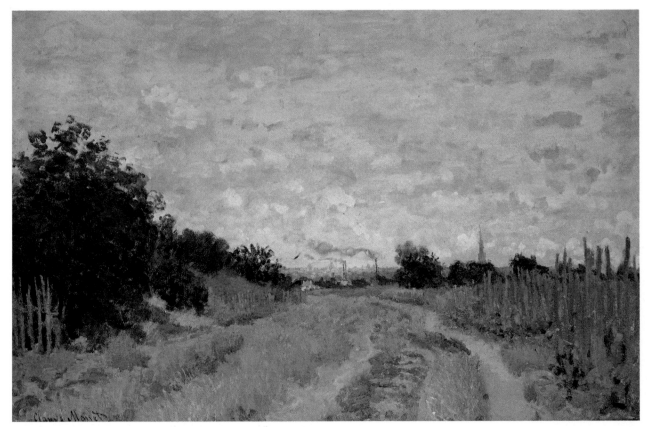

IV. Claude Monet, *The Path through the Vineyards*, 1872. 47 × 74. Private Collection, Great Britain.

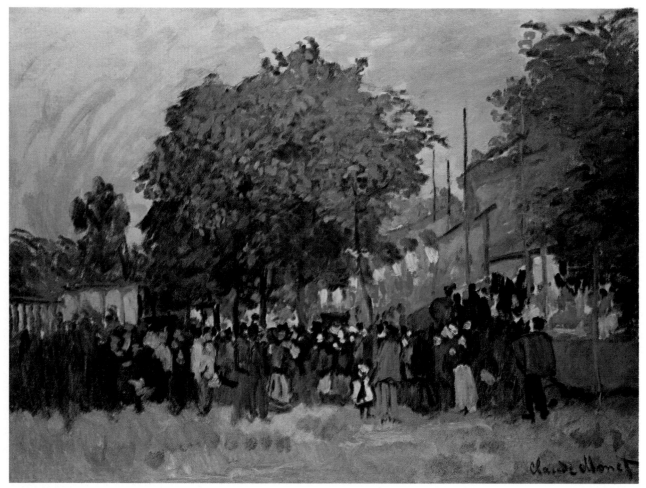

V. Claude Monet, *Fête d'Argenteuil*, 1872. 60 × 81. Private Collection, United States.

first appeared in the twelfth century, adds to the suggestion of age because it means "footpath," indicating a road hardened by the constant wear of pedestrian traffic.

In Monet's painting of 1872, millions of footsteps and hundred of years later, the street hardly seems to have changed. Although by then the monastery which had been located just to the right of Monet's view no longer existed, the street appears as full of associations with the past as those in the more rural town of Honfleur that Monet had painted eight years earlier (fig. 12). One would never suspect that just one street down to the left was the Christian brothers silk factory, which less than a year before had been converted into a distillery, or that one block in front of him was the recently built town church, the Eglise de Notre-Dame. In Sisley's view of the same street painted at the same time, while he was staying with Monet in 1872, the church tower crowns the scene (fig. 11). Sisley must have exaggerated its height, for, as the postcard suggests, it would have barely been visible from his vantage point. Monet, painting from nearly the same spot as his friend, did not even include it. Perhaps it was a question of composition, for in Sisley's picture the tower is a disruptive vertical. Or perhaps Monet wanted to keep his view secular and anonymous. In either case, the care with which he chose his vantage point and arranged the scene emphasizes the consciousness with which he selected the site and his desire to make Argenteuil appear unchanging. This is one of the more extreme cases of Monet's looking backwards. It seems he recognized that, because he did not return to paint the street again.

He did paint another monument of Argenteuil's past, however, during his first year—the hospice (fig. 13). Not surprisingly, he approached it in a manner quite similar to that of *Rue de la Chaussée*. In the foreground he placed a large open section of the street which narrows and fades as it moves into the background. He infused the scene with a similar sense of tranquillity, not by bathing it in an Italianate light, but by wrapping the buildings in dense foliage and dwarfing them with several large trees.

Although lusher than the sunbaked rue de la Chaussée, this section of town still evokes a sense of reassuring timelessness. There is, however, a stronger element of detachment here, evident in the smaller number of people, the empty foreground, and the distance between Monet and the hospice. Lacking emphasis, the building and the area seem unimportant, but just the opposite is the case.

The hospice was one of the oldest buildings in Argenteuil (fig. 14). Located at the eastern end of the boulevard Héloïse, it had been the *hôtel* of René Coiffier, Seigneur de Roquemont, who in 1674 had willed it to the Argenteuil Charity as a home for the sick poor. It had served that purpose under the direction of different religious orders for two hundred years and was such an important part of the town's history that in 1858 Argenteuil's second chronicler, Etienne Chevalier, wrote a history of the building and its role in the town's life.[7]

Undoubtedly, the age and significance of the structure influenced Monet's choice of the site. He was probably also attracted by the charm of the area, for the trees and garden are emphasized in the picture more than the hospice. More important, perhaps, would have been the fact that just beyond the hospice, up the narrow street visible in the background, was his own house. The picture, therefore, shows his neighborhood.

This is important for two reasons. Monet, unlike many of his contemporaries at the

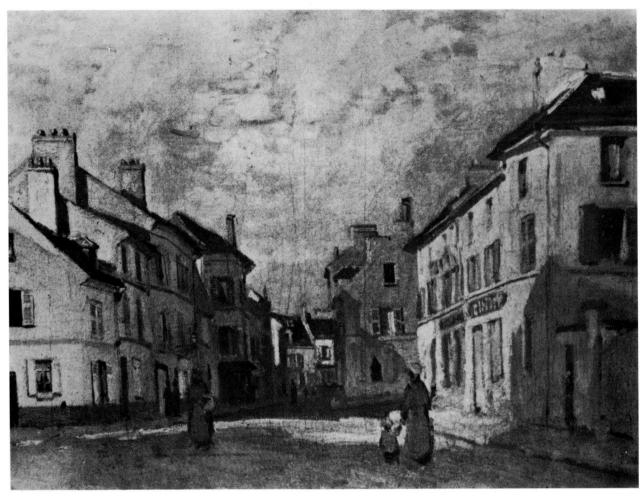

9. Claude Monet, *Rue de la Chaussée*, 1872. 55 × 73. Formerly Collection Landrin, Paris.

10. Postcard of the rue de la Chaussée, *c.* 1900. Medici Collection, Argenteuil.

11. Alfred Sisley, *Rue de la Chaussée*, 1872. Musée du Louvre, Paris.

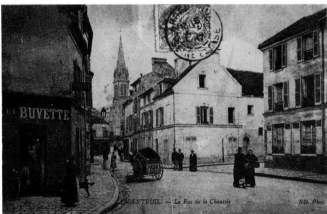

28

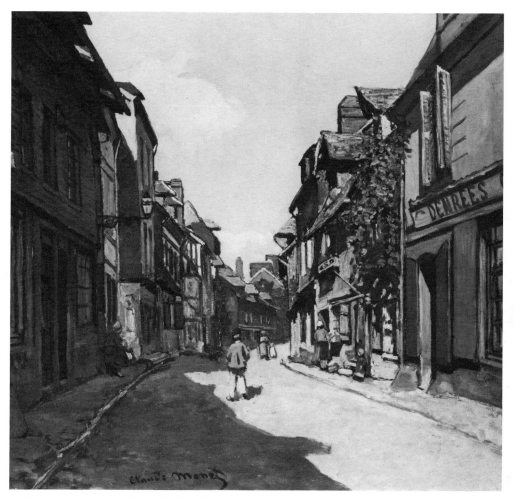

12. Claude Monet, *Rue de la Bavolle in Honfleur*, 1864. 56 × 61. Museum of Fine Arts, Boston.

Salon, did not feel the need to search for new subjects in exotic places like Morocco, Egypt, or Turkey; he could find inspiration enough in the humble surroundings of his house, just as Théodore Rousseau and the Barbizon painters had done.[8] This localization—which historically was most ardently practiced by the seventeenth-century lowland artists—is a consistent element of Monet's work at Argenteuil. The second reason builds on the first. Monet came to Argenteuil not as a native returning home, but as a Parisian leaving the city. He knew no one in the town prior to his arrival and does not appear to have made any acquaintances of consequence while he was there. Moreover, he had no business relations with any Argenteuil resident. Although many Parisians owned houses there, none patronized Monet, and certainly none of the local vineyard, mine, or factory owners or workers had anything to do with him. He enrolled his son in the local Ecole des Arts et Métiers and registered his family in the censuses of 1872 and 1876, but, beyond that, he seems to have remained aloof from the town and its internal life. Whether

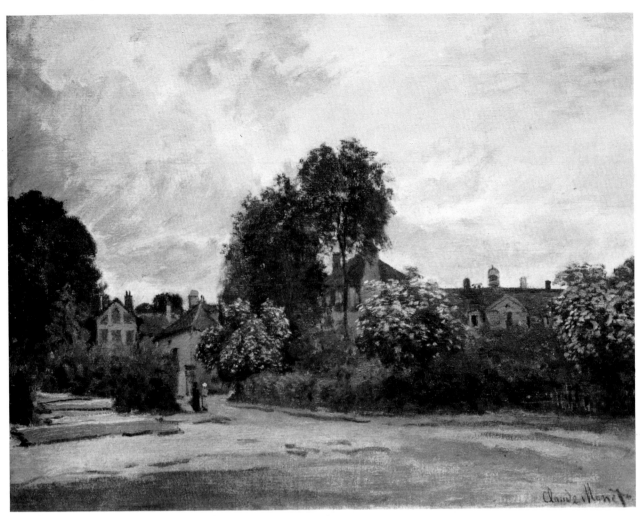

13. Claude Monet, *The Hospice*, 1872. 49.5 × 63.5. Private Collection, United States.

14. Postcard of the Argenteuil Hospice, *c.* 1900. Medici Collection, Argenteuil.

self-imposed or not, this isolation is another consistent element in his work at Argenteuil. He was not an "Argenteuilian"; he was an *étranger*—a visitor, a distanced observer. Perhaps it was this feeling of detachment that led him to paint certain sites over and over again—that only by becoming thoroughly familiar with a place could he overcome his alien status and feel "connected" enough to Argenteuil to both record what he saw and express what he felt.

This combination of enthusiasm and coolness, involvement and restraint, was not peculiar to Monet; it was characteristic of the modern Parisian, a fact that is important to establish because Monet's attitude is too often seen as different from that of the urbanite of the 1870s.

One journalist writing in 1878 in the biweekly Parisian newspaper *Le Sport* referred to the capital and its residents as "inhospitable." In Paris, he asserted,

> one does not find those solid affections that are passed on from generation to generation as in the provinces and that cement a mutual and constant hospitality. If you look among your entourage or among your acquaintances at the club or salon, you find that there is always an ulterior motive that pushes people to see you and call you their friend. For some it's vanity, for others, insecurity. . . . Selfishness brings about those magnificent rapprochements of a season, a night, or a ball. . . . It is not affection, or solid friendship, that makes relationships; it is the need to have one from the other.[9]

Behind all of this stood the phenomenon of modern life. In Paris, which had been so radically transformed by money, industry, Napoleon, and Baron Haussmann, people could no longer live by the old standards of mutual trust and sharing. You survived by wit and intuition, social connections and chance acquaintances. Success and security were far from assured there, unlike in the provinces, where just the pace of life and the continuity of nature provided comfort and reassurance.

In the city you rapidly learned how much to give of yourself, how far to go with certain relationships, how to compensate for personal failings, how to make the most out of advantageous situations, and how to avoid or withdraw from unprofitable ones. It required calculated maneuvers and strong personal defenses, harnessed emotions and no small amount of luck. It was a life of dialectics, of romance and rawness, of empathy and dispassion, and, as the journalist noted, it created people "who seem as though they cannot live without someone else and yet are cold, indifferent, and reserved." It caused Maxime DuCamp to characterize Parisians as "superficial" and Victor Fournel to accuse them of being "anxious, nervous, and irritable, the most volatile and capricious people on earth."[10]

Beyond the mechanisms they developed to cope with the myriad situations in the city, and beyond their methods of attaining some measure of financial or social success, many Parisians, because they inhabited a city that had undergone so much change, quite understandably experienced a sense of estrangement. "For us Parisians of another age, bees born in another hive," wrote Edouard Gourdon in 1861,

> we are in modern Paris rather like foreigners in a spa; we take deep breaths of the fresh air we are given; we look with wonderment and satisfaction at the new streets, the houses they are building, the palaces which they are adorning; we understand that in

all this sunlight we ought to feel well; we realize that what has been done has been done with intelligence and that, without a doubt, it is useful. But we don't go any further than that; we are not moved. In short, we enjoy it all without being attached to anything, just as if this city were not our own and as if tomorrow we were to pack our bags and move on.[11]

Gourdon admitted he was critical of the new Paris because he felt "less admiration for the future than regret for the past," but even for those who did not suffer from nostalgia, detachment was a way of life in the capital. And how could it not be, when the population of the city in 1870 was more than double what it had been in 1830? Swelled by what one cynical Parisian called a "motley, floating, hurried, busy, frightened population of provincials and foreigners,"[12] Paris had become a large, impersonal urban center where one would not know the person he sat next to in a restaurant, or the person who passed him on the boulevard, or even the person who lived below him in the same building. The mélange of peoples, types, and classes provoked interest and excitement, even empathy —everyone underwent some of the same experiences—but it also bred indifference. You could be fascinated by the crowds, but you had to maintain your distance and preserve your identity.

These conflicting emotions were a part of Monet's character as well. Even though he had left the environment that nurtured these feelings, they did not disappear when he came to Argenteuil. The same dichotomies that characterized the spirit of his age were a part of his work. While this is evident in most of his views of the town, it is particularly apparent in his *Fête d'Argenteuil* (fig. V).

First, he separates himself from the fair, which was Argenteuil's most important celebration, by placing an empty area in the foreground. Then he bars any entrance to the space beyond by stretching the dense crowd of people in the middleground across the entire canvas. He adds a further note of impersonality by turning most of the people away from him and, finally, he denies any participation in the fair itself by not showing any events clearly.

However, he does evoke the sense of a jostling crowd and the general spirit of a fête. The white bonnets and dark hats bob up and down, the figures in the middleground move in and out, and the people on the right seem to push toward the booth on that side. Above, the leaves of the trees, rendered in short dashes of rich pigment, almost seem moved by the excitement of the crowd below; and the sky, sketched in with large rapid strokes of thinner consistency, adds a final spirited touch. At once involved and indifferent, Monet here is realistic without being a reporter, romantic without being nostalgic.

If *Rue de la Chaussée* is a retreat into the past, the *Fête d'Argenteuil* is a confrontation with the present. Not only was the fair one of the biggest events in Argenteuil, it was also representative of a broad social development in the relationship between Paris and its suburbs. From the mid-nineteenth century onward, the traditional religious celebrations held in the outlying towns became exceptionally popular among Parisians because such festivals were accompanied by various forms of entertainment. With railroad lines spreading out from the capital and allowing more and more Parisians to invade the suburbs,

local governments saw the opportunity to increase their towns' income and prestige through enlarging their festivals. They therefore promoted bigger and bigger celebrations to such an extent that by the 1870s the original religious ceremonies took second place to public entertainment.

Argenteuil's fête was a prime example of this.[13] Traditionally, it was held the Sunday, Monday, and Tuesday of Pentecost in honor of the descent of the Holy Spirit to the apostles. On Sunday, a high mass was celebrated in the town church, with a noted religious official frequently invited to give the sermon. After psalms, songs, and prayers, the most momentous of events took place. The town's world-renowned relic, the tunic of the Lord, was removed from its private altar and carried through the streets in a solemn religious procession. This was the only day in the year that it left the confines of the church. When it was returned, there was a long period of prayer and song, followed by a final blessing that closed the services. Then came the games, jousts, concerts, and fireworks which filled the program for the next two days. As early as 1818, Monday and Tuesday of the fête saw everyone enjoying "amusements of all kinds."[14]

By the 1860s all of those diversions had multiplied. The fête was still only three days, although occasionally it was extended by popular demand, and the religious events were still enacted, but the simple entertainments became spectaculars and the little booths of the fair became big business. There were balloon ascents by Godard, boating regattas with the Société du Sport Nautique de la Seine, and huge firework displays by Zwillings, Ruggier, or other Parisian *artificiers* specializing in suburban-fêtes. Announcement of the occasion was no longer done by word of mouth or local notice but by posters that were hung in towns from Puteaux to Herblay and by advertisements in the Parisian *Petit Journal*. The main reason for the expansion was, as the *Journal d'Argenteuil* wrote in 1866, "to attract the Parisian population that go to other fêtes in the suburbs." In 1870 their success was confirmed by *Le Sport*'s announcement of the town's upcoming celebration as the "big popular fair with dancing, music, and fireworks."[15]

Thus, when Monet painted it two years later in 1872, he was painting not a quaint small-town event but a large, commercial, Parisian-run venture whose raison d'être was not the religious mysteries of the Pentecost but the money and prestige gained from entertaining pleasure-seeking city dwellers and suburbanites. Like many other Parisians, Monet was attracted to the crowds and festivities, just as the town had hoped.

Monet's commitment to paint the modern aspects of Argenteuil is also evident in his view of the *Boulevard Héloïse* of 1872 (fig. VI). The street, the town's largest, longest, and straightest, was the closest approximation of a city boulevard that Argenteuil offered. The association had been made more apparent in the 1850s when the street was aligned and paved by a company that had worked on the major boulevards in Paris.[16]

More than his selection of this subject, Monet's handling of it emphasizes these ties. Standing in the middle of the road, he takes a direct, head-on view. The width of the street stretches from one side of the canvas to the other, making it appear broader than it was. The dark lines of the curbs also make it seem extremely straight and long; like railroad tracks, the curbs shoot into the distance, converging at some blurry point halfway up the painting. Nothing obscures their disappearance. On the contrary, the trees on the right and the wall on the left emphasize their recession while the potentially distracting

figures and cart are placed unobtrusively in the middleground. The broad empty foreground makes the street appear to flow right out from under Monet's feet while it places a substantial distance between himself and the scene beyond, a formal strategy that he had used several times already. Thus, in its breadth, length, order, and impersonality, Monet's boulevard strongly recalls some of Haussmann's new avenues in Paris.

Sisley also painted the boulevard Héloïse in 1872 (fig. 15), but, unlike Monet, he emphasized its rustic qualities. Standing to the side, in a less vulnerable position out of the way of traffic, he looked obliquely down the street, which appears narrower and shorter than in Monet's picture. Instead of rushing out from under him, the street rolls gently by. The sidewalk, on the other hand, aided by the strong diagonal of the trees, shoots into the background and diverts attention from the boulevard, while the overhanging foliage provides a canopy and makes the view less stark than Monet's. The immediate foreground is empty, but there are two horse-drawn carts, one so close that we can see the prancing step of the white mare and the wobbly knees of the two men on the sidewalk.

Sisley's greater emphasis on the quaintness of the site is also evident in his treatment of the houses. Monet's walled-in, orderly arrangement of buildings becomes in Sisley's work a more confusing jumble of big and small structures. Seemingly unplanned, like those on the rue de la Chaussée, they appear to be part of a town that is further away from Paris. Moreover, Sisley does not include any lampposts; Monet shows two, one prominently in the foreground. They had only recently been installed and thus bear witness to Argenteuil's modernization.[17]

15. Alfred Sisley, *Boulevard Héloïse*, 1872. National Gallery of Art, Washington, D.C.

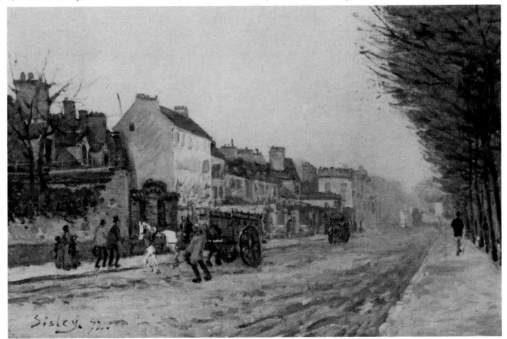

Despite its modernity, Monet's view is based on a compositional format of seventeenth-century Dutch landscape as exemplified by Hobbema's *The Avenue, Middelharnis*. However, Monet has modified Hobbema's arrangement. Instead of a low horizon and broad sky, Monet tilts the road up on the picture plane, empties the foreground, and provides fewer spatial signposts. As a result, his view is flatter and more challenging, a fact that is emphasized by the broader application of paint.

The bluntness of the paint and picture structure together with the dispassion with which Monet renders the scene all reflect an urban sensibility, as if they are the product not only of his quest to be modern but also of his experience of the city. But, of course, Monet was not a city painter. Unlike Manet, for example, he was not drawn to the life of the boulevards or cafés. Unlike Degas, he was not excited by the circus, the theater, or the horse races; unlike Renoir, he could not be satisfied with the Bois de Boulogne, or the Moulin de la Galette. He was a landscape painter and he needed a countrified setting. Argenteuil, which provided that setting while also allowing him the opportunity to paint scenes of modern life, seemed to be an ideal place.

It was not, however, an unchanging one. On the road to an ever brighter future, the town continued to see its population grow and the number of houses and factories increase. Some of Monet's formerly idyllic subjects changed before his eyes. The surrounding fields were affected the most, since they were open land that aggressive speculators could acquire and transform. Because these fields were one of the main attractions of Argenteuil for Monet, their development must have been particularly painful, a notion that is suggested by another view of the town, *The Effect of Fog* (fig. 16).

Standing in the vineyards near where he had been when he painted *The Path through the Vineyards* (fig. IV), Monet looks across the field to the town and the smoking chimney in the distance. In contrast to his earlier view, the scene is cloaked in a thick mist. While adding visual interest, the fog physically changes the site and alters its implications. On one level, Monet may simply have wanted to capture the evanescence of the day, but if that had been his only concern, he could have painted any number of other sites around town. Instead, he returned to one where formerly he had found harmony among Argenteuil's contrasts.

The Effect of Fog, painted late in 1872 after Monet's first full year in Argenteuil, implies a change in attitude. The fields themselves are barren and unpopulated; they are also dampened by the mist, which adds a melancholy note to the view. It is the end of the season, for the bundles of faggots lie on either side of the furrows, while the stakes in the immediate foreground have been reduced from what they were in *The Path through the Vineyards* and have been stripped of their grapevines. Most important, however, there is no path here leading from the foreground to the background, from the fields to the factories. The apparent optimism of *The Path through the Vineyards* seems to have been replaced by sadness and resignation. Monet seems to have recognized that these fields, like those all around the town, were destined to change. In fact, by October 1872 government officials had already authorized the establishment of a chemical factory, the third in Argenteuil, to be located on the chemin des Charretiers at the Porte Buttée,[18] close to where Monet painted *The Effect of Fog*.

Such development had long been greeted with enthusiasm by most though not all of

Argenteuil's residents, as one local journalist pointed out as early as 1862. Noting that the town consisted of three distinct middle classes—the businessmen, the vineyard owners, and the people who lived there but who worked in Paris—he observed that the number of commuters was growing and that what the town really needed was new industry. There was, however,

> a part of the population that was not much interested in all this progress—the vineyard owners; formerly the only or almost the only owners of the land (they numbered 700 in 1840), they regret the annihilation of their supremacy, the diminution of their fields, and the fading of their customs. Buildings are going up on all sides of town gaining land little by little and making the owners of the vineyards, who formerly harvested their grapes from their front door to the town borders, powerless to change the course of events.[19]

The battle was uneven, their defeat inevitable. As a landscape painter, deeply attached to nature, it is likely that Monet shared their regret.

Another painting from the same winter of 1872–73, *The Vineyards in the Snow* (fig. VII), like *The Effect of Fog*, can be seen simply as a sensitive rendering of a snowbound landscape. However, it too can be read as a heartfelt response to the transformation of the countryside. Standing near where he had been for *The Effect of Fog*, Monet turns his back on the encroaching town, looks north toward the hill of Orgemont, and renders the snow-covered vineyards as a veritable battleground. Unlike a popular illus-

16. Claude Monet, *The Effect of Fog*, 1872. 48 × 76. Formerly Collection André Weil, Paris.

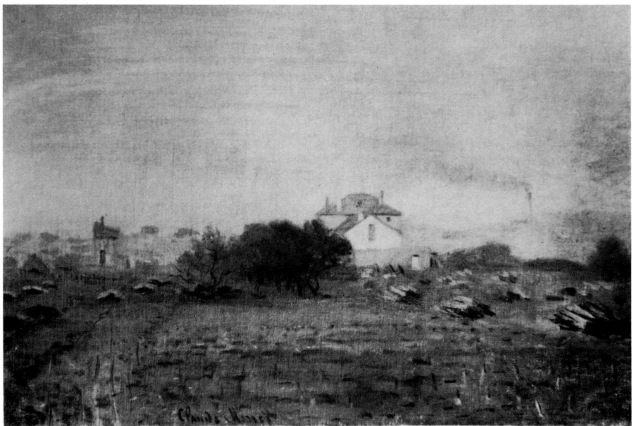

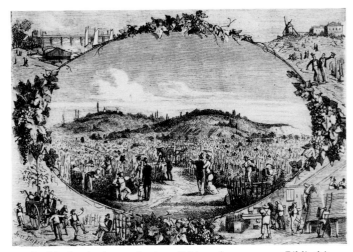

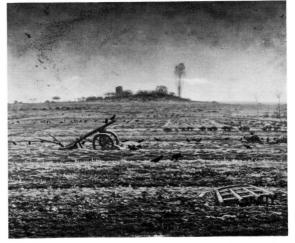

17. *Le Vendage à Argenteuil*, 1877. Cabinet des estampes, Bibliothèque Nationale, Paris.

18. Jean-François Millet, *Winter Fields with Crows*, 1862. Kunsthistorisches Museum, Vienna.

tration of the same fields during the harvest of 1877 (fig. 17), *The Vineyards in the Snow* is cold, desolate, and melancholy. There are no people in the fields and no fruits on the vines. The land is an unattractive and seemingly infertile morass of mud and snow. The stakes and the furrows stretch from one side of the canvas to the other and from the foreground to the folding hills beyond, but they are in total disarray. In the popular print, although they are not ordered in the patchwork-like arrangement that one sees in a wine-producing region, they do blanket the earth. Indeed, they are so dense and so sun-drenched that their wholesomeness cannot possibly be doubted. As if to ensure this, the artist frames the scene with a grape-laden vine and includes the vignette of the presses in the lower right. And in the lower left, as if to reassure his Parisian audience that all is well in the country, he shows the bucolic peasants singing and dancing on their way from work. He even includes the modern bohemian artist who is working *en plein air* to capture their Breughelian gaiety.

Obviously, the artist in the illustration is not Monet. There is no gaiety in *his* scene, no peasants, no Parisians, no picturesque distractions—just empty fields and two un-majestic hills. And yet Monet has infused the scene with grandeur and monumentality. The silence and starkness are haunting. The land is subtly contoured, richly textured, and intricately patterned. The hills, although simple, rise above the agitation of the fields and gain a certain nobility. The fields themselves, although barren and unpopulated, com-municate a sense of timelessness reflecting the fact that they have been worked for centuries. Monet's careful, almost painstaking application of multiple but unmingled touches of grays, browns, and greens in the fore and middlegrounds adds weight to these reflections. The fields likewise exude a sense of stoicism; it was man who had labored there all those years and, although he is absent, his presence is felt, most poignantly perhaps by the evidence of Monet's hand.

In composition and in spirit, Monet's picture is not far from Millet's view of the fields near Barbizon, *Winter Fields with Crows* (fig. 18). Both reveal a particular sensitivity to the significance of the fields, an awareness that they represent man's continual labor and his traditional ties to the earth. Both express a deep appreciation for winter's beauty. Both finally share a heartfelt melancholy—but perhaps for diametrically opposed reasons.

37

Millet saw the rural workers struggling under the same conditions and performing the same backbreaking tasks that they had for centuries; he saw that they had no opportunity for advancement, no hope for change, and thus were damned to their miserable existence.[20] While Monet was certainly less concerned with the inequities of the rural worker, his melancholy too can be read as pessimism. Seeing the new houses and factories usurping the land that for so long had nourished the grapevines and thus the rural traditions of Argenteuil, Monet realized that the peasant, the farmer, the vineyard owner—indeed, all agrarian use of the land—were fated for extinction; that the town with its growing population and burgeoning industry would eventually absorb them and relegate them to history. Where progress was totally absent from Millet's Barbizon, it was the driving force in Monet's Argenteuil.

Part of Monet's resignation in *The Vineyards in the Snow* may come from the fact that those fields, having been planted and worked to produce wine as a commodity for the capital and its ring of *guinguettes*, had now themselves become the latest commodity being offered to the residents of Paris—land for commercial and residential development. One member of Argenteuil's municipal council, recognizing the preliminary effects of railroad and steam travel in the 1830s, had predicted this change for suburban vineyards in general: "The facility of communication by water and land . . . allows the wine of Burgundy, Cher, Orleans, Lorraine, Saintonge, and of all the south of France to arrive in Paris. . . . They block the gates and fill the stores of Paris today, threatening to destroy the winegrowers of the suburbs who, because of their inferior product, can in no way keep up with the competition; it will cause their total ruin."[21] Less than forty years later his pessimistic prediction was becoming more of a reality. As one resident wrote in 1869, "A large amount of land has been sold to Parisians who . . . intend to build themselves country houses." Many in fact already had, for, as he noted, "bourgeois houses with stylish gardens surrounded by walls and closed off on their facades by iron gates have replaced the vineyards [on the western side of town]."[22]

It was happening all over the town, and it would not be long before it happened to the vineyards Monet was painting. They too would be replaced by houses and factories; their furrows would turn into footpaths and then streets and sidewalks; their stakes become surveyors' sticks and then geometrically planted trees or chimneys spouting smoke. And what land might be left over could become the domesticated field, the garden, as in *The Garden in the Snow* (fig. 19)—a little bit of nature, a reminder of what once was.

The differences between Monet's view of the garden and that of the vineyards (figs. 19, VII) is the difference between Argenteuil past and present. The garden is former open farmland subdivided, sold, walled off, and developed—Cartesian order imposed on fields that for generations had been held by families and defined by neighborly agreement; enter surveyors, architects, city taste and culture.

This, of course, was not a phenomenon unique to Argenteuil, as we shall see in Chapter 5. The greater suburbs of Paris in general were being carved up by speculators to provide the rich industrialist or the striving clerk with a place "at the doors of the capital and, at the same time, in the middle of the country, calm, forgotten, solitary, as rural and idyllic as areas of Morvan, Brittany, or the Jura."[23]

Argenteuil was not as rural as any of these areas, but it was at the doors of the capital

and it did have surrounding countryside. It was also a place, according to *The Garden in the Snow*, where one could experience the pleasures once exclusive to the elite landowning class. The geometry and order of the garden in Monet's picture, evident even down to the neat, snow-dotted rows on the right and its limited, walled-in space and carefully planned paint surface and color harmonies, attest to the possibilities of finding here a harmony with nature—stability, intimacy, peace, and repose. There is no tension as there had been in the vineyard view, no anxiety or agitation.

Tranquillity and beauty are the primary qualities of *The Garden in the Snow*, just as they were the goals of the commercial developer and the owner of the garden Monet depicted. They were Monet's goals as well. He was like one of the people described by Gustave Flaubert in *L'Education sentimentale* who, riding the steamboat down the Seine from Paris to Le Havre, saw on the hills houses with "sloping gardens separated by new walls, iron gates, lawns, greenhouses, and vases of geraniums, [and] who felt a longing to possess one and spend the rest of his days there."[24] *The Garden in the Snow*, and other views of his own house and garden that will be discussed later, show that Monet's longing was being satisfied—that in Argenteuil he could be "as happy as a *coq en paté*," a phrase he used to describe his situation in 1868 while renting a small house in Normandy.

19. Claude Monet, *The Garden in the Snow*, 1873. 55 × 73. Private Collection, United States.

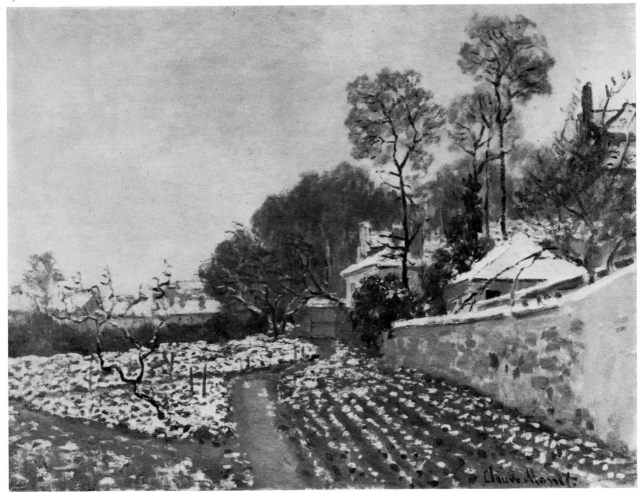

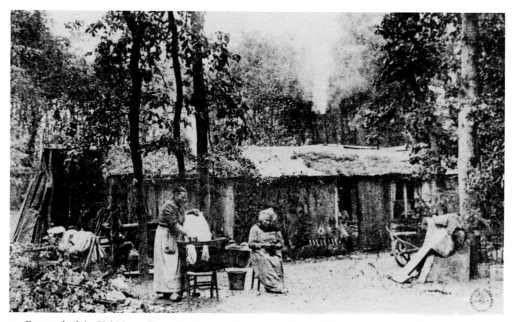

20. Postcard of the Val Notre-Dame in Argenteuil, *c.* 1900. Medici Collection, Argenteuil.

Unlike many of the city dwellers who were moving to the suburbs, Monet clearly was sensitive to the changes that were occurring in Argenteuil. He was therefore torn between wanting a place in the suburbs and not wanting to see those once rural areas altered. And yet he could do nothing to stop it. He simply had to accept the facts and make his own world out of the changing one in which he lived.

What Monet wanted for himself was what he shows in *The Garden in the Snow*. It is not surprising, therefore, that he painted this picture at the same time as *The Vineyards in the Snow*; he wanted to reaffirm Argenteuil's attractiveness, a desire that would frequently emerge as he confronted the problems of the area. In the following spring of 1873, for example, he even went so far as to paint the developing western end of town in *The Houses at the Edge of the Field* (fig. VIII) as if it were a small addition to an idyllic little village.

Standing in a waving field, dotted with poppies, Monet shows four newly built *pavillons*. The three on the left appear like dollhouses in their size and similarity, although in the way they emerge from the fields and harmonize with the foliage they seem quite appropriate for the setting. Above them rise several tall trees, and above the trees, the crowning spire of the church. The spire is silhouetted against a sky whose breadth parallels the fullness of the fields. Enclosing the ensemble of houses and trees, the fields and sky affirm the town's pure country air, its slow pace of life, its peace and tranquillity, in short, everything that Monet and hundreds of others like him were looking for. What a change from the remorseful, lonely vineyards! Indeed, two people are actually working in the garden area on the right.

Of course, Monet has been somewhat selective, which is evidence we can use in speculating upon his attitudes toward Argenteuil. In addition to showing only four new houses (there were over one hundred built in that area over the previous twenty years),

40

adding an abundance of uncultivated fields and shady trees, and using a heightened palette of rich mustard yellows, strong reds, and greens, Monet gives no indication that less than one hundred meters to his right was the tannery of Monsieur Dulong, and just beyond that, the mill and building supply company of Monsieur Bouts.[25] In a single decade from 1849 to 1859 the tannery had grown into an establishment employing over forty people. In 1859, when a new owner, Mr. Alboy, requested authorization to expand his plant, area residents protested, claiming that their neighborhood was one of the most attractive in Argenteuil and the most likely to continue its rapid development, so long as the tannery—the "foyer of infection"—was held within its boundaries. That was not sufficient for one resident, a Parisian who owned two houses on the present rue Jean Moulin. He had not known of the tannery problem when he had bought his land in 1856, but he learned fast, not only because of its incessant noise and horrendous stench but also because in 1848, without government approval, the owner of the plant had constructed new buildings on the property next to his. "My entire view," he complained, "is presently blocked by the mountains of hides which fill the air with a smell so strong that on certain days my apartments even when closed are uninhabitable. The tenant who lives in one of my houses refuses to pay the rent just because of this smell."[26] The author-

21. Claude Monet, *Farmyard in Normandy*, c. 1863. 65 × 80. Musée du Louvre, Paris.

ization to expand was not granted but the factory was not closed down. In 1873 it still employed thirty people. The saw mill did not provoke as much controversy, probably because it was located on the Seine and not in the heart of the "new cities being built." It had been in operation since the 1830s but, like the tannery, had grown so much after mid-century that by the 1870s it employed fifteen to twenty people.

In his arguments against the tannery in 1859, the mayor of Argenteuil had noted that "each locality in the Paris suburbs has its own particular advantages. In some places, industry dominates, as Puteaux, Clichy, and many other communities attest; here, on the contrary, one comes to find the peace and calm of the country."[27] Ten years later the industries and population of Argenteuil had grown more than the mayor had probably anticipated, but people still came for the same reasons. Certainly Monet did, as *The Houses at the Edge of the Field* suggests.

To gauge the picture's forthrightness, it is helpful to know that Monet could have chosen to paint the rustic *chaumières* that lay further to the west in an area known as the Val Notre-Dame; they still existed at the end of the nineteenth century (fig. 20). There, he also could have found a farmer and his barn, such as he had painted ten years earlier in *Farmyard in Normandy* (fig. 21). Either one would have fulfilled his commitment to realism, but neither would have satisfied his desire to paint the most up-to-date aspects of his world. By choosing these modern *chaumières* instead, he frankly confronts the way of the future.

Even if one did not know the history of Argenteuil's expansion, one could recognize that *The Houses at the Edge of the Field* shows the new section of town by the way Monet has arranged the scene, especially when it is compared with the view of the Normandy farm. The field is open and windblown, but unlike the pond and yard in the earlier picture, it is tightly contained in a strict, horizontal band. The houses likewise are carefully ordered in a row across the picture, in contrast to the barns which are placed at seemingly arbitrary angles. The arrangement of the barns reflects country casualness; the row of houses and the new saplings, developers, architects, and municipal planners. And with the church steeple in the background included here so prominently (in contrast to its artful exclusion in *Rue de la Chaussée*) it seems that Monet is not only creating a picturesque view of this new section of town, but also perhaps contrasting Argenteuil's religious heritage with its latest aspirations.

Monet's own circumstances brought him in direct contact with the combination of the old and the new that *The Houses at the Edge of the Field* exhibits. The house he was renting belonged to a Madame Aubry, who came from an old Argenteuil family. The house was located in the *quartier* of the Porte Saint-Denis, which was also in the throes of development. Ever since the railroad crossed the Seine in 1863 and the station was built parallel to the boulevard Saint-Denis, the area had undergone marked change. Many houses had been built, several factories established, most of the streets and sidewalks fixed, a new avenue opened, and an old one widened. Although not on the scale of the western end, the development was nonetheless substantial.[28]

The Aubry house was close enough for Monet to be able to hear and see the trees being felled and the buildings going up. And in 1874 he experienced the results first-hand; in October he moved from the Aubry house to another that had just been built on the

VI. Claude Monet, *Boulevard Héloïse*, 1872. 35 × 59. Yale University Art Gallery, New Haven, Connecticut. Lent by Mr. and Mrs. Paul Mellon.

VII. Claude Monet, *The Vineyards in the Snow*, 1873. 58.5 × 81. Virginia Museum of Fine Arts, Richmond.

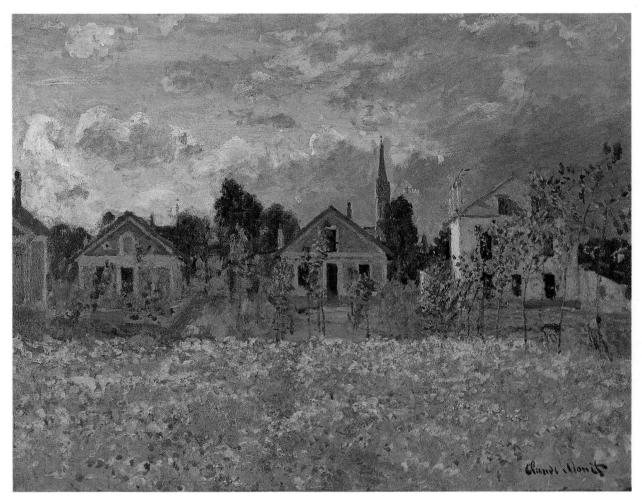

VIII. Claude Monet, *The Houses at the Edge of the Field*, 1873. 54 × 73. Nationalgalerie, Berlin (West).

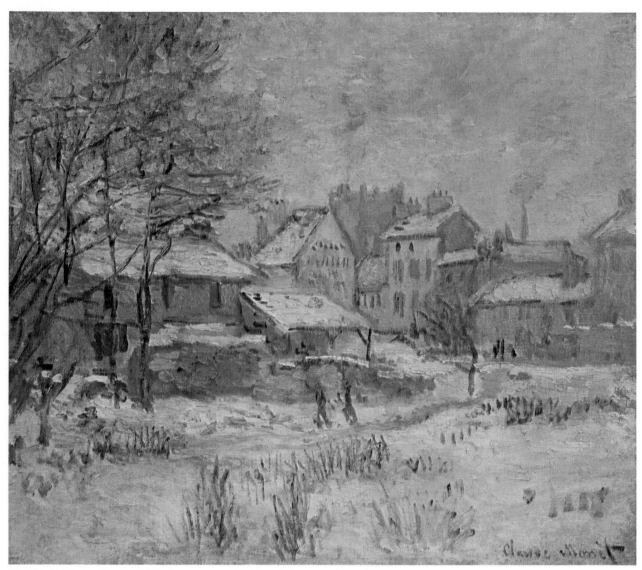

IX. Claude Monet, *The Croix Blanche*, 1875. 53 × 64. Musée Marmottan, Paris.

boulevard Saint-Denis,[29] just like the scores of other Parisians who were coming to Argenteuil and renting places that were being constructed on speculation.

It is not clear why Monet moved. Perhaps it was owing to strained relations with Madame Aubry, for he was always late with his rent. On 1 April 1874 he had written to Manet that the landlady had come by his house that morning at seven-thirty to present him with his bill of two hundred and fifty francs for a quarter of the year's rent; he only had two hundred to his name and would Manet be so kind as to send him one hundred more?[30] However, Monet's move might also have been due to his need for more space. When he paid Manet back almost two months later, he apologized for his tardiness by saying that he had returned to the country and was greatly occupied with moving his atelier. It is difficult to know whether he was referring to his studio in Paris (which he kept until the end of 1874) or to his house in Argenteuil. In any case, on 18 June he signed a lease for his new place on the boulevard Saint-Denis.

The rent for his new house was substantially more than what he had been paying (1,400 francs a year as opposed to 1,000). Obviously, Monet was moving up in life. Why then are his letters filled with complaints about not having any money, and why was he always borrowing small sums with the excuse that he was about to be thrown into jail by angry creditors? The answer is simple. Monet always spent what he earned, and then some. Although he had a good yearly income, it was not consistent from month to month; yet he employed two maids at Argenteuil and most likely a gardener, and he ordered his wines from Narbonne and Bordeaux. In the 1880s Durand-Ruel, who was generous with his support, suggested that Monet's financial difficulties would be greatly diminished if he lived more frugally—for example, perhaps he might drink the local wines?[31] Monet found this insulting.

Monet was also a niggler about money. It almost made no difference how much he had; he would insist he needed more, demanding it out of spite, revenge, or defense. This is particularly evident in his letters of the 1880s and 1890s and in René Gimpel's accounts after 1900, when Monet was so successful that he could get almost any price he wanted for his paintings. It is also apparent in his pleading letters of the 1870s.

Several factors could have led Monet to believe that his new, more expensive house was within his means. The first was his wife's inheritence.[32] Camille's father had died in September 1873 leaving her 12,000 francs. She received 4,000 francs in November but her mother initiated legal procedures to avoid or postpone paying her the rest for almost a year. Finally, in October 1874, Camille received 2,000 francs and the right to 100 francs interest on the remaining money to be paid twice a year until 1877, when the principal would legally be hers.

A second and more important factor was Durand-Ruel's patronage. In 1872 and 1873 the dealer had purchased almost 29,000 francs worth of paintings from Monet (9,880 the first year and 19,100 the second). This income and the fact that it increased from one year to the next were undoubtedly encouraging; even more so was the rise in Monet's total earnings. In 1872 he made 12,100 francs, and in 1873 more than double that amount, 24,800. These were substantial sums for the time, as the average worker in Argenteuil during the same years made from 4 to 6 francs per day, or about 2,000 francs a year. Clearly, Monet was not struggling to get by.[33]

His move into the new house does not seem to have affected his style or his output, although from 1874 onward his views of the town became increasingly limited to his own neighborhood. Perhaps he did not want to venture too far from his own hearth, for most of them were painted during the winter of 1874–75. Numbering nearly two dozen, these views are some of the most beautiful paintings that Monet produced during all of his years in Argenteuil. His work of the 1870s is generally thought of in terms of summer sunlight sparkling on the waters of the Seine, but, in fact, many pictures from this period depict a winter atmosphere, hushed snow-covered roads, and leafless trees stretching toward gray, overcast skies—pictures like *The Croix Blanche* and *Snow at Argenteuil I*, both of which show the area behind Monet's house (figs. IX, 22).

Monet's vantage point is important to each picture. In both he is looking westward to the same group of buildings. In *The Croix Blanche*, however, because the building in the center with three second-story windows is viewed more directly, it seems that Monet has come down the street and taken up a position slightly to the left. He was probably standing just off the rue des Bicherettes, which appears as a footpath in the middleground. For *Snow at Argenteuil I*, therefore, he must have been on the far left side of the Grande

22. Claude Monet, *Snow at Argenteuil I*, 1874. 57 × 74. Museum of Fine Arts, Boston.

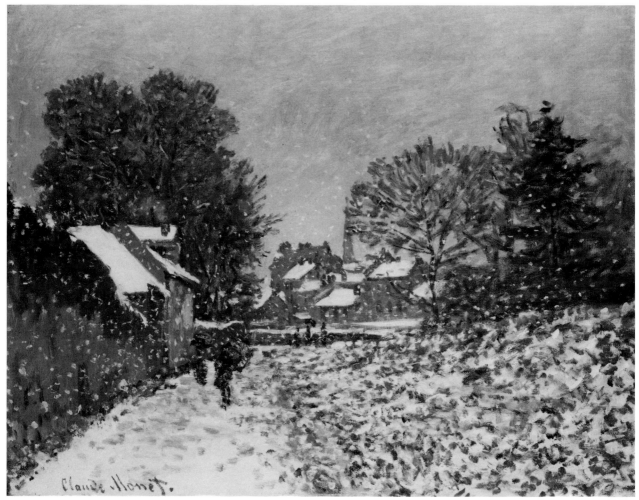

Rue (the present rue Paul Couturier). His vantage point there allowed the church steeple to rise up in the distance, whereas in the first view it is cut off on the left.

The differences between the two views are substantial, recalling Sisley's and Monet's different versions of the boulevard Héloïse. Although in both paintings from 1874–75 the buildings do not appear uniform, they are a more ordered ensemble in *Snow at Argenteuil I*, just as they were in Monet's earlier *Boulevard Héloïse*. The street in *Snow at Argenteuil I* is also like that in the earlier Monet picture, while the more cluttered foreground in *The Croix Blanche* is analogous in spirit to Sisley's version.

In *Snow at Argenteuil I*, the old stained wall on the left, the house with the smoking chimney, the many trees, and the sloping expanse of green, white, and brown indicate that this is a countrified place. It appears less rural, however, than what Monet shows in *The Croix Blanche* where the stalks of grass, long untended, poke up through thick snow-drifts. The land in *Snow at Argenteuil I* is totally irregular, moving off to either side and sloping down in the middle with uneven and obviously unplanned contours. The narrow path below curves out from the mélange of houses, dips and rises over the bumpy terrain, and then disappears into the trees and undergrowth on the left. The broken wall and the shed are far more rustic than any element in *Snow at Argenteuil I*. Without knowing anything about either site, a viewer looking at both pictures would understand that the town of *The Croix Blanche* has been renovated in *Snow at Argenteuil I*; its footpaths have been widened, leveled, aligned, perhaps paved; its open spaces have been built on, walled off, or landscaped; its rambling structures straightened; its innocence lost.

Like the differences in Monet's views of the vineyards and the garden, those here show two Argenteuils, past and present. And the changes they allude to actually occurred. In 1865, after having lived in his house on the rue Pierre Guienne for years, Monsieur Aubry requested and received permission to build a wall around the entire circumference of his property, which stretched from the boulevard Héloïse to the rue Diane. In 1869 the government, in response to complaints about the narrowness of the streets in the area, undertook the widening and aligning of the rues Man, Carême Prenant, ah! ah!, Diane, Pierre Guienne (Monet's former street), and a part of the boulevard Héloïse. And in 1873, because "the growing development of the railroad [made] the establishment of large and spacious streets at that point indispensable for the circulation of vehicles and the security of travelers," the government bought the estate of Monsieur Bray, which lay on a direct line between the Croix Blanche and the station, and built a new street across its northern section.[34]

This is the street that Monet shows in *Snow at Argenteuil I*. Emphasizing the breadth and emptiness of the foreground by rendering the entire lower right half of the picture as a myriad of mingled brushstrokes, Monet pushed the traditional seventeenth-century compositional format even further than he had before. Space and form are defined simply by the size, shape, and direction of the strokes. The orientation of this sea of paint is extraordinary; it slopes down to the left and back to the center so precariously that the white sidewalk and the dark walls on both sides are essential to maintaining the balance of the picture. How far we are from Middelharnis, and yet how calm and ordered the scene actually is. In reworking Hobbema in a new and more modern way, and in choosing a site that is likewise the old made new, Monet created a picture that in form as well as content speaks about the world he was living in.

49

This is not to say that his view of the Croix Blanche is *retardataire*. Although it does not show the new Argenteuil, it likewise does not portray the older side of the town in the most picturesque light. The buildings are dingy and unattractive, and the dominant tone of the picture is a cold, icy blue. It is winter, of course, but the chill seems to emanate from something more than just the season.

The time is late afternoon and Monet is facing westward. The sky is lit with an orange-yellow light which bursts out from behind the trees to the left and dissipates as it spreads out to the right. There are fleshy pinks along the skyline, but the icy blue mist above chills any hint of warmth. That mist is partially the product of the smoke that spews out of a large purple-gray mass in the middle of the picture and a tall, thin chimney on the right. Although separated by a section of sky, the mass and chimney were actually a part of the same complex—the Joly factory. Located only two blocks from where Monet was standing, the huge iron works was a formidable contrast to the jumble of buildings in the Croix Blanche (see maps, fig. 23), a fact which Monet seems to suggest in his picture by the juxtaposition. The buildings in his view are almost like a false front, a western frontier Hollywood set—and, indeed, there is truth to this resemblance.

Just in April 1874 the municipal government, against the wishes of many residents, had authorized a Parisian company to open a new iron works in the western part of town. The authorities, argued the residents, were trying to realize an immediate profit at the expense of the future. The area would be lost for new residential construction, just like the area where the Joly factory had grown up. "This very important establishment . . . could serve as an example of what will happen to our neighborhood," they wrote. "Around this factory there is a great deal of land, near the railroad station and perfectly located for the construction of country houses. But the noise and inconveniences stopped all construction in the area and caused people to build in the western part of Argenteuil . . . even though it was the furthest from the railroad."[35] Although not entirely true (houses did go up near the factory, but on the northern side where there were fields), the residents' protests and the action of the government affirm what Monet suggests in *The Croix Blanche*. Argenteuil was sacrificing its traditions for a more progressive future. The

23. Maps of Argenteuil indicating the area around the Joly Factory. (left) 1890. Department Archives, Versailles. (right) 1880. Town Archives, Argenteuil. Direction North to right.

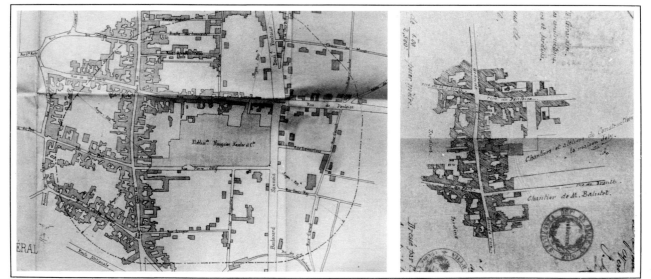

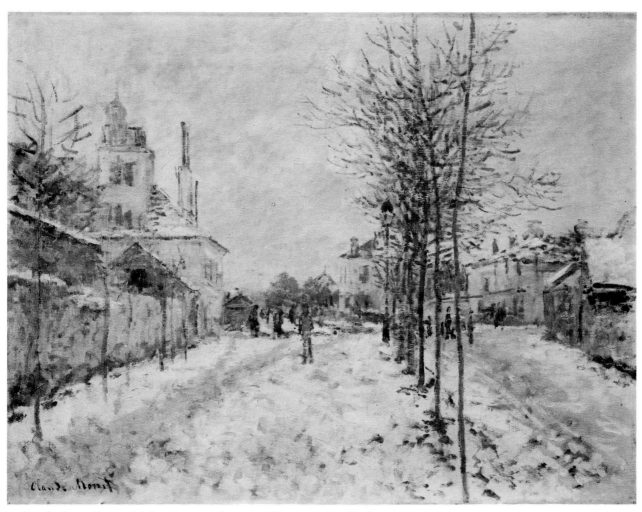

24. Claude Monet, *Boulevard de Pontoise*, 1875. 60.5 × 81.5. Kunstmuseum, Basel.

chilly tone of the painting, therefore, arises not only from the season and the moment, but also from Monet's awareness of the town's particular situation.

That awareness also seems to have produced a kind of tension, as perhaps is evident in *Boulevard de Pontoise* (fig. 24), a view likewise done in the winter of 1874–75. The breadth and straightness of the street, reminiscent of the boulevard Héloïse, indicate that this is a modernized part of town; but the immediacy of the scene, the contrast of the structures on the right and left, and, most important, the row of newly planted saplings that divides the view into two unequal parts make the picture appear more strained than any previous painting. To paint this picture, Monet stood no less than two hundred meters from the Joly factory, located behind him to the left.

More often during that winter, however, Monet painted views like *The Entrance to the Grande Rue* (fig. 25), where he could fulfill his commitment to nature and the modern world without the sense of conflict (the Grande Rue had just been renovated in 1874), or *Snow at Argenteuil II* (fig. 26), so calm and uncomplicated it seems more like the outskirts of Honfleur that he had painted nearly ten years earlier. These are the "country" aspects of Argenteuil in uncompromised form.

This is not to say that Monet stopped making difficult pictures. On the contrary, in the same months, he painted the *Boulevard Saint-Denis* (fig. 27), a view of the same street, though now seen from the east with an obvious emphasis on the site's suburban features—new houses, trees, and commuters (the railroad station being directly behind Monet). More modern still are his views of the railroad itself, the great contemporary symbol of industry, science, and progress during that era. In *The Train in the Snow* (fig. 28) Monet's vantage point is no more than thirty meters from the engine, with its glowing eyes and smoking stack. The speed of the machine is implied in its sleek, blurry body, its rapid recession, and the converging lines of the tracks, fence, and trees. Cloaked in a purple-gray mist, it almost seems like some seething creature resting before it moves on into the unknown, as Zola would describe it some years later.[36] Yet the picture is so beautiful and so poetic, with its pervasive atmosphere softening all contrasts and seducing one into a kind of reverie, that industry and the grittier side of modern developments seem far away indeed.

25. Claude Monet, *The Entrance to the Grand Rue*, 1875. 55 × 65. Private Collection, France.

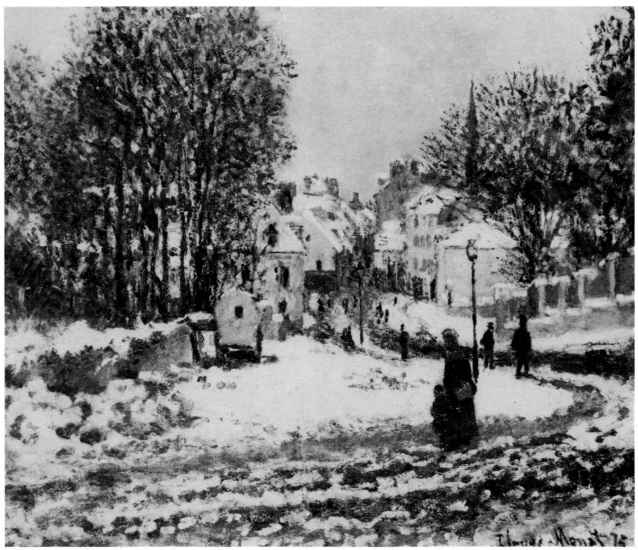

That same winter of 1875, however, Monet painted *Men unloading Coal* (fig. X), a work which he characterized eight years later as a "note apart" from his other efforts.[37] For the first and only time, Monet shows industrial labor in unabashed human terms. Several barges are moored by the banks of the river, their holds black with coal. Long wooden planks lead from the orange and brown decks across the sea-green water to the murky shore on the right. On these planks are men walking in single file while others load their baskets in the boats or line up to leave. Beyond, in the middleground, the metal arch of a road bridge spans the scene. On the surface of the painting, the arch is pierced by the mast of one of the ships on the left and pricked by another in the center. High above the water, on the bridge itself, horse-drawn vehicles move off to the right while people walk to and fro or hang over the railing to watch the men below. In the distance, a railroad bridge crosses the river, its single arch imitating the one in the middleground. To the right, smoking factory chimneys are silhouetted against a pallid gray sky, their verticality echoing the masts of the boats in the foreground. Despite the intricate movement of

26. Claude Monet, *Snow at Argenteuil II*, 1875. 55 × 65. National Museum of Western Art, Tokyo.

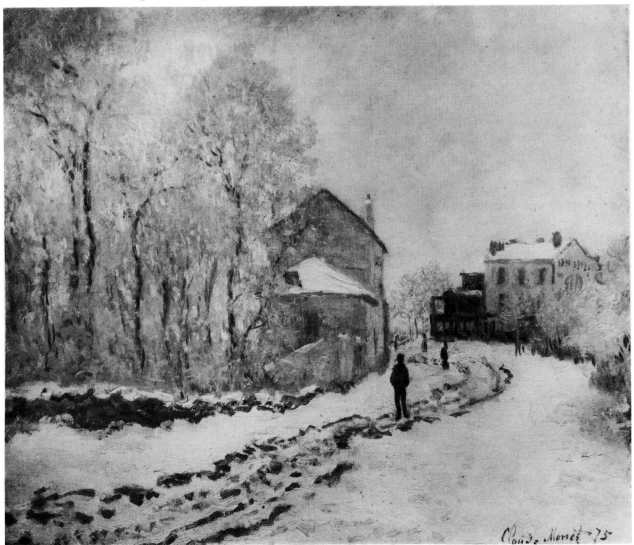

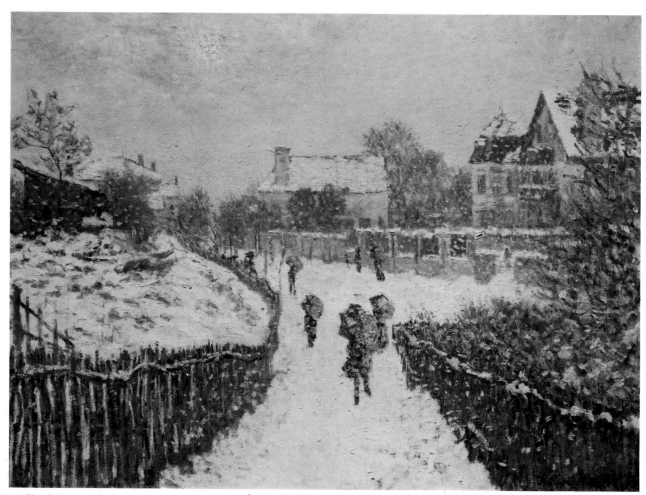

27. Claude Monet, *Boulevard Saint-Denis*, 1875. 55 × 65. Museum of Fine Arts, Boston.

lines, the scene is ordered, and, despite the nature of the subject, it is remarkably free of tension. Perhaps this is because Monet is not attempting to balance city and country, footpaths and boulevards. This picture is about only one side of suburban life, the modern industrial side. It presents the ugly but very real part of that great new deity progress—human labor. This is evident in the way that Monet has focused on the activity of the men on the planks. He has established a rhythm between them by placing three on the first plank and three on the second; two on the fourth and two on the fifth. The three in the middle of the fourth and fifth plank seem to form a set, thus imitating those in front of them. There is only one person on the sixth plank, but, since he is at the beginning of the board, he counterbalances the person on the fourth plank who is just coming into the picture. The two on the last plank fill the void in front of them. The rhythm between the groups of men is also in terms of movement; those on the first plank walk down to the boat with their empty baskets on their heads while those on the second walk up to the bank with their loaded baskets on their shoulders. The same is true for those on the next two planks. However, the rhythm is not just back-and-forth; Monet has put each person in step with the person ahead and, in fact, has made everyone going

54

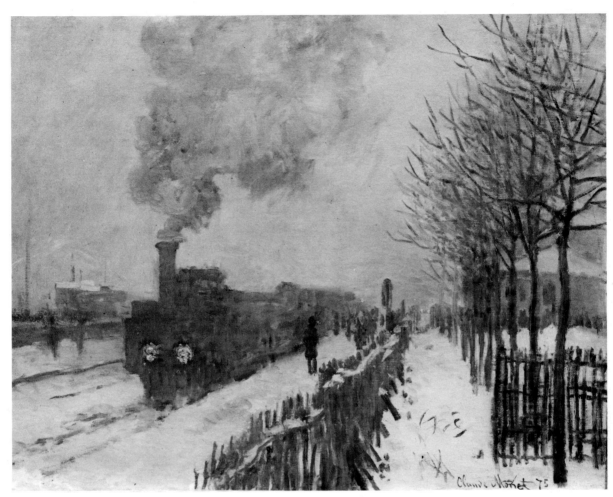

28. Claude Monet, *The Train in the Snow*, 1875. 59 × 78. Musée Marmottan, Paris.

down the plank have his left foot forward, everyone going up, his right. All of this might seem belabored, but obviously Monet felt it to be important, not for the harmony of the scene, or for the geometry of the composition, or for the atmospheric effects, but for the sense of the laborers mechanically repeating a single action. There is, of course, a practical explanation for why they stay in step. The planks are narrow and flexible; if every man walked at his own pace, the boards would bend irregularly and make it more difficult for each person to maintain his balance. No such logic can lie behind the coordination between the men on different planks, but Monet wanted to give the impression of men locked into a regularized pattern like pistons in a machine. For the subject of this painting is not just men unloading coal, not just human labor, but the mechanization of man in the industrial age. These laborers are indeed dehumanized, as one critic recognized almost thirty years ago; it is no wonder that another critic at the turn of the century felt that their silhouettes took on a demonic, fantastic aspect or that the scene had the qualities of an inferno.[38]

This picture reveals those grimmer realities of the Parisian suburbs. It shows that they were not always the peaceful idylls that Monet had made them out to be; that they were

not a romantic fusion of city and country where farmer, factory worker, landowner, and Parisian businessman lived and worked in harmony. The picture, therefore, is about everything that Monet had obscured behind the facades of *The Croix Blanche* (fig. IX) or the fog of his *The Effect of Fog* (fig. 16).

Yet the site is not Argenteuil—it is the Seine at Clichy and Asnières, one loop of the river closer to Paris. On the one hand it makes no difference; Monet has rendered the urban side of the dialectic without reserve. On the other hand it is extremely significant, because instead of confronting this aspect of life in Argenteuil, which he knew and lived with, he left and painted the same subject somewhere else. He could have found a comparable scene in Argenteuil, but he did not. Why?

As we have seen, the sites Monet chose to paint had personal as well as esthetic significance for him. During his first year in Argenteuil, he chose those that reflected the past and present in the town and the interest of the tourist and city dweller in himself. If and when he included any reference to the town's industrial life, it was always in the most harmonious context. Argenteuil, it seemed, was a perfect fulfillment of the desire for modern subjects and his desire for contact with nature. But it could not remain that for him because, despite its beauty, it was being fundamentally altered by the town fathers' faith in progress. It did not take Monet long to realize this, as his view of the vineyards painted at the end of his first year reveals. He was able to live with these changes because they were those of the modern age. Besides, he could always find relief from the smoking factories in the fields or promenades around the town, or in his house and garden. But after continued exposure to these contrasts his relationship with the town became strained. Developments in Argenteuil itself contributed to this revised attitude. In 1875 Argenteuil was not the town it had been when he first arrived, and he knew that.

Monet could not face the industrial side of the town as an isolated phenomenon. His world there could not accommodate such an intrusion because it was essentially a mythical one, a world that he created for himself to satisfy his own personal and esthetic needs. Although it was grounded in reality (the sites he chose did indeed exist as he showed them), it was infused with romance. And how could it not be? The idea that industry meant improvement or that modern life meant happiness was by its very nature romantic. It was even more fanciful for a landscape painter, because factories and Parisian pleasure-seekers were foreign elements in nature. Nature was not progressive, it was permanent. Most important, it was not something that could accommodate industrial or residential expansion; it was consumed and displaced by such growth. Yet Monet had been trying to make these diametrically opposed facts compatible. He had done rather well. The beauty and sheer number of his pictures attest to that fact. But *Men unloading Coal* and everything it stood for had a profound effect on Monet. When he returned to Argenteuil from Asnières after completing this painting, he was a changed man.

3. Bridges over the Seine

IN THE WINTER OF 1871, when Monet left Paris to live in Argenteuil, he left behind a city badly scarred by almost ten months of violence. Between September 1870 and May 1871 the recently rebuilt capital had been besieged by the Prussians and torn apart by the Commune and its bloody aftermath. The Hôtel de Ville, the Tuileries Palace, the Palais Royal, and the Palais de Justice all lay in ruin. Stunned, one observer wrote, "Destruction everywhere. From the Châtelet to the Hôtel de Ville, all was destroyed; there was not a room left."[1]

When Monet arrived in Argenteuil, it would have been immediately apparent that he had come to a town that had also suffered from the war and the insurrection. Although the face of the town was for the most part unchanged, its two arms across the Seine, the highway bridge and the railroad bridge, were girded in scaffolding. Like many of the bridges around Paris, they had been destroyed during the fighting and were now being rebuilt (figs. 29, 30).[2] The railroad bridge was not yet open, so that when the train Monet had taken from the Gare Saint-Lazare arrived at a makeshift station on the plains of Gennevilliers, across from Argenteuil, he had to disembark. There he mounted a coach operated by the railroad company, which took him over the highway bridge that had been opened to traffic only in September. From inside the carriage Monet probably could not have seen the carton factory at the end of the promenade that had just reopened after having been burned ten months earlier; but when he got out at the Argenteuil railroad depot, the coach's last stop, he could not have failed to notice that the seven-year-old station was in shambles. It too had been destroyed, but because the damage was attributable to the Commune uprising and not the war, the railroad company was refusing to rebuild it without financial assistance from the government.[3]

Monet's first impression of Argenteuil would have been of a thriving town recovering from the upheavals of the previous year and a half and undergoing a considerable amount of modernization. As he stepped off the train in Gennevilliers, Monet would have noticed the towering brick chimneys of Argenteuil's factories, and in going from the makeshift station to the highway bridge, he would have seen that, in addition to pleasure boating, Argenteuil accommodated a large amount of commercial river traffic. To the right of the

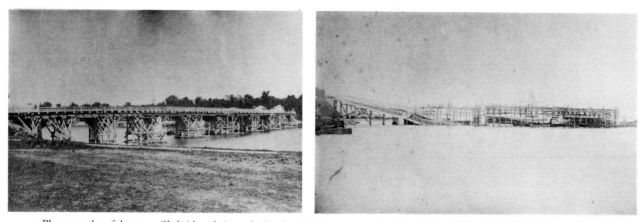

29–30. Photographs of Argenteuil's bridges being rebuilt after the Franco-Prussian War, *c*. 1871. Musée du Vieil Argenteuil.

railroad bridge there would have been barges lined up ready to take the town's plaster to points north and south, while to the left more barges would have been coming to and from the town's busy commercial port, loaded with everything from spices to building supplies. The sight would have prompted Monet to recognize that Argenteuil was a working town and the Seine a working river.[4]

Monet would have seen these aspects of modern life in a setting that, though no longer rural, still displayed some of the natural beauty of the traditional French countryside. He referred to it once as "la campagne," but it was not as rustic as Fécamp, Etretat, or Chailly—all rural sites he had painted not long before. Here in Argenteuil there were fields under cultivation and factories smoking, swaying trees and clanging machinery. Smells of fertilizer mixed with the stench of potassium chromate while blue-vested workers mingled with black-frocked bourgeoisie.

The contrasts were evident throughout the town, but they were expressed most explicitly and most prominently in the two bridges over the Seine. Running north–south across the river, the bridges were visible from a considerable distance away and served as landmarks for travelers coming by land or by water from any of the neighboring suburbs or from the capital. The highway bridge was a structure of "seven graceful arches that spring from stone pilings," in the poetic phrase of Adolphe Joanne, describing the entrance to Argenteuil in his *De Paris à Saint-Germain à Poissy et à Argenteuil* of 1853.[5] Built in 1831–32 from the traditional materials of wood and cut stone and employing the traditional design of a series of romanesque arches, the bridge, burned during the war, was rebuilt in the same style in 1871. It rose to a height of fifteen meters and spanned the two hundred meters across the river from Gennevilliers to Argenteuil with picturesque beauty and architectural grace. In its function—it served pedestrians and horse-drawn vehicles—as well as in its form and original date of construction, it represented the Argenteuil of old.[6] The railroad bridge, although only a few hundred meters from the highway bridge, was separated from the latter by decades of technology. It was made of poured concrete and prefabricated iron according to a stripped-down, industrial design, appropriate for both its materials and its function. It served not the traditional slow-moving carriage but the new, rapid, iron horse. Built only eight years before Monet arrived in Argenteuil, it represented everything new and progressive about the town.

Soon after he was settled, Monet retraced his path towards Gennevilliers to paint *The Highway Bridge under Repair*, 1872 (fig. XI), a picture which at first glance seems to present

58

a relatively simple subject. The bridge, buttressed by scaffolding, stretches across a calm body of blue-gray water to several beige houses on the opposite bank. A steamboat approaches from the right, emitting a cloud of smoke as it enters an arch webbed with timbers. The interlocking members of the boxlike scaffolding form intricate patterns that contrast with the emptiness of the overcast sky and serene water and they occupy a portion of the water's glassy surface with their reflections. On the bridge itself, a carriage moves off to the left while pedestrians walk in both directions; in the distance, almost as a backdrop to the structure, Monet places a dense mass of purple-gray, presumably a grove of trees.

Monet probably chose to paint the scene from the river bank by the southern (Gennevilliers) end of the bridge so that in the background he could include some houses as a reference to the town, for indeed it served as the entrance to Argenteuil, leading to the center of town and, like the parish steeple, announcing the existence of an established community. Besides being attracted to the bridge as a major architectural landmark, Monet must also have found the web of scaffolding to be an interesting motif, for, in contrast to the photograph (fig. 29), he gave it considerable prominence. He also might have been moved by the traditional associations of man's relation to nature that the bridge evoked. As natural materials reshaped by the human hand and reordered by the human mind, bridges had always been seen as the primary expression of how man could cross rivers and gorges without upsetting the balance of the environment or the beauty of the landscape.

But it is difficult to believe that Monet would not have been conscious of what the bridge meant in 1872. Barely a week went by that *L'Illustration* or *Le Monde Illustré* did not have an article or illustration about the country's recent defeat by the Prussians. Military paintings at the Salon multiplied after the armistice; and, as the demands for revenge at the outbreak of World War I confirm, no Frenchman forgot what happened. Monet, having fled France after the war broke out, staying first in London and then in Holland, had avoided the horrors of the Prussian occupation and the suppression of the Commune. But, as he made clear in a letter to Pissarro in June 1871, he was concerned

31. *Autour de Paris—Reconstruction du pont du chemin de fer de Chatou.* (From *Le Monde Illustré*, XV, 2 September 1871, 159.)

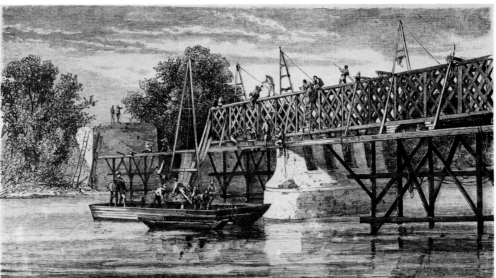

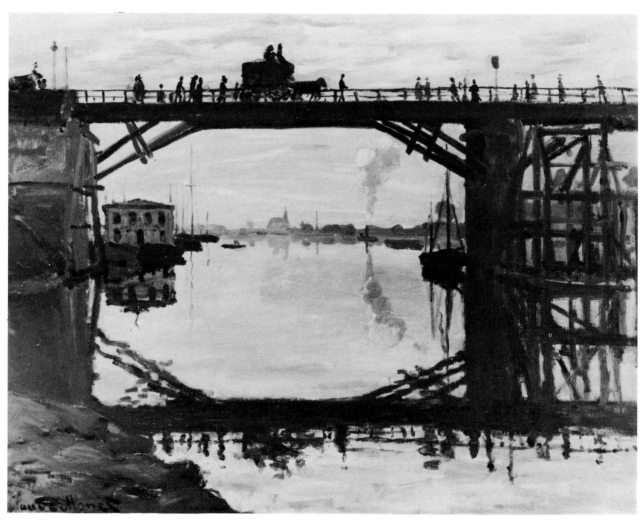

32. Claude Monet, *The Highway Bridge*, 1872. 54 × 73. Private Collection, Switzerland.

33. Claude Monet, *Windmills in Zaandam*, 1871. 47 × 73. Private Collection, United States.

34. Claude Monet, *View in Zaandam*, 1871. Musée Marmottan, Paris.

60

about the situation: "We have been completely without news of Paris since we left London," he wrote from Zaandam. "It's impossible to get a French newspaper here. I hope to have one tomorrow."[7] Although he had not helped to defend the country and was enjoying the post-armistice summer in Holland, he was optimistic about returning to France, as is evident from another paragraph of that same letter: "I gather you have not been as fortunate as I have and that you have not been able to do anything since I left. That is too bad, because it would have been a good thing to bring back some English landscapes; however, you are still going to find beautiful things [to paint] in France. The country is not lacking in that regard."[8]

Having expressed such optimism from afar, Monet must have felt some sorrow when, traveling from Holland to Paris across the countryside that had only recently been evacuated by the enemy, he arrived in the capital to find the newspaper reports of destruction to be true, and similar disillusion when he came to Argenteuil and saw that it too had not escaped the war unscathed.[9] Once there, he would have learned that Argenteuil had been occupied by the Prussians and that its residents had been forced to pay more than fifteen thousand francs in indemnity. He would also have learned that Argenteuil had been abandoned by the French army, who in the face of the advancing Prussians, had burned the highway bridge before they retreated to Paris.[10] Thus, when he came to paint the bridge, it could have been both a painful reminder of defeat and a cogent symbol of France's physical and spiritual collapse.

However, his picture is not about war and defeat, for the bridge is not the ruin of a year earlier; it is under reconstruction and open to traffic. It can therefore be seen, like popular illustrations of the subject (fig. 31), as a symbol of France after the war, rebuilding her monuments, reopening her lines of communication, and revitalizing her economy. In fact, by the time Monet painted this picture, France, although obliged to pay the Prussians an indemnity of five billion francs, had seen her industries start up and move forward with such speed that she had met President Thiers's call for unity by oversubscribing the loan he floated by five times the amount necessary.[11]

35. Hokusai, *River Scene with Bridge and Fujiyama in the Distance*, from Thirty-Six Views of Fuji. Metropolitan Museum of Art, New York.

36. *A View of Oissel*. (From Jules Janin, *De Paris au Havre*, Paris, 1853, 44.)

The evidence of this recovery can be found not only in the bridge and the traffic, but also, and most significantly, in the steamboat. A popular contemporary symbol for industrial progress, the steamboat is at the focal point of the picture, its bow just entering the maze of scaffolding, its chimney pipe paralleling the vertical members of the buttresses. Contrasted with the horse-drawn carriage exiting the scene on the left, the boat puffs out a billowing cloud of smoke that curls around the toll house at the end of the bridge before it twists up into the air. While undesirable to most citizens of the twentieth century, this smoke was welcomed by those of the nineteenth, for it came from a steam engine, and steam, as Benjamin Gastineau pointed out in 1863, was, after the printing press, "the discovery that most improved human life."[12] More powerful than man or beast and more easily harnessed, it could run machines that would both improve man's material condition through mass production and greater employment and change his living habits—even his perception of the world—through faster and more efficient transportation and communication. "As the accession of domestic animals . . . began an era of liberation and progress for ancient societies," wrote Alphonse Esquiros, the editor of *La Revue Parisienne*, "so too should the invention of machines run by steam mark for our modern societies an epoch of regeneration. Steam, that soul of modern industry, . . . is a breath that renews the world."[13] Pierre Lachambeaudie was not, therefore, expressing merely a personal opinion when he claimed in his poem "La Vapeur" that steam was bringing back the golden age; he was speaking for his epoch.[14] Although he wrote his verse more than twenty years before Monet painted his picture, the sentiments, while tempered by circumstances, had not really changed. Steam might not bring back France's golden age, but it would help her to recover her pre-war prosperity.

Argenteuil itself was regaining its former momentum, and this picture, as a view of the town, is as much about Argenteuil's recovery as it is about France after the war. Monet stated this more directly in another painting of the area, *The Highway Bridge* (fig. 32), done during the same months. Standing on the same side of the Seine for this second view, Monet turned to the left to look down the river into the late afternoon sun. The first section of the bridge, set against the rich lavender sky and reflected in the quiet water, stretches from one side of the painting to the other, dominating the scene by its boldness and size. Like an imposed Euclidian form, it frames the elements of the landscape in the distance—houses, factories, boats, and trees—all of which link the site to progressive Argenteuil.

Compositionally, this view is without precedent in Monet's work. He had recently done two pictures in Zaandam with a pedestrian bridge silhouetted against a colorful sky (fig. 33), but the bridge is not the principal element in either picture. Certain sources may have influenced Monet's formal arrangement of *The Highway Bridge*. He might have seen any number of paintings that employed a similar format—Hubert Robert used it frequently. But a drawing by Monet in one of his eight sketchbooks at the Musée Marmottan indicates a more likely source (fig. 34).[15] One of several executed in Holland during the summer of 1871, it shows a bridge quite similar to those in the two Zaandam paintings, but with the structure more centrally located in the foreground, much larger, and positioned to frame the landscape beyond, and thus more like the painting of the bridge at Argenteuil. While the drawing probably represents a specific site, it is remi-

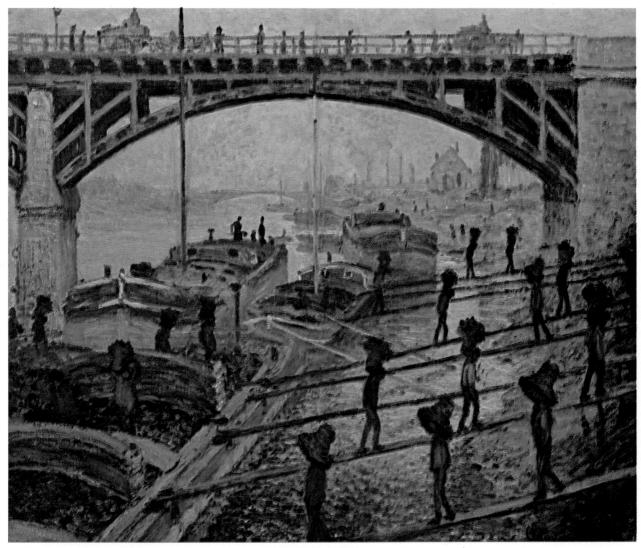

X. Claude Monet, *Men unloading Coal*, 1875. 55 × 66. Private Collection, Paris.

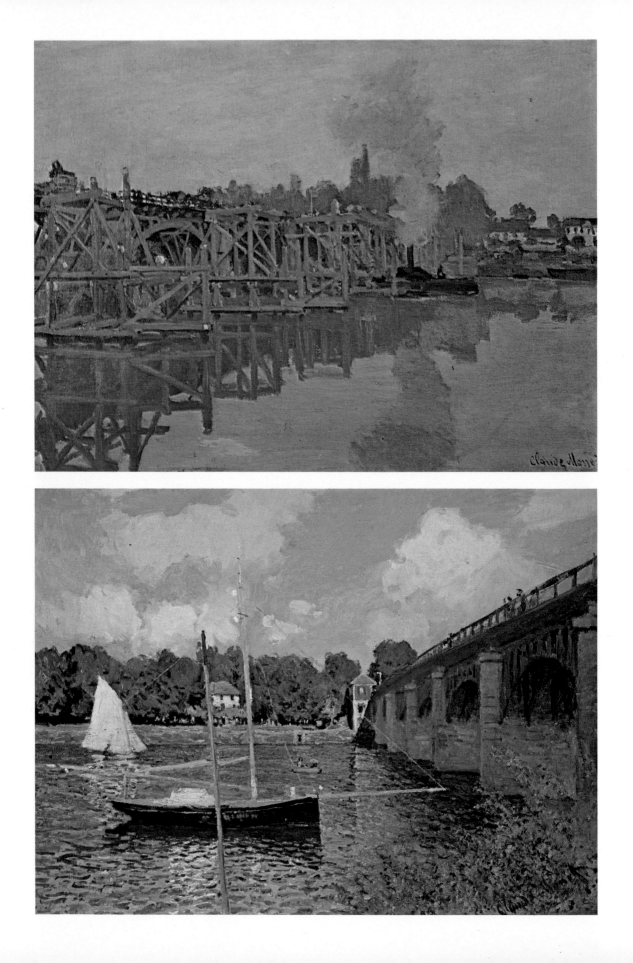

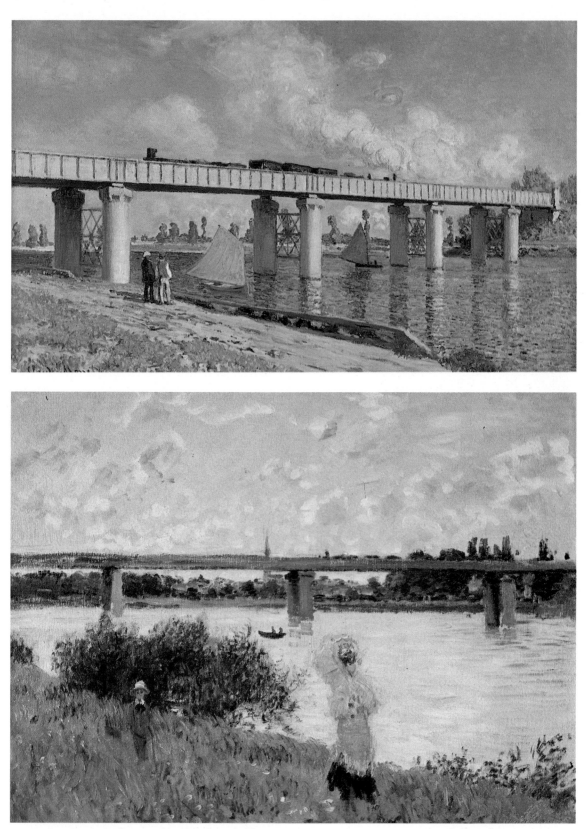

XI. (top left) Claude Monet, *The Highway Bridge under Repair*, 1872. 60 × 80.5. Rt. Hon. R. A. Butler Collection, Great Britain.
XII. (bottom left) Claude Monet, *The Highway Bridge at Argenteuil*, 1874. 60 × 80. Collection Mr. and Mrs. Paul Mellon, Upperville, Virginia.
XIII. (top) Claude Monet, *The Railroad Bridge viewed from the Port*, 1873. 60 × 99. Niarchos Collection, London.
XIV. (bottom) Claude Monet, *The Promenade with the Railroad Bridge*, 1874. 54.5 × 78. St. Louis Art Museum, Missouri.

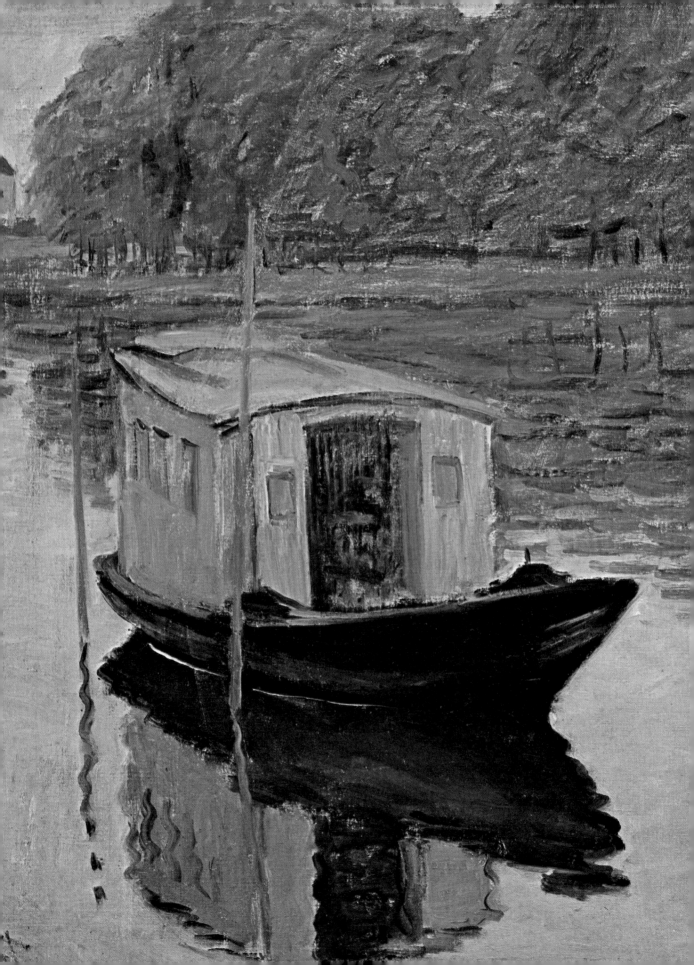

niscent of many Japanese prints such as Hokusai's *River Scene with Bridge and Fujiyama in the Distance* (fig. 35).

It has long been claimed that Monet first "discovered" Japanese prints during his visit to Holland and that his enthusiasm for them was the primary reason for his change to a brighter palette. Monet could, of course, have become familiar with Japanese art and oriental artifacts during the 1860s in Paris, as they were bought by numerous artists and collectors, discussed by several leading writers of the day, reproduced in a number of popular publications, and even exhibited at the Universal Exposition of 1867.[16] However, no picture prior to his departure from France in 1870 is as closely related to a particular print or to the general interest in things Japanese as this drawing in the Musée Marmottan. The drawing is significant, therefore, since it establishes the East–West connection with greater certainty.[17] In addition, since it relates in composition and spirit to *The Highway Bridge*, it shows that that connection continued upon his return.

Monet would have been attracted to Japanese prints for their dramatic compositions, unexpected spatial arrangements, bold colors, and untraditional emphasis on the surface. Being new and different, these formal factors would have complemented Monet's unorthodox subject matter. Japanese art also added a popular aspect to his work, for the interest in oriental things was widespread. As early as 1868 the Goncourt brothers could note in their journals, "The taste for things Chinese and Japanese! We were among the first to have this taste. It is now spreading to everything and everyone, even idiots and middle-class women."[18] The popularity of Japanese prints was due, however, not only to their formal features, but also to the contemporary belief that they depicted everyday scenes from Japanese life—a critical consideration, for it may have encouraged Monet to render his prosaic subjects with equal directness.

Just as important in this regard were popular illustrations in contemporary guidebooks and weekly Parisian journals. *A View of Oissel* (fig. 36), for example, which appeared in guides to northern France from 1853 onwards, is strikingly similar to *The Highway Bridge*. Both are directly frontal and although the single arch in the print is curved, closer, and larger than Monet's, it spans the scene creating a similar picture within a picture. A steamboat, closer, larger, and more aggressive than in Monet's view, sits under the arch spouting a billowing cloud of smoke. While the smoke covers part of the bridge and train, it does not obscure the factories, houses, and boats in the background, the same elements that are in Monet's picture.

More significant, perhaps, both views are windows onto related worlds revealing the contrasts of modern life—industry and nature, work and pleasure, town and country. Both underscore the harmony of these worlds by their strong compositions. Both finally emphasize in particular the diverse means of transportation, as Jules Janin, the author of the guidebook in which the illustration appeared, pointed out when describing the Oissel scene:

> Two miles from Rouen, at the small town of Oissel, one finds one of the most beautiful works of the railroad, a bridge of rare and bold design, so beautiful that at a certain elevation industry becomes total poetry.... There all at one time, and even at the same instant, you see in front of you all the diverse means of travel gathered at the same point—the post-chaise enveloped in its rapid dust; the Norman's peasant horse; the

67

calèche of the neighboring chateau filled with children; the cart which brings the farmer from the market; the horse towing the barge; the sailboat pushed by the wind; the scull; the *galiote*, this fabulous ship used to haul Norman provisions; the steamboat which mixes its smoke with the smoke of the machines; finally, the happy man who follows his fantasies and who revels in the dreams, the landscapes, the monuments, all the joys of the route . . . the happy man who travels on foot.[19]

Janin could have been describing Monet's Argenteuil of 1872; Monet was attempting to be equally forthright, as is evident when his painting is compared to Jongkind's view of Argenteuil from just three years earlier (fig. 37). If it were not for Jongkind's inscription (which reads "dimanche 26 juillet 1869 Argenteuil") it would be difficult indeed to associate this pastoral scene with Monet's adopted home.

Upon occasion Monet would paint works such as *The Highway Bridge viewed from the Port*, done in the summer of 1873 (fig. 38), which, like Jongkind's, evokes memories of former times. The bridge here is like a metaphor of old Argenteuil, solid, unassuming, and less frequently crossed. It frames a view that is also a throwback to the past—well-spaced houses sitting on an unpopulated bank and facing a deserted basin. For this painting, Monet stood on the Argenteuil rather than the Gennevilliers side of the river as he had in his two other pictures. He still looked in a westerly direction, but he did not broaden his view enough to include the floating structure that served as a boat house— evident in *The Highway Bridge*—or any of the sailboats. He also did not include any reference to the commercial side of the town; there are no steamboats, barges, or factory chimneys. Removed in time and space from its actual context, the scene lacks complexity, even charm, making it in the end rather empty and uninteresting.

The bridge itself may have provoked this rare step backwards, as it was a simple structure. Monet may have known someone who wanted to own such a restrained picture or he may have been responding to the view of Gennevilliers through the arch. The area framed by the bridge was relatively undeveloped and thus less interesting visually. When Monet painted the same houses and trees in 1873, *The Plains of Gennevilliers* (fig. 39), he filled the scene with the atmosphere of a spring thaw, enlivened the fields with rich, colorful pigment, and emphasized their breadth by using strong perspective lines. There are no such devices or juxtapositions in *The Highway Bridge viewed from the Port*.

37. Johan Bartold Jongkind, *The Seine at Argenteuil*, 1869. Cabinet des dessins, Musée du Louvre, Paris.

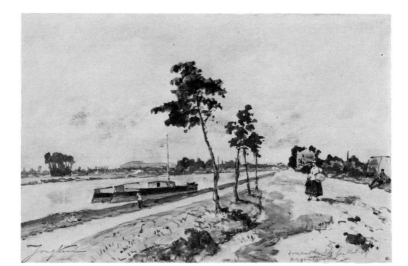

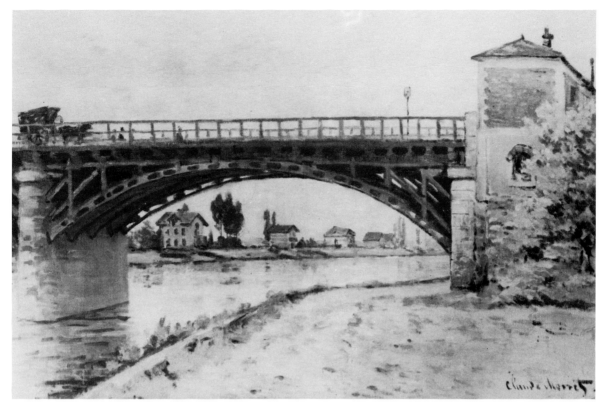

38. Claude Monet, *The Highway Bridge viewed from the Port*, 1873. 45.5 × 71. D. W. Cargill Collection, Great Britain.

39. Claude Monet, *The Plains of Gennevilliers*, 1873. 55 × 73. Private Collection, Paris.

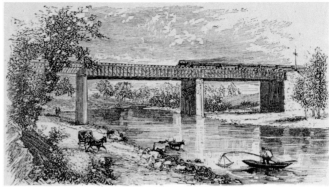

40. Postcard of the docks at Argenteuil, *c.* 1900. Medici Collection, Argenteuil.

41. *Le Pont de Conestoga.* (From *L'Illustration*, LXVIII, 5 August 1876, 84.)

Although in painting this later picture Monet was truthful to what was in front of him, he turned his back on a more active and more telling site, the port of Argenteuil. The big empty area in the foreground of the picture is actually the beginning of a loading dock that stretched almost three hundred meters between the highway bridge and the railroad bridge. A substantial part of the town's commerce passed through this port. Because of this traffic, the department prefect constantly issued notices about docking regulations. Although the traffic increased over the years and changed the physical appearance of the port, a postcard view from the turn of the century (fig. 40) gives some indication of what Monet would have seen had he turned around.

Even more antithetical was the railroad bridge deeper in the background. And during the same summer, perhaps at the same time, Monet painted it in *The Railroad Bridge viewed from the Port*, 1873 (fig. XIII). Supported not by massive cut-stone piers but by four sets of slim, poured concrete cylinders, the bridge has no series of rounded arches, just one straight boxlike span. The trestle is made of iron, not wood, prefabricated by machines, not modeled by hand. Monet shows it gleaming in the afternoon sun, its stripped-down materials reflecting the strength and impersonality of industry, its dominant position in the landscape speaking of man's triumph over nature.

The product of the new technology, the bridge carries across the river the new hope for the future, the train. The sleekness of the trestle and the long trail of smoke emphasize the speed at which the train is traveling. So too do the sailboats. Powered by wind instead of steam and guided by the whim of the skipper rather than the dictates of the rail, they glide out from under the imposing structure noiselessly, effortlessly, and at quite a different pace. To make sure that this structure and everything it stands for is recognized as a marvel, Monet places two men in the scene, just as so many popular artists of the day did (fig. 41). Monet's figures, while small enough to be dominated by the bridge, are large enough to relate to it as its beneficiaries. They stand still as the train thunders above them and, although they do not hail the bridge with dramatic gestures, their position bespeaks their wonder.

This picture, unlike *The Highway Bridge viewed from the Port*, shows Argenteuil as a place where the contrasts of modern life—the bridge and the sailboats, labor and leisure, industry and pleasure—could coexist. Although Monet has turned his back on the town's port, just as he had in *The Highway Bridge viewed from the Port*, he has confronted an even more important element of his day, one that had inextricably altered the town.

Even before the bridge opened in 1863, residents of the town knew what the future held. In 1862, in the second issue of the newly founded *Journal d'Argenteuil*, Jules Beaujanot, one of the editors, stated:

the moment was perfectly chosen to begin this publication, Argenteuil is growing every day. It will receive a new boost when the railroad line presently under construction . . . puts Argenteuil in direct communication with the Montmorency valley, Saint-Denis, Pontoise, etc.

It is evident to everyone that under these conditions the Argenteuil station will become the center of a very important movement of merchandise and travelers and that the commercial interest of the locality and surrounding suburbs will have there a focus of development. The town of course will have roads to widen, new accesses to pierce, improvements to make; numerous constructions will come to group themselves around this center and will create in this part of town which today is empty and silent a populated and animated neighborhood. Finally, the diverse industries of Argenteuil will also experience the effects of the new state of things, which will have an effect on the public and private interests of the district.[20]

His predictions were indeed fulfilled, for after the bridge was open, industries for both work and pleasure increased with every passing year. Thus, when Monet painted it a decade after the first train rumbled through its trestle, he was painting Argenteuil's ironclad ties to industry and growth.

He was also painting the period's highest symbol of hope and achievement. While steam might usher in Lachambeaudie's golden age, it would do so only when it was harnessed to run some machine. And the most glorious machine of all was the steam-powered train, as Lachambeaudie and his contemporary Pierre Dupont made clear in many of their poems and fables. "Allons, ô ma locomotive!" wrote Dupont in 1853,

> Tes rails nous mènent au progrès.
> La génération hâtive
> Appelle des ombrages frais.
> Plus de frontières, plus de guerre!
> Nous sommes las du sang versé.
> Peuple! de tout le mal passé,
> Buvons l'oubli dans un grand verre.[20]

While poets and writers sang the praises of this creation that would redraw the map of the world and carry men to a new and brighter future, popular artists adopted it as a subject with equal enthusiasm, providing Monet no doubt with encouragement and ideas. Filling weekly magazines which multiplied in the 1840s and 1850s and guidebooks which increased dramatically with the rapid rise in the number of people who traveled by railroad (6.3 million people in 1841 to 93.1 million in 1866),[22] these popular artists generally glorified the train as the inspired product of science and man's genius. They showed it winding through the rolling hills, streaking across the open plains, or rolling by the rushing streams (figs. 42–3). Frequently, like Monet, they pictured it crossing a bridge or a viaduct, which enhanced its appeal because, like the train, such structures

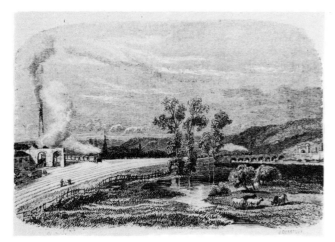

42. *Bifurcation de chemin de fer de Rouen au Havre.* (From Jules Janin, *De Paris au Havre*, Paris, 1853.)

43. *Tour de Catilina et viaduc delle Svolte.* (From *Le Monde Illustré*, XII, 8 February 1868, 92.)

were examples of man's wondrous technological ability. The combination was especially appropriate because bridge-building skills had developed substantially with the growth of the railroad; hundreds of structures spanning gorges, valleys, and rivers went up throughout France as the miles of track were laid down. And in many ways the bridges were even more inspiring than the invention that they were supposed to be serving. Some, like the one at Morlaix (fig. 44), were so daring that they naturally reaffirmed one's faith in the brilliance of the age. Others, such as at Chaumont (fig. 45), were of such gigantic proportions that they provoked apt comparison with ancient constructions like Roman aqueducts. And, because they crossed gaps in nature and permitted a measure of control over uncontrollable elements, some bridges were even praised for correcting the flaws of the natural world and for improving the environment. "Happily for the landscape," wrote Amedée Guillemin in 1869, "the viaducts are taking on gigantic proportions, and their long files of high arches are replacing the heavy and graceless masses of the earth."[23] It is therefore not surprising that railroad bridges were referred to as "ouvrages d'art" or that Guillemin could claim they now "make up the majority of real monuments" in Europe, usurping the position formerly held by cathedrals.[24] Those medieval houses of stone would be physically refurbished as a result of the century's interest in the "dark" ages, but their significance would never be fully restored. It was lost to a faith in science, the belief in industry, and the secularism of modern life. Cathedrals were the monuments of the spiritual past; bridges were those of the materialistic present.[25]

Guillemin probably would have had difficulties convincing many Argenteuil residents that such was the case with their iron bridge, especially when it first opened. The town had awaited its completion with great anticipation. They had admired the concrete piles as they rose out of the river, and as those piles assumed their height of fourteen meters above the surface they believed that the "ensemble of the viaduct [i.e., piles and trestle] will be a veritable monument that will win the admiration of all who will come to see it."[26] However, the iron trestle, the most important part of the bridge, had not yet been built. Since it was to be over 200 meters long and to weigh more than 800,000 kilograms, it was expected to gain instant recognition just by being put into place. According to one Argenteuil journalist, it would have no equal in France other than the bridges at Bordeaux and Strasbourg, both of which had only recently been finished.[27] The Strasbourg/Kehl

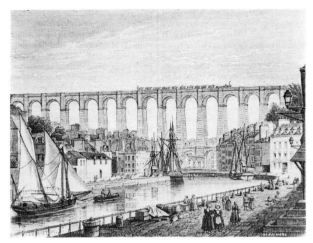

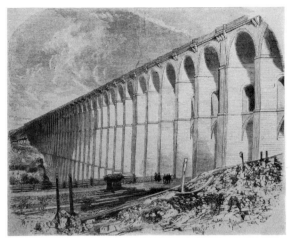

44. *Viaduc de Morlaix, sur le chemin de fer de Paris à Brest.* (From Louis Figuier, *Les Merveilles de la Science*, I, Paris, 1867, 344.)

45. *Viaduc de Chaumont, sur le chemin de fer de Paris à Mulhouse.* (From *Le Monde Illustré*, I, 9 May 1857, 13.)

bridge was a telling comparison, for it was an extraordinary work spanning the Rhine between Strasbourg and Kehl, uniting France and Germany. Made entirely of iron, it was a tunnel-like structure elevated above the water by large supporting piers. And, because the Rhine was traversed by numerous tall-masted ships, it was designed so that one section at either end could turn, which for the time was a fabulous engineering feat, made possible only because of the advances in technology and the material used—iron. Most spectacular, however, was its trestle. Enthused with the gothic revival and the analogies between bridges and churches, the architects made the trestle a modernized cathedral nave, and the entrance, a veritable gothic portal (fig. 46).[28]

Argenteuil's pride, therefore, was naturally at its peak in early 1863; not only was the town receiving a potential rival to this monument, but also, and perhaps more important, it was contributing to its construction, for the railroad company had commissioned Argenteuil's own Joly factory to build the trestle. But when the bridge opened many felt that the hopes they had nutured had not been fulfilled. "Instead of an elegant construction of grandiose or bold forms," wrote Monsieur Lebeuf, editor of the *Journal d' Argenteuil*, "there is only a heavy and primitive work which is not at the level of the progress of science. Instead of those gracious constructions on which wagons and machines slide onward to discovery, they made a wall of iron that is impenetrable to the eye. . . . It is a tunnel without a roof."[29] He felt that the construction was undoubtedly careful and irreproachable, since it had been carried out by the Joly factory. Although it could be considered a masterpiece of technology, it was a "defective work" from the point of view of architecture and design. "It is too bad," Lebeuf lamented, "that they did not let the Joly factory draw up the plans, because then we would not be criticizing the design today."

Another resident, Claude Collas, a wealthy landowner, agreed with Lebeuf. "Let us embellish our bridges," he suggested, "with the taste that so gloriously characterizes our nation." The piers of the Argenteuil bridge, in his opinion, "should have been surmounted by carved capitals instead of the bulging blobs that sit there now." In addition, "the bridge itself should have been adorned with some cast-iron decorations, which would have broken up this relentless straight line."[30] Anything but to have the bridge be what it was: an industrial structure made from industrial materials. If nothing could be

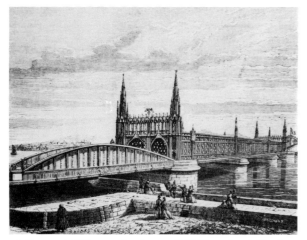

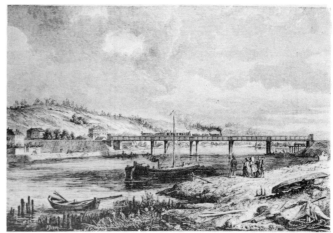

46. *Pont sur le Rhin, entre Strasbourg et Kehl.* (From Louis Figuier, *Les Merveilles de la Science*, I, Paris, 1867, 345.)

47. *Le Nouveau Pont d'Argenteuil.* (From *Le Monde Illustré*, XIII, 29 August 1863, 141.)

done to humanize this "dry," "rigid" abuse of the term *"ouvrage d'art"* then "let us at least hope," wrote Collas, "that the mound of earth at the end of the bridge which cuts off our view of the plains of Gennevilliers will be planted with trees whose foliage will reach beyond the rails and close off the horizon more agreeably." Obviously, in his opinion, the bridge did not blend with the landscape; it streaked across it dispassionately as a prominent industrial contrast—just as Monet showed it.

It is apparent that Monet has emphasized precisely those qualities of the bridge that the two critics despised. Taking up a position close to the structure, he has rendered its unsculpted capitals and primitive, undecorated trestle with bold clarity. He has made the concrete piers and the "wall of iron" glisten in the afternoon sun and, contrary to the second critic's desires, has not allowed the foliage of the trees to reach above the rigid chute. The leafy bank on the right closes off the scene and breaks the horizon on that side, and the flamelike trees in the distance rise above hills to puncture the skyline, but no natural element interrupts the relentless straight line of the trestle. While Collas felt that the trestle had "cut the horizon in the ugliest, most awkward manner and had deprived us, without compensation, of a view that is very much like, in minature of course, certain lakes in Switzerland," Monet shows it dominating the landscape like the majestic monument that both critics had hoped for.

Monet was not the only one who apparently liked the bridge. In August 1863, a month after the ribbon-cutting ceremonies, an article praising the structure appeared in the popular weekly journal *Le Monde Illustré*.[31] The author felt that the bridge was bold and elegant and that "its construction did honor to the ingenious engineers who were in charge of the work." An illustration of the bridge was included so that the reader might be able to have a better idea of what a marvel it was (fig. 47). The view is quite descriptive, of course, but in comparison with Monet's it reveals far less of the bridge's modernity. Instead of standing close to the structure on the Argenteuil side of the Seine and looking at it against the low plains of Gennevilliers as Monet did, the illustrator took up a well-removed position on the Gennevilliers bank and has the large hills of Orgemont and Epinay provide a comforting backdrop; as a result, the bridge blends more with the environment, making its "primitive" features less apparent. Unlike Monet, who clears the foreground of distracting elements and focuses attention on the structure, the popular

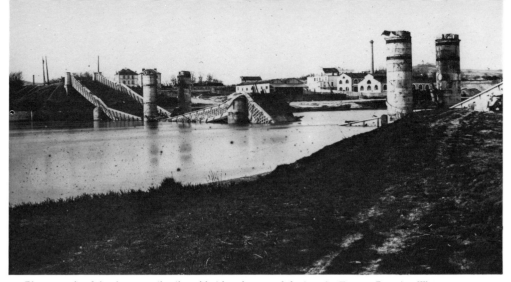

48. Photograph of the Argenteuil railroad bridge destroyed during the Franco-Prussian War, *c.* 1870–71.

artist shows a scruffy bank strewn with old boating gear. He includes admiring spectators on both sides of the river, and he places a barge prominently in the center, which complements the bridge iconographically but does not have the visual impact of Monet's sailboats. Furthermore, under the bridge where Monet's sailboats were emerging, the popular artist includes men poling rafts—a recollection of the ferry that formerly was the only means of crossing the river. While in theory these elements might emphasize the bridge's modernity, the artist's treatment turns the scene as a whole into a quaint combination of the old and the new, rather than a frank confrontation with an imposing contemporary construction.

This does not mean, however, that Monet's view is stripped of all romance. Indeed, it conveys an optimism that is as fanciful as it is direct. First, the bridge is shown in the best light; it is clean and gleaming and colored with tints of blue—hardly industrial hues. Furthermore, the vantage point has been carefully chosen. Besides the port, there was also a popular restaurant just behind Monet; it was relatively new, having opened in 1871, but it had gained a steady clientele. Just to the other side of the bridge were the loading docks for the plaster concerns, a warehouse, and a boat-launching structure belonging to the Joly iron works and the Pochet–Julien crystal factory. As a photograph of the area taken after the Franco-Prussian War shows (fig. 48), it was not a picturesque site at all. What neither the photograph nor Monet's painting shows, however, is the Argenteuil station which was just over the hill on the left and which still lay in ruins from the Commune. Aware of the context, Monet excerpted the bridge to make it a symbol of industry, transforming Argenteuil into a modern utopia.

It is not surprising that *The Railroad Bridge viewed from the Port* was not painted until the second year that Monet was in Argenteuil. It would have required considerable audacity to have rendered these strikingly new aspects of the town with such directness and poetry—not only because he was settling there, calling it home, and trying to carve out of its contrasts a pleasing compromise, but also because the railroad was not a common subject in the realm of "fine art." While it proliferated in the popular arts, it fared badly in the Salon and in the hands of the avant-garde. Other than Daumier, artists in the 1840s and 1850s simply did not paint it. Gustave Flaubert's fictional Pellerin in *L'Education sentimentale* considered taking it up; Horace Vernet even proposed the subject for the

49. Horace Vernet, *Le Génie de la science*, *c.* 1850. (From Edmund Textier, *Le Tableau de Paris*, I, Paris, 1852, 317.)

decoration of the town hall in Paris, *The Genius of Science* (fig. 49).[32] But direct, non-allegorical confrontations with the steam-powered Pegasus were reserved for popular artists and the popular press.

The Railroad Bridge viewed from the Port was not Monet's first picture of the railroad; he had painted a landscape with the Paris–Saint-Germain train, *The Train in the Countryside* (fig. 50), when he was in Bougival three years earlier. Although he showed the train nestled in the foliage in the background of the picture, he elevated it high above the rolling green meadow and the well-dressed Sunday strollers so that it broke the horizon and became a prominent element in the scene. He carefully delineated each car even to the extent of indicating passengers, and he artfully stretched the long trail of smoke across the center of the sky, filling what would otherwise be a void in the picture while imitating the shadow of the tree on the left. For Monet, this new product of man's genius was a thing of great utility and beauty, and thus a welcome element.

The Railroad Bridge viewed from the Port, although painted only three years later, is clearly bolder and more immediate. There is no rolling meadow, screen of trees, or natural viaduct. The train and the bridge shoot across the landscape with an industrial bluntness, making no concessions to the nostalgic vista hoped for by the Argenteuil critics. Slicing the picture in half, the bridge speaks for the intrusion, indeed for the importance, of industry in Argenteuil.

It also attests to Monet's embrace of the town's development, paralleling the optimism implied in many of his views of the new streets. These public building projects were reassuring signs of France's renewed life and prosperity and of the brighter future that lay in store for everyone, Monet included.

In 1874 and 1875 Monet continued to paint scenes such as *The Highway Bridge and Three Boats*, 1874 (fig. 51), whose Claudian calm and distilled beauty reaffirm Argenteuil's charm, but his handling of the older bridge becomes more complex, paralleling the changes in his other views of the town. The beginnings of this can be seen in *The Highway Bridge at Argenteuil* (fig. XII), which, while ordered and peaceful like *The Highway Bridge and Three Boats*, is considerably more dramatic. The bridge closes off the scene on the right, for example, as in *The Highway Bridge and Three Boats*, but instead of being little more than a continuation of the foreground bank, the structure pierces the surface of the

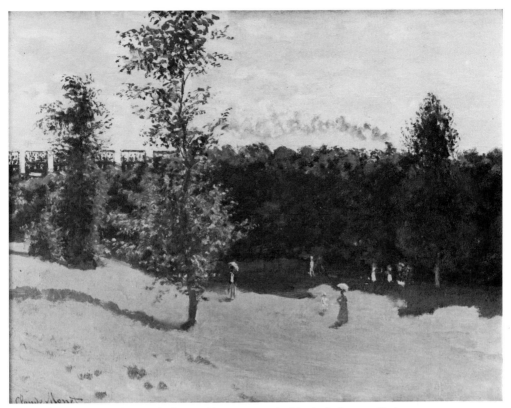

50. Claude Monet, *The Train in the Countryside*, 1870. 50 × 65. Musée du Louvre, Paris.

painting on a radical diagonal and rushes headlong into the scene to meet the background trees at a sharp angle. Its aggressiveness energizes the whole, while its imposing size lends a monumentality to the picture.

More significant perhaps is the moored boat in the middleground. Although in comparison with the bridge its weight and mass are totally disproportionate, it has an equivalent height and an equally prominent position in the composition. It confronts the bridge with a contrasting strength and manages through the most meager means—the thin but taut stay of its jib rigging—to balance the structure like some great arrow on a bowstring. While emphasizing the artful ordering of the scene, this confrontation gives the picture a tentativeness that *The Highway Bridge and Three Boats*, for example, lacks. This tentativeness is also evident in the unexpected intrusion of the mast in the immediate foreground. Rising from the bottom of the canvas from no apparent source, the mast is a startling element that initially seems out of place. However, it is firmly attached to the right side of the cockpit of the boat in the middleground and to the left side of the house in the trees beyond. It is also almost parallel to the mast of the middleground boat while its dark-colored top just breaks the boat's rigging. Thus, though alien, it is tightly woven into the view.

The bushes to the right, like the mast, at first seem accidental or arbitrary. They shoot up in the immediate foreground, jarring the viewer's attention and making the spatial relationships in the picture more dynamic than in *The Highway Bridge and Three Boats*. The triangular configuration of the bushes fills the lower right corner of the view, providing a stable counterbalance to the bridge above it. Another triangle—defined by the top of

77

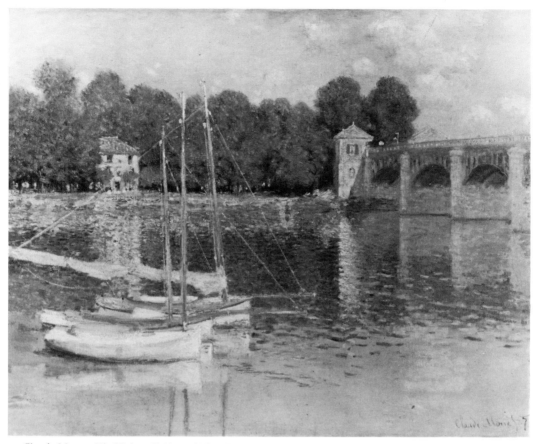

51. Claude Monet, *The Highway Bridge and Three Boats*, 1874. 60 × 80. Musée du Louvre, Paris.

52. Claude Monet, *The Railroad Bridge with a Single Sailboat*, 1874. 54.5 × 73.5. John G. Johnson Collection, Philadelphia.

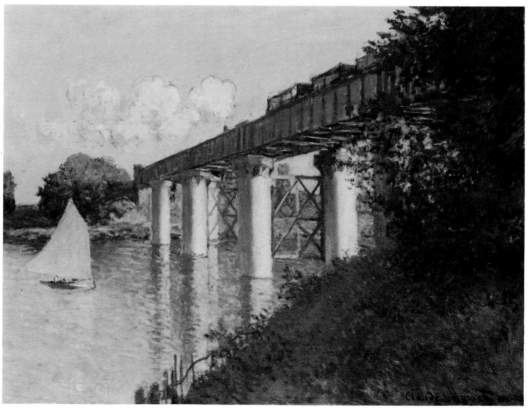

the bushes, the bottom of the bridge's piers, and the reflection of the tower—is wedged above the foliage, making the right side of the scene a tightly knit ensemble. But Monet does not simply let this rest. He punctures it with the swordlike boom of the middle-ground boat, which adds another unexpected note to the view. He uses the boat on the left for the same purpose. While repeating the triangles on the right and filling what would otherwise be a void in the picture, the boat contrasts with its surroundings because it is the only major element in the scene that is in motion. Caught for just a moment, it engenders a sense of the fugitive, emphasizing the tentativeness of the picture as a whole.

The three boats, although separated, are actually linked to each other by the rigging of the middleground craft. After touching the foreground mast, the rigging meets the boat in the background where the mainsail and the jib intersect. It then mysteriously stops.

Hiroshige used similar devices, as for example in figure 53. While Monet undoubtedly would have been attracted to such a work, he suggests in *The Highway Bridge at Argenteuil* that he is not interested simply in their decorative qualities but in the meaning that the devices can communicate. The relationship between the boats in *The Highway Bridge at Argenteuil*, for example, could perhaps be read as a metaphor for the way we perceive the picture as we move from a part to the whole or from intuition to confirmation. The picture's compositional devices together with the broken brushwork and color contrasts also imply a sense of movement that reminds us of the flux and flow of modern life. With the unexpected, the permanent, and the fleeting merging to form an animated ensemble, the picture speaks about Monet and his world, and about the process of making art.

The artfulness of that process and the meaning it can convey are more evident perhaps in his *Railroad Bridge with a Single Sailboat* (fig. 52). Although using the same format as in *The Highway Bridge at Argenteuil*, Monet simplifies the scene, making it closer in effect to the railroad bridge itself. Streaking across the landscape without the intricacies of the earlier view, the bridge alone seems to represent the modernity of the suburb. It shoots further across the picture than the highway bridge in figure XII, as if to emphasize its presence and its tensile strength. Its piers, bathed in bright afternoon sunlight, under-score its sleekness while their reflections in the river tie the whole structure to the grassy foreground bank. The trestle itself is carefully linked to that bank, for after leaping out from behind the large bush on the right it ends at a point just above where the wedge of grass at the bottom of the picture begins. The foliage in the foreground, which is more

53. Ando Hiroshige, *Tsukadajima*, from Twelve Views of Edo, Cabinet des estampes, Bibliothèque Nationale, Paris.

54. Camille Corot, *The Bridge at Mantes*, 1868–70. Musée du Louvre, Paris.

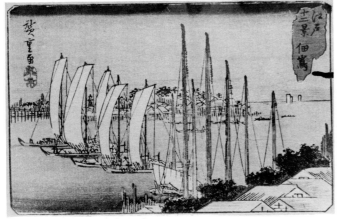

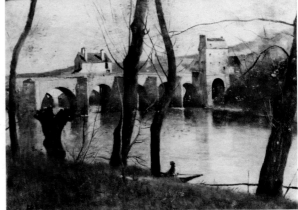

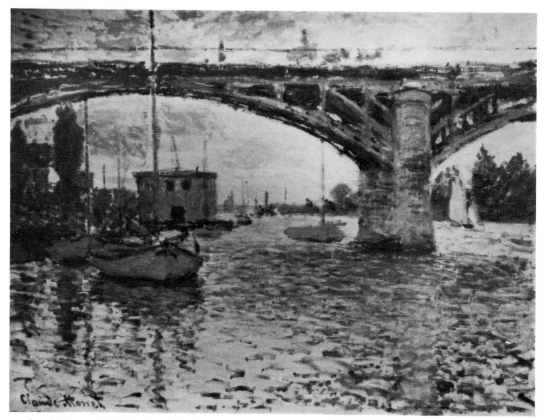

55. Claude Monet, *The Bridge beyond the Mast*, 1874. 54 × 73. Private Collection, France.

56. Claude Monet, *The Bridge on a Gray Day*, 1874. 61 × 80.5. National Gallery of Art, Washington, D.C.

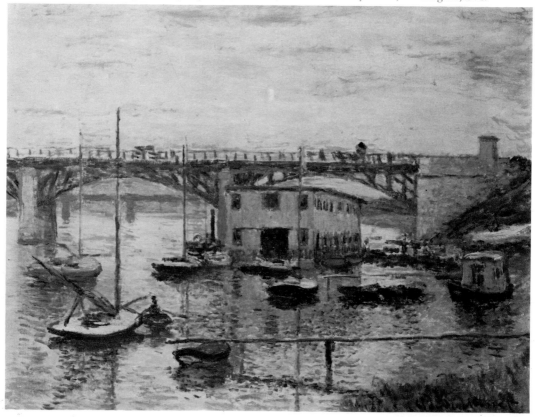

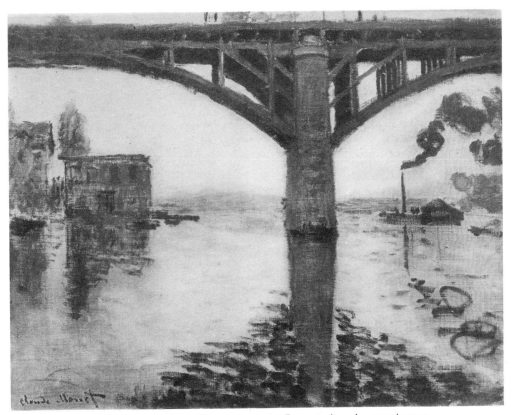

57. Claude Monet, *The Bridge as a Single Pier*, 1874. 50 × 65. Present whereabouts unknown.

abundant than in the view of the highway bridge, both heightens the novelty of the bridge and holds it with the bushes on the opposite side in a kind of perfect equilibrium.

The single sailboat also contributes to the picture's formal strength and iconographic life. Confronting the bridge head-on, its mast parallels the piers; its sail, billowed by the same wind that blows the steam of the train above it, imitates the shape of the foreground undergrowth. As a symbol of contemporary leisure in the country, it represents the benefits progress can bring. And since it is held, like the bridge and bank, in such tight balance, the picture must be seen as Monet's idyllic view of modern utopia—suburbia.

It is startling to discover, however, that in order to paint the picture Monet stood on the Epinay–Argenteuil side of the bridge, by the embankment built for the railroad, and that just behind him, no more than one hundred yards away, were the warehouses, docks, and factory evident in figure 48. The neighborhood, according to many residents in the 1860s, "was destined for development since it was so close to the station."[33] By 1874, when Monet was painting his view, their predictions had indeed come true, making the area less attractive than he chose to show.

Monet's picture is unquestionably modern, however, as can easily be seen when it is compared to Corot's view of *The Bridge at Mantes* (fig. 54). The differences in site, subject, and presentation are like those Benjamin Gastineau noted in the world before and after the railroad. "Before the creation of the railroad," he wrote in 1861, "nature did not throb; it was a Sleeping Beauty, a cold statue, a vegetable, a jellyfish; even the sky seemed

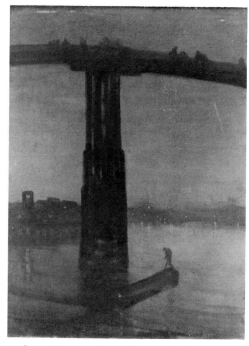

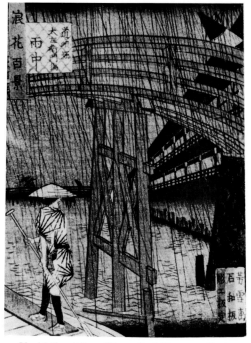

58. James Whistler, *The Old Battersea Bridge — Nocturne Blue and Gold*, 1872–75. Tate Gallery, London.

59. Yoshi-Iku, *View of Doton-Bori, Tazaemon Bridge in the Rain*, from 100 Views of Naniwa. Cabinet des estampes, Bibliothèque Nationale, Paris.

immobile. The railroad animated everything, mobilized everything. The sky became an active infinity, nature an energized beauty."[34]

That energy is perhaps even more evident in *The Promenade with the Railroad Bridge* (fig. XIV) from the same summer of 1874. Seen from the Gennevilliers bank half a kilometer upriver from Argenteuil, the bridge is rendered with such bravura that the paint stands out boldly on the surface. Slicing the scene on a strict horizontal dividing earth and sky, the bridge seems to energize the heavens, which are painted in dynamic swirled strokes, while its forceful presence reminds us not only of the strength and daring of its construction, but also that the train, in transporting perhaps these very promenaders in the foreground to the countryside, has given to everyone a share in the progress it symbolizes. Superimposed on the church while defining a new horizon for the town, the bridge is clearly a monument to behold, Gastineau's new symbol of the age.

Yet Monet has again been quite careful in choosing what to include, for, despite its breadth, the view is cropped on the right just before the bridge reaches the Argenteuil bank with the factories, warehouses, shipping docks, and storage areas. For Monet, Argenteuil's development was something to be hailed on a symbolic level—i.e., using the railroad bridge as a metaphor—but it clearly was something to be avoided on a realistic one. Esquiros had asserted that "the ideal of industry is the same as the ideal of poetry. Only poetry dreams; industry produces."[36] Monet preferred the realm of poetry.

He affirmed this not only by stopping the bridge just before the Argenteuil bank, but also and more importantly by ceasing to paint the railroad bridge entirely. After these views, Monet never again shows Argenteuil's "hideous tunnel of iron," as Monsieur Lebeuf had called it in 1863. This was probably not due to his revised opinion about its esthetic merits, but instead to his changing view of the town and of himself as a landscape

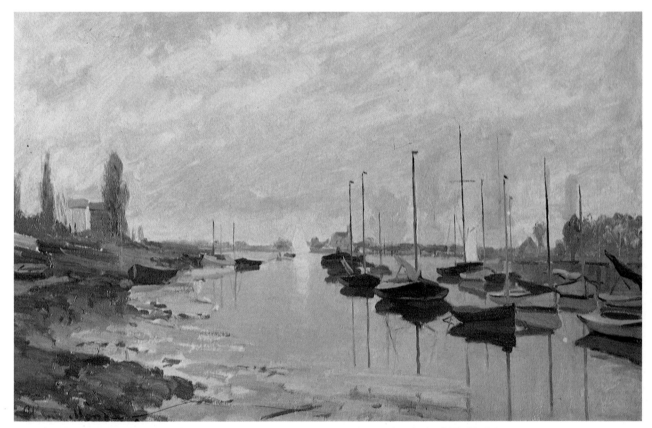

XVI. Claude Monet, *The Boat Rental Area*, 1872. 46 × 72. Museum of Mohammed Mahmoud Khalil, Cairo.

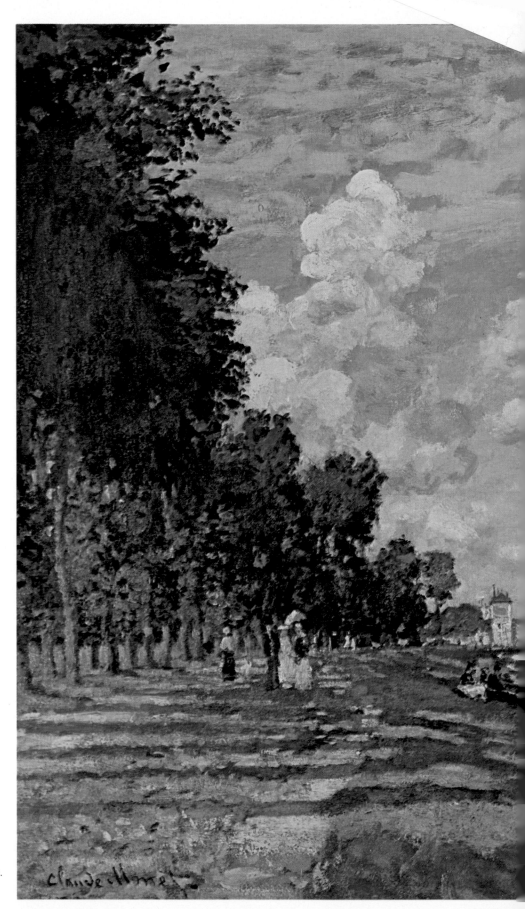

XVII. Claude Monet,
Sunday at Argenteuil, 1872.
60 × 80.5. Musée du
Louvre, Paris.

painter. This change, first noted in *The Highway Bridge at Argenteuil* (fig. XII), where the bridge becomes less of a picturesque addition to the landscape and more of a figurative bridge between the past and the present in the town, is even more apparent in *The Bridge beyond the Mast* (fig. 55). Here Monet shows the same section as in *The Highway Bridge* (fig. 32) of two years earlier, but now it is an elongated, tenuously balanced form. The pier is well to the right of center, the arch on the right is cropped just before it meets the horizontal part of the bridge, and the arch on the left stops just before it meets the pier by the bank. Stretched out of proportion, the arches seem to lean on the frame for support. Under the one on the left, the boat house floats further out into the Seine than in the earlier view, blocking more of the area to the left of the house in the background. That area was where Monsieur Commartin, the former mayor of Carrières Saint-Denis, was authorized in April 1874 to open a new iron works.[37] Residents of the neighborhood protested Commartin's proposal but to no avail.

The strain between progress and tradition, industry and rural calm, while causing Monet to express himself more forcefully than he had in the earlier picture, could still inspire him to paint one of his most sublime pictures, *The Bridge on a Gray Day*, 1874 (fig. 56), a work that is so harmonious, so meticulously ordered, and so carefully painted that it seems to look forward to the modern master of precision, Mondrian, while also glancing backward to the older master of idyllic effects, Claude.

Appropriately, Monet includes his floating studio on the far right side of the picture, tucked into the cove, implying that he was a part of the scene he was depicting. The boat, because it is distinct from the surrounding pleasure craft, also speaks for what Monet is actually doing in this painting—making art from the mélange of boats and bridges, reordering the elements around him to make a new, more satisfying world.

Monet, of course, had been doing this since he arrived, but the results have changed, as a final picture, *The Bridge as a Single Pier*, makes clear (fig. 57). Returning to the same site as the *The Bridge beyond the Mast* and *The Highway Bridge*, Monet strips the view of all extraneous subject matter. There are no pleasure-seekers, no flotilla, no details in the distance; even the pedestrians and the carriages of the earlier views are pushed out of the picture. Like Whistler in his *Battersea Bridge* of 1872–75 (fig. 58), or Yoshi-Iku in his view of the Tazaemon bridge (fig. 59), Monet places the main part of his bridge slightly off center, isolated against the sky. Like Whistler and Yoshi-Iku, he crops the arches on either side, pushes the single pylon high above the water, and makes the trellis a continuous band across the composition. His greater classicism is evident in the more geometric ordering of the structure, but his desire for metaphor is also apparent in his artful manipulations. Like old-fashioned scales, the bridge seems to be weighing what Monet himself has been trying to balance. On the left is Argenteuil as the pleasure-filled "country" town, represented by the boat house and the gabled *maison de plaisance* in the trees. On the right is Argenteuil as the industrialized suburban city, represented by the barge, the steamboat, and the long trail of smoke. When Monet rendered these same elements in *The Highway Bridge* they were not only all under one arch but also a part of a seemingly idyllic world. Two years later that world was no longer mythical: it was irreconcilably divided. And Monet from his head-on confrontation with these facts seems to have reached the formal limits of dealing with it. The bridges of Argenteuil do not appear in his work again.

XVIII. (top) Claude Monet, *Sailboats and Sculls*, 1874. 60 × 81. Private Collection, Paris.
XIX. Claude Monet, *Sailboats in the Boat Rental Area*, 1874. 54 × 65. The California Palace of the Legion of Honor, San Francisco.

VILLE D'ARGENTEUIL

FÊTE NAUTIQUE

PREMIÈRES et GRANDES

RÉGATES D'ARGENTEUIL

à l'instar de celles du Havre

LE DIMANCHE 25 AOUT 1850, A UNE HEURE APRES-MIDI.

COURSES A LA VOILE. **COURSES A L'AVIRON.**

La beauté et l'importance du Bassin d'Argenteuil ont permis d'organiser une course spéciale pour les Côtres.

COTRES,	Prix unique,	une Médaille en Vermeil.
	1er Prix,	une Médaille en Or.
CANOTS.	2me Prix,	d° en Argent.
	3me Prix,	d° en Bronze.

CANOTS à 4 avirons,	1er Prix, une Médaille en Vermeil.	2me Prix, d° en Argent.
CANOTS-YOLES,	1er Prix, une Médaille en Vermeil.	2me Prix, d° en Argent.
	3me Prix, d° en Bronze.	

YOLES. 1er Prix, une Médaille en Vermeil. — 2me Prix, une Médaille en Argent.
GODILLE. 1er Prix, une Médaille en Argent, — 2me Prix, une Médaille en Bronze.

MM. les Canotiers devront se faire inscrire avant les Courses, chez M. POULAIN, maître du pont, sur le port, près la Mairie à Argenteuil.

GRANDE JOUTE SUR L'EAU A LA LANCE

PAR LES MARINIERS D'ARGENTEUIL,

Premier Prix, UNE MONTRE D'ARGENT. — Deuxième Prix, UNE TIMBALLE.

FANFARES ET MUSIQUE DE LA GARDE NATIONALE

Pendant les Courses, sous la direction de M. LAMBERT.

Jeux et Amusements de toutes espèces sur les Allées ombragées du bord de la Seine

ESTRADES RÉSERVÉES POUR LES SPECTATEURS.

BARQUES PAVOISÉES

LE SOIR,

GRAND BAL CHAMPÊTRE

Illuminations, Spectacles Forains sur le Quinconce.

CAFÉS-RESTAURANTS A DES PRIX MODÉRÉS.

SERVICE EXTRAORDINAIRE pour Argenteuil au Chemin de Fer de Saint-Germain, et à l'Administration des Diligentes, rue des Dames à Monceaux.

DÉPART TOUTES LES DEMI-HEURES JUSQU'A DIX HEURES DU SOIR, ALLER ET RETOUR.

NOTA. Les Diligentes de Monceaux à Argenteuil correspondent dans Paris avec tous les Omnibus, et partent toutes les heures.

Un Service spécial d'Omnibus est organisé entre Asnières et Argenteuil, pour les Voyageurs du Chemin de Fer qui s'arrêteront à cette station. — Le trajet se fait dans quelques minutes.

Un autre Service d'Omnibus existe de la Station de Colombes à Argenteuil.

LES CANOTS SERONT REMONTÉS SANS FRAIS, JUSQU'AU PONT NATIONAL.

Les Marchands y trouveront sûreté et protection. — Les Jeux de hasard sont défendus.

Le Maire, RECAPPÉ.

PARIS. — Typographie d'Eugène et Victor Penaud frères, 10, rue du Faubourg-Montmartre.

4. Boating at Argenteuil

RAILROADS, INDUSTRY, steam, and progress were distinctly nineteenth-century phenomena in France—so too was pleasure boating. Although practiced and enjoyed for centuries, boating did not develop as a science and take hold as a sport until the 1800s.[1] This was not without reason. From the 1820s onward, as the country became industrialized, factories, machinery, mass production, and disciplined labor came to rule people's lives. That meant regimentation and long hours on the job—the ten-hour day and the six-day week were standard in Argenteuil as well as elsewhere. It also meant a lack of contact with nature. Indeed, nature increasingly became a Sunday commodity, something enjoyed during the one free day of the week. This was especially true for those who lived and worked in the cities of nineteenth-century France, above all Paris.

Growing in size from 548,000 people at the turn of the century to 1,053,000 in 1851, Paris became a "forest of humanity without air, sleep, or virtues," an "inferno" from which one had to escape. "To fly from the city, to breathe an enlivening, balsamic air instead of the stifling air of the streets heated by the summer sun, that is the biggest desire, the most pressing need of those who are chained to Paris."[2] It was not only to breathe *l'air pur de la campagne*, however, that people left the city in droves; it was also to find in the world of nature diversions from the doldrums of daily existence. And from the 1850s onward, the diversion that became one of the most popular was boating.

Why boating? Because, in its various forms, it offered the Sunday pleasure-seeker the chance to exercise or relax, to test his strength and ingenuity in organized competition, or to while away the time in the arms of mother nature. And as skipper or oarsman, the boater was in charge; he charted his own course and, once under way, relied on his own intelligence and skill. The freedom he experienced in breaking out of his work routine was therefore accompanied by a heightened sense of individualism. This was recognized by Frédéric Lecaron, a distinguished member of the most important boating club in Paris, the Société des Régates Parisiennes. Speaking to the general assembly of the Society in February 1858, he observed that boating should be "the most encouraged of all sports because it addresses itself to man alone; it calls into play his united abilities, strength, and intelligence and [because of that] it allows man to rise above the animals which are the

89

principal subjects of other sports."[3] Lecaron himself had noted in an article in *Le Sport* of 10 June 1857 that boating was already catching on: "The taste for nautical sports has expanded so much in the last few years in the provinces that we find amateur boaters not only in the important maritime and river cities such as Le Havre, Rouen, Lyon, Nantes, Bordeaux, etc., but even in certain cities in the center of France, such as Rheims, which seem the least likely to have any."[4]

The most important place in France, however, for nautical sports and pleasure boating was the area around Paris. Its primary competitor, Le Havre, could claim the advantages of the Channel, proximity to England (where boating was more developed), and longer association with marine affairs; but Paris and its suburbs had the Seine, numerous lakes, and a population that was larger and more in need of pleasurable diversions. In 1854 Eugène Chapus could go so far as to assert in his book *Le Sport à Paris* that "the Parisian is essentially a sailor,"[5] a statement that, although an exaggeration, was founded on the truth that great numbers of Parisians turned to boating to escape the impersonal, unpleasant environment of their city and the intensive, unbending demands of their jobs. Lecaron was certainly closer to the mark when, in that same speech of 1858, he asked: "For this very real and bustling century in which we live, is not boating one of the rare means of tempering one's character, of maintaining the physical capacities of the younger generation whose blood and vitality boil with the necessity of constant work?"[6]

Not surprisingly, the towns on the Seine that were closest to the capital, such as Bercy and Charenton to the south, and Sèvres, Saint-Cloud, and Asnières to the north, were the first to be frequented by these younger people. Easily reached by omnibus, steamboat, and railroad, these Parisian suburbs offered prime boating conditions at minimum travel cost. But after mid-century, when the railroad to Asnières was extended, Parisians found an even better playground for pleasure boating: the picturesque *petite ville* of Argenteuil, with its rolling hills, its shady promenades, and—most important of all—its long stretch of the Seine that was ideal for this new recreational sport. After looping back on itself at Saint-Denis, the river dropped between Epinay and Bezons to an average depth of 21 meters, opened to an average width of 195 meters, and flowed unencumbered by islands or curves for more than 10 kilometers—a combination of physical attributes unequaled by any other suburb of the capital.

The town fathers of Argenteuil recognized this and on 25 August 1850 they sponsored the town's first regatta. As its advertising poster (fig. 60) makes clear, Parisians were the people the town was trying to attract. And Parisians came. Only five years later a writer for *Le Sport* declared that "nowhere in the immediate vicinity of Paris does the Seine present to amateur boaters a basin as favorable in length and breadth as well as current as at Argenteuil."[7] Three years after that, in 1858, the Société des Régates Parisiennes established their sailing club, the Cercle de Voile, on the banks of that basin, confirming popular opinion that Argenteuil was the site "*par excellence* for the grand development of sailing."[8]

Nine years and dozens of regattas later Argenteuil had not only become the preeminent sailing area of the suburbs but had also been selected as the site for the international sailing competitions of the 1867 Universal Exposition. Thus, by 1871, when Monet moved there, his new home was not just some secluded little town outside of Paris but

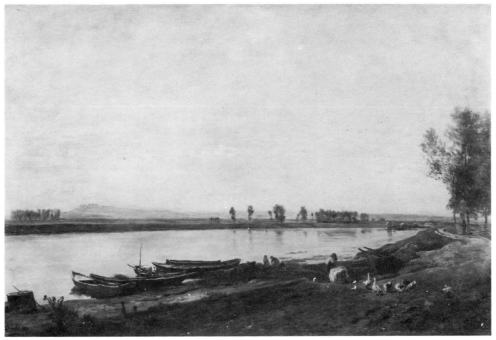

61. Charles Daubigny, *View of the Seine at Bezons*, c. 1865. Musée du Louvre, Paris.

62. Claude Monet, *Regatta at Sainte-Adresse*, 1867. 75.5 × 101.5. Metropolitan Museum of Art, New York.

63. Claude Monet, *River Zaan with a Sailboat*, 1871. 48 × 73. Metropolitan Museum of Art, New York.

a celebrated center for pleasure boating in France. Boating meant Argenteuil and Argenteuil meant boating; the two were inseparable.[9] The importance of this fact cannot be overemphasized, considering how much of Monet's work is devoted to sailboats on the Seine. He could have painted the barges or the fishing boats as Daubigny had when he came to neighboring Bezons (fig. 61)—for these vessels could still be seen coming and going on the river in Argenteuil in the 1870s—but they were old-fashioned. Rather, Monet chose to depict only those craft that represented the leisure activity of the day, and one of the most up-to-date aspects of the life of the town.

Boating, of course, was not new to Monet. He had painted the marine activity in Honfleur and Le Havre as early as 1864; in 1867 he had even done a picture that he described as a view of the "Le Havre races with a lot of people on the beach and a sea covered with small sailboats" (fig. 62).[10] When he was in London in 1870 he spent more time painting the boats on the Thames than the strollers in the park. And when he went to Holland he concentrated almost exclusively on the ships along the waterways or the stormy coast.

This interest in boating was a natural product of his upbringing in Sainte-Adresse and the many summers he spent on the Normandy coast. Monet was fascinated by the limpid, reflective qualities of water but he never painted it without including some aspect of human life; that which he chose most frequently was boats. Before his move to Argenteuil, the boats he depicted were international merchant ships, fishing vessels, and old dories, with only a few exceptions. Paintings of pleasure craft in Monet's oeuvre before 1871— such as the view of the regatta at Le Havre and the important series of pictures done in 1869 at La Grenouillère—number scarcely half a dozen. During his first year in the town, that number nearly tripled.

Monet's views of boating at Argenteuil fall into three categories, according to their sites. The first is the group painted along the stretch of the Seine known as the Petit Bras, thus named because it was literally a small arm of the river that reached out approximately a kilometer and a half from the highway bridge to encircle an island called the Ile Marante. Lined with trees, this inlet was an idyllic little retreat. It was far enough away from town to give the impression of a different place and small enough (it was forty meters wide at the most) to create a sense of intimacy and tranquillity. The plains of Gennevilliers bordering the inlet to the east were undeveloped except for a few houses along the Seine itself, and the Ile Marante to the west was dotted only with a few scattered structures.

92

64. Claude Monet, *Petit Bras with Unmanned Boats*, 1872. 54.5 × 72.5. Private Collection, Great Britain.

However, the arm was not deserted; it served as a mooring place for a dozen or more boats, many of which were too big to be kept by the boat rental house under the highway bridge. Mooring space was a problem at Argenteuil because of the number of people who wanted to dock their boats there and the large volume of commercial traffic on the river.

The second is the group of pictures painted in the boat rental area, an open though congested stretch of the river that extended approximately one kilometer along the south bank across from Argenteuil, from the highway bridge toward the Petit Bras downstream. According to the time of year, there could be anywhere from twenty to two hundred boats coming, going, or sitting at anchor. Many were for rent; depending on the size of the boat, the cost was seventy-five centimes to one franc an hour, or from three to four francs a day.[11] The majority, however, were privately owned, which was why the total number in the area was never the same. Between the middle of March and late November, owners took their boats to regattas held throughout France and stayed away as long as they could afford. Many, however, preferred the frequent Sunday competitions at Argenteuil itself or those held with equal regularity at other towns nearby.

Sailboats made up the majority of the fleet at Argenteuil, but there were rowboats as

well, both to rent and to transport boat-owners to their vessels. Steamboats also docked at Argenteuil; one—the Croissy-Vernon, belonging to Monsieur Perigon—had gained international fame by participating in races off the coast of England.[12] Argenteuil itself had gained prominence when it hosted the first steamboat regatta in France in 1867, and others were held there during the 1870s. However, despite the frequency with which steamboats appeared in Argenteuil, Monet gives little indication of their presence.

Contemporary observers or boating enthusiasts, never finding the boat rental area empty, generally referred to it as the "port of clippers" or the "garage with flotilla."[13] In contrast to the tranquillity of the Petit Bras, it conveyed a sense of life; where the Petit Bras was more of a reflective private world, the boat rental area was decidedly a restless public one.

The third category of boating pictures consists of those that show the basin of the river, the area that extended from the highway bridge to the Petit Bras and where most of

65. Claude Monet, *Petit Bras, Springtime*, 1872. 51 × 65. Joan Whitney Payson Gallery of Art, Westbrook College, Portland, Maine.

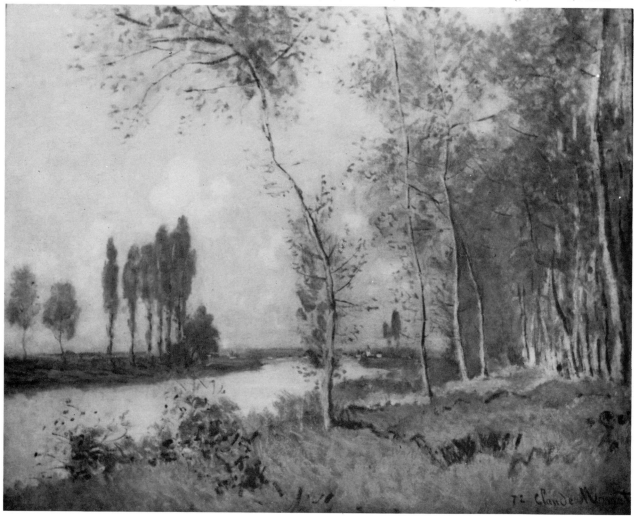

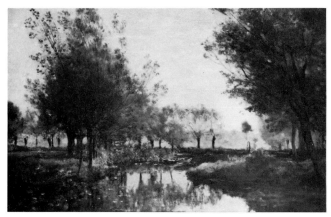

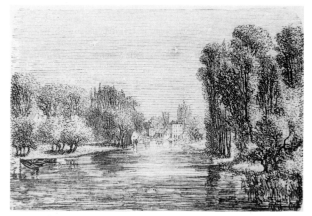

66. Charles Daubigny, *Landscape—"La Petite Rivière,"* 1863. Sterling and Francine Clark Art Institute, Williamstown, Massachusetts.

67. *La Chapelle Saint-Mesmin.* (From Adolphe Joanne, *De Paris à Bordeaux*, Paris, 1867, 87.)

68. Claude Monet, *Petit Bras with Rowboats and Sailboats*, 1872. 51 × 65.5. Private Collection, Paris.

the races took place. It was here that the Seine opened to its greatest width (208 meters) and attained its greatest depth (23.8 meters). Contributing to the basin's appeal were the promenades along both banks. From these shady paths, without much difficulty, spectators could follow the races and actively participate in the spirit of the competition. If they were not greatly interested in the boats' maneuvers or even who won or lost (most of the races took close to three hours), people could simply lounge on the banks or stroll through the Champs de Mars on the Argenteuil side or the fields on the Gennevilliers side. For the boaters, the currents and the winds in the basin were fairly regular, although there were problems with the latter. If the breezes were coming from the north-west, the factories at the end of the promenade were tall enough to block them, causing lulls and frustrations. This did not offset the advantages of the area, however, or discourage from coming those 'skillful boaters . . . whom everyone knows . . . could match without problem the top French yachtsmen."[14]

Of the three sites, the Petit Bras attracted Monet the most during his first year. In addition to its Barbizon appeal, it was similar to the waterways he had recently painted in Holland. However, it did not occupy him to the exclusion of the basin and the boat rental area. As in his views of the town, Monet painted the gamut of tourist subjects, even an actual regatta. Over the next three years, he shifted his attention to the more public areas, returning to the Petit Bras only in 1876 after he stopped painting the highway and railroad bridges.

Monet's views of the Petit Bras were among the first paintings that he executed upon his arrival in Argenteuil. The similarity of the site to the waterways of Holland can be seen when the *Petit Bras with Unmanned Boats* (fig. 64) is compared with the *River Zaan with a Sailboat* (fig. 63). In both, the rivers are alleyways that stretch from one side of the canvas to the other and extend with little interruption into the background. The converging orthogonals of the foliated banks lead in both paintings to the boats in the middleground and the silhouette of the town in the distance. The empty foregrounds and the pervasive sense of light and air contribute to the peacefulness of the scenes. The Petit Bras, however, was more "countrified" than the river Zaan. While this is implied in figure 64 by the absence of any houses along the banks, it is plainly stated in Monet's idyllic view of the *Petit Bras, Springtime* (fig. 65).

What is apparent in these pictures is Monet's desire to show that undisturbed nature still existed in populated areas despite surrounding evidence to the contrary, a desire that, as an artist, he was not alone in feeling. *Petit Bras, Springtime*, without houses, boats, or people, is like Daubigny's *Landscape—"La Petite Rivière"* (fig. 66); although its lighter palette is unmistakably Monet's, its sense of isolation in nature is a holdover from the older Barbizon tradition. *Petit Bras with Unmanned Boats*, while similar to other Daubignys, is also like a popular illustration of the Loire at La Chapelle Saint-Mesmin (fig. 67). Unlike Daubigny or the popular artist, however, Monet depicts modern forms of recreation in his otherwise rustic scenes, thus keeping them from being regarded merely as views of anonymous French countryside from no era in particular, and placing them in the more specific realm of Argenteuil in the late nineteenth century.

In painting the Petit Bras as a modern pastoral retreat, Monet was actually continuing a long tradition, for the Ile Marante had been a rural refuge for Parisians from the

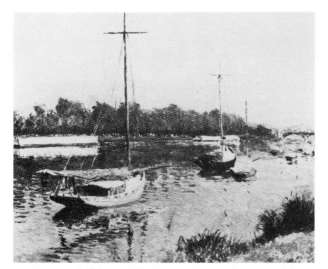

69. Gustave Caillebotte, *The Seine at Argenteuil, c.* 1882. Private Collection, France.

70. Edgar Degas, *At the Races in front of the Grandstand,* 1879. Musée du Louvre, Paris.

eighteenth century onward. Louis Watelet, the painter, sculptor, writer, and garden designer, had bought the island in 1770 and had converted it into a place where "all country distractions awaited with cordial welcome and enjoyable refuge the elegant people of the time."[15] There was a rustic windmill, a luxurious cottage, a small zoo, a milking stable, sheep, and shepherdesses, artificial rocks, and meandering streams. Its bucolic appeal attracted members of the court as well as several contemporary artists including Hubert Robert. Although by Monet's time the sheep and the bucolic creations of Watelet were gone, the inlet still retained its charm; indeed, it was the place cherished by Monsieur Morrisot, the character in Guy de Maupassant's *Les Deux Amis* who went fishing there every Sunday.[16]

The extent to which it was a refuge depended not only on one's predisposition, but also on how far one went down the arm of the Seine away from the main body of the river. Most of the pleasure boats were moored near the inlet's mouth so that they could be maneuvered without much delay onto the river. That area, therefore, was the most active. When Monet moves closer to it, his views generally become livelier, as can be seen by comparing *Petit Bras, Springtime* (fig. 65) with *Petit Bras with Rowboats and Sailboats* (fig. 68).

Conversely, when Monet turns around, putting Argenteuil behind him, and looks down the Petit Bras toward Colombes (fig. III), not only is his painting less dynamic, it is clearly *retardataire*. There are no sailboats here, no urban pleasure-seekers, no sense of the complexities of Argenteuil or modern life.

The boat rental area, a kilometer or two upriver, closer to town, was an entirely different world, as evident in *The Boat Rental Area* of 1872 (fig. XVI). Although the water is extremely calm, there is no cushion of trees and no green mossy bank. The dozen moored boats crowd the right side of the view, their masts like the stems of musical notes, activating the scene with a staccato rhythm. On the left, the muddy bank paralleling the line of boats stretches from the immediate foreground into the distance, making the area less attractive than the Petit Bras. Together with the flotilla, the bank encloses a waterway that is narrower than the inlet and that recedes into space with greater speed. In fact, it recedes so fast that it is almost difficult to linger over the other elements in the scene.

In the context of Monet's work at Argenteuil, the painting is closer to the *Boulevard Héloïse* (fig. VI) from the same year than it is to the *Petit Bras with Unmanned Boats* (fig. 64). Like the *Boulevard Héloïse*, it is a head-on view of an active public site, with the waterway analogous to the boulevard, and the masts on the right and the bank on the left like the trees and the houses in the street scene. The two views share an essential urbanism. In *The Boat Rental Area* this sense of the city stems not only from the streetlike arrangement of the waterway, but also from the crowdlike ordering of the boats. To emphasize this, we need only compare the picture to Gustave Caillebotte's view of the same site from the opposite direction, painted *c.* 1882 (fig. 69). There, the boats are far fewer and yet more generously spaced. Although diagonally arranged, they face away from the viewer, which makes them less aggressive and the waterway less of an onrushing boulevard. For Caillebotte, the area is an unhurried, enchanting corner of the country; for Monet, it is peaceful, light-filled, and quite pleasant, but it is also energized.

From the compositional complexities of his picture, and the strongly felt sense of detachment, it is clear that Monet is presenting the boat rental area for what it was: the suburban playground for the urban dweller. His view, lacking the homogeneity of Caillebotte's, is closer to Degas's *At the Races in front of the Grandstand*, 1879 (fig. 70), a picture that presents an analogous form of entertainment—horseracing—with equal directness and intrigue. Using a similar compositional format and similar contrasts be-

71. Claude Monet, *Sheds on the Banks of Gennevilliers*, 1872. 47.5 × 63. Private Collection, Belgium.

tween active and empty areas, Degas also evokes feelings of isolation and unfulfillment, showing, like Monet, that these leisure activities are not pure entertainment just as their sites are not pure country nor pure city.

Unlike Degas's horses and jockeys, however, the craft in Monet's picture sit perfectly still on the glassy water, their solitude compensating for the lack of people. They are as much objects for private contemplation as they are vehicles for public entertainment. Monet clearly labored over their arrangement just as Degas did with his horses and riders, consciously planning their rhythms and relationships. He even went so far as to paint out five or six masts among those on the right. He also artfully created the country calm in the view, as he chose not to include the belching factory chimneys that were located along the bank in the background and which Manet later showed so prominently in his view of Monet working in his floating studio in 1874 (fig. 81). Monet's picture vacillates, therefore, between a straight-forward rendering of the site and a carefully constructed statement about his desire to make this renowned boating spot a personal world of art.

Monet could be much blunter about the area, as is evident in *Sheds on the Banks of Gennevilliers* of 1872 (fig. 71), painted just a short distance downriver from the boat rental area. Although the blood red sky and its deep pink reflection add a lusciousness to the scene, there is still no carpet of green grass, no shady trees, and no *maisons de plaisance*. The bank on the left is covered with mud, left-over timber, and several ships under repair. A shanty built from scraps and cluttered with remnants of broken boats squats in the foreground at the water's edge. Beyond, two taller but equally uninspired structures are silhouetted against the sky. To the right, a steamboat coughs out a long trail of black smoke; twisting towards us, it pulls the background forward and adds to the dingy character of the site.

Compositionally, the view is almost a replica of one Monet painted in Holland in 1871, *Windmill on the Zaan* (fig. 72). The Argenteuil site, however, is a place for work, not pleasure, the antithesis of what one would want to see in picturesque spots whether in the suburbs or in foreign lands. In fact, given the number of boats dragged up on the bank, the area is most likely the *chantier* of one of Argenteuil's three boat builders.[17] Since these workshops made many of the boats that sailed at Argenteuil, the picture poses the evidence of work as the counterpart to leisure in *The Boat Rental Area*, attesting to Monet's candor.

The appeal of the third boating area that attracted Monet, the boat basin itself, is

72. Claude Monet, *Windmill on the Zaan*, 1871. 48 × 73.5. Private Collection, United States.

73. Eugène Boudin, *The Seine at Argenteuil*, 1869. Collection Mr. and Mrs. Paul Mellon, Upperville, Virginia.

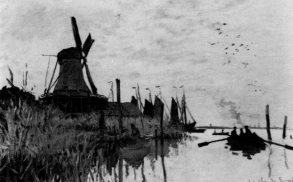

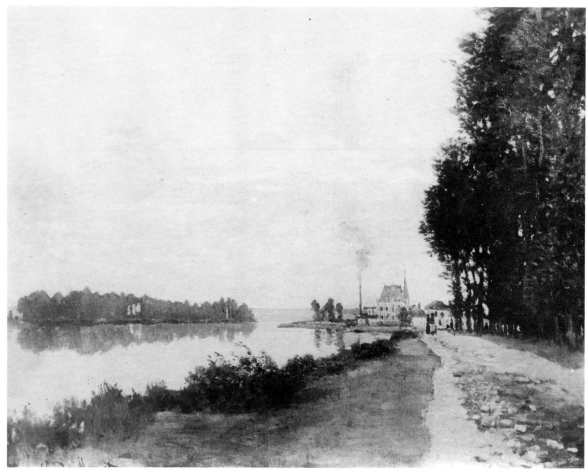

74. Claude Monet, *The Promenade and the Basin*, 1872. 53 × 73. Private Collection, Switzerland.

75. Claude Monet, *Sailboats*, 1872. 41.5 × 71.5. Private Collection, France.

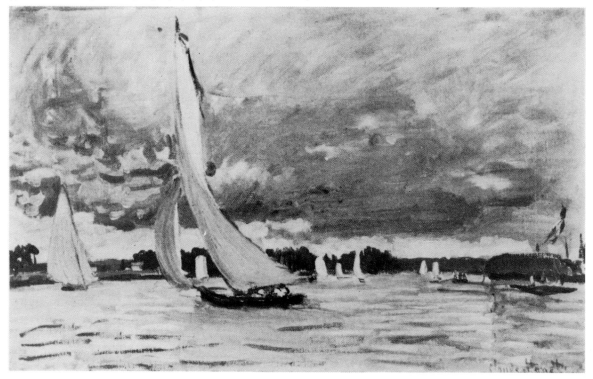

evident in *Sunday at Argenteuil* (fig. XVII). People walk along the sun-stripped promenade, the Champs de Mars on the left, the river and the floating bath houses on the right. Others lounge on the grass, rowboaters frolic on the water, sailboats tack back and forth, and a steamboat in the middle of the river toots as it approaches the bridge. As an inventory of all the basin's activities presented with the fervor of someone enthused by the modern countryside, Monet's picture surpasses *The Seine at Argenteuil* (fig. 73) by his former teacher Eugène Boudin, which shows the same site from a more distant location. Where Boudin's view is removed and passive, Monet's is immediate, lush, and spirited.

Monet frequently turned from where he was standing in *Sunday at Argenteuil* and, looking westward down the river, painted views that fall into two distinct groups. The first, represented by *The Promenade and the Basin* (fig. 74), show the path along the shore leading to the Louis XIII–style chateau and the factory sheds and chimneys. They are poems of tranquillity where the house and factories, the placid water of the Seine, and the peacefulness of the nearly deserted promenade speak for the idyllic harmony of the modern suburb. The second, represented by *Sailboats* (fig. 75), are veritable chronicles of the area's marine activities. Filled with boats, people, flags, and gusty winds, they proclaim Argenteuil to be a lively, public recreational center.

These three areas then, the Petit Bras, the boat rental area, and the basin, offered Monet quite different opportunities to paint essentially the same subject—leisure on the Seine. The range from the secluded to the worldly, the reflective to the rambunctious, is perhaps nowhere quite as critical in Monet's work as in these boating pictures. Far more than any of his other subjects, boating required Monet to confront a popular, public phenomenon more appropriate for (and more practiced by) storytellers, popular illustrators, sports writers, and social commentators.

The most public boating affair was a regatta. And, not surprisingly, Monet's view of one in *Sailboats* is the most active and the most broadly painted of his boating pictures in 1872. That Monet would have chosen to paint a regatta during his first year in the town is in keeping with his initial enthusiasm for everything Argenteuil offered. Regattas were held there at least twice a month from April to November. In addition, boating had gained such a following by the 1870s that regattas throughout France were reported in the Paris press, so Monet would have been aligning his interest in boats with his town and the times.

Nevertheless, *Sailboats* is the only view of a race that Monet painted that year. And during the next five years, while he did dozens of boating pictures, he painted only two others that show regattas, *Regatta from the Basin* (fig. 76) and *Regatta from Gennevilliers* (fig. 77), both from 1874. Monet may have been concerned about the formal problems the subject posed. If, as in *Sailboats* or *Regatta from the Basin*, the crowd was to be eliminated and the indications of a race downplayed, regattas were difficult to paint. Perhaps for that reason, Monet set both of these pictures in stormy weather; darkened skies and choppy water contribute to the sense of excitement a race would generate but they also enliven what could be an excessively prosaic subject.

It is more likely, however, that Monet painted so few regattas because he was not a public chronicler. Boating was for him what the horserace or the ballet was for Degas, a modern subject that revealed the spirit and opportunities of the era and the processes and poetry of art.

It is quite possible, in fact, that the two regatta pictures from 1874 were the product not of Monet's initiative but of Renoir's. An occasional houseguest that summer, Renoir was more attracted than his host to people and public events, and may have persuaded Monet to join him when he rendered the same regatta from Gennevilliers (fig. 78). He also may have convinced Monet to be more specific than usual, for Monet included a crowd of spectators and a scull in his view, the first time they appear in any of his boating pictures.

One particular event, however, may have been the instigation for both of their paintings. On 7 June 1874 the Cercle de Voile des Régates Parisiennes, under the patronage of the Yacht Club de France, held a regatta at Argenteuil that was so impressive journalists claimed it rivaled the international races of 1867 that had taken place there under the auspices of the Universal Exposition.

> The basin presented the most animated spectacle: clipper ships tacking back and forth, sculls coming downstream to see the race course, houses, marinas all decked out; Parisian yachtsmen gathered around the pole designating the finishing line and a large crowd covered the banks the entire length of the basin.[18]

The crowd was a "select group" that Argenteuil did not see every Sunday, including counts, captains, ambassadors, composers, inspectors, polytechnicians, and military school personnel. Even other artists were spotted, as the presence of Ziem, Rious, and Manet was reported in the local press. Manet, of course, had received enough critical attention by that time to merit celebrity status; Monet and Renoir had not. But if Manet was there, undoubtedly Monet and Renoir were as well. Given the importance of the occasion and the fact that neither Monet nor Renoir was immune to the appeal of a gala affair such as this, it is quite possible that figures 77 and 78 are views of the activities of that day. As such, they are not only views of modern life in the country, but also documentaries about a specific event, and thus "history" paintings. But Monet and Renoir, instead of immortalizing an occasion of consequence, as Manet had done in his *Execution of Maximilian* or the *Battle of the Kearsarge and the Alabama*, of 1865, were preserving a moment that had no historical importance except to yachtsmen and sports enthusiasts.

It must be pointed out, however, that the regatta of 7 June was not for sailboats or sculls; it was for steamboats. If Monet and Renoir were in fact there, they did not depict the main event of the day, for neither picture shows such crafts or even hints at their presence. But what would be more appropriate for a new kind of history painting than presenting the peripheral activity, which in this case would be as memorable and as important as the main event?

It would be just like the article on the race partially cited above. Of its six paragraphs, only one deals with the facts of what happened. The others describe the setting, the ambiance, and the crowd, just as Monet and Renoir do. Furthermore, if Manet could include in his *Execution of Maximilian* the distractions of a soldier loading his gun or the crowd of faces peering over the wall, then surely Monet and Renoir, in dealing with an event that carried no historical weight, could concentrate simply on these secondary but circumstantial elements. Indeed, it would be in keeping with the general tendancy of Monet, Renoir, and, most notably, Degas, to subordinate or disregard the "important"

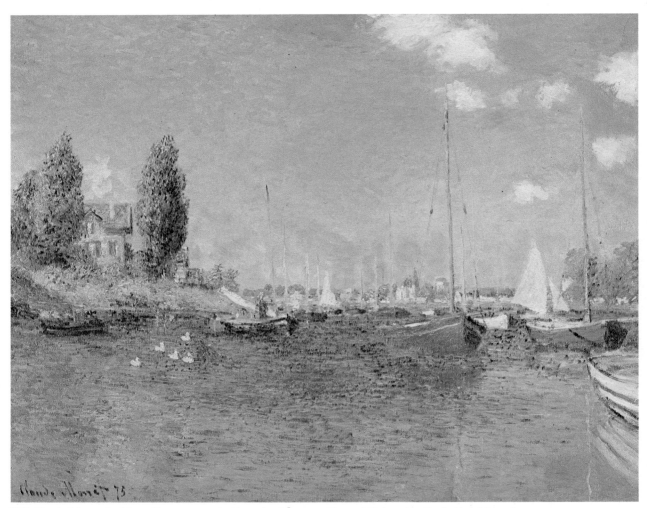

XX. Claude Monet, *Red Boats II*, 1875. 55 × 65. Fogg Art Museum, Harvard University, Cambridge, Massachusetts.

XXI. Claude Monet, *Boat Rental Area with Boat Rental House*, 1875. 54 × 74. Private Collection, Madrid.

action in favor of that which would express the "mysterious beauty" lent to modernity by human life. Finally, the absence of steamboats is also in keeping with Monet's apparent disdain for this type of pleasure boat; although he was willing to show them in scenes describing industry and progress, he painted them only once as pleasure craft (*Sunday at Argenteuil*, fig. XVII) and included them in only one view of the area where they were moored (*The Bridge on a Gray Day*, fig. 56). Perhaps he was a boating purist, who like many sailors then and now found the steamboats to be undesirable "stinkpots."

In an article on the development of pleasure boating in Paris, however, which appeared in *Le Sport* in 1865, Eugène Chapus raised a crucial issue about these and other boats— their social implications:

> What changes are occuring in French habits in the realm of sport! How the enthusiasm for it is spreading in all classes of society. We're not speaking about the track; everyone can see how the passion for that has proliferated, but . . . of other activities. Look at boating, which is making big headway among our young men of fortune. It's no longer a question of the simple, modest sport of twenty years ago—of a small dinghy for rowing or sailing and limited excursions along rivers or lakes. The pleasure craft today, the yachts, are not sailboats but steamboats—even propeller boats. We counted several in different marinas along the Seine and we believe we're correct in affirming that two years from now the Seine in Paris and its suburbs will literally be covered with boats of this kind.[19]

Steamboats did in fact proliferate in the next few years, but the list price for one, according to Chapus, was from fifteen to twenty-five thousand francs, so it was only the "young men of fortune" who could own them. Even to rent them was out of the question for most people, as seventy-five to one hundred francs a day was the going rate.[20] To buy a sailboat, on the other hand, was also beyond the means of many, but at least the rate of three to four francs a day allowed the majority of the middle to lower classes to pass a few Sunday afternoons gliding up and down the Seine. This is not to say that Monet painted sailboats and not steamboats because he felt the former more democratic; but it is to suggest that, since sailboats were more identified with the bourgeoisie, he painted them because he was a member of that class and because he was hoping to find bourgeois patrons.

The identification of boating with the middle classes had actually been a recent development. In the early 1850s the sport was considered "nothing less than the most condemned eccentricity" practiced primarily by "extremely crude, boisterous people who, under the name of boaters, terrorized the people who lived peacefully along the river."[21] In 1858 Alphonse Karr and several respectable Parisian friends who had taken up boating wrote a book, *Le Canotage en France*, in which they attempted to legitimatize the sport, and thereby win over those who still, in their words, had "a deep prejudice" against it.[22] Their efforts over the next decade, which included the creation of several prestigious boating clubs, raised the reputation of the sport and increased its popularity. Thus when Monet painted the sailboats at Argenteuil he was painting that sport which, according to Lecaron, "belongs to everyone, far unlike all the others, which demand riches."[23]

76. Claude Monet, *Regatta from the Basin*, 1874. 60 × 100. Musée du Louvre, Paris.

However, Monet did not paint the students, artists, and workers who comprised a majority of those "loups d'eau douce," as boaters were called. Although more common in the 1850s and 1860s, these scruffy pleasure-seekers still existed in the 1870s and many frequented the basin at Argenteuil. The town was the weekend hangout of people like Guy de Maupassant, who in the 1870s was "a penniless clerk leading his life between the office in Paris and the river at Argenteuil." His existence was "carefree and athletic, a life of poverty and gaiety, of noisy rollicking fun."

> There were five of us, a small group of friends who are pillars of the community today [1884]. As none of us had any money, we had set up an indescribable sort of club in a frightful pothouse at Argenteuil, renting a single dormitory bedroom where I spent what were the maddest nights of my life. We thought about nothing but having fun and rowing, for all of us with one exception regarded rowing as a religion. I remember these adventures these five rascals had and pranks they thought up which were so fantastic that nobody could possibly believe them today. Nobody behaves like that any more, even on the Seine, because the crazy fun which was the breath of life to us means nothing to people nowadays.[24]

We did not see those pothouses in Monet's views of the town and we do not find those obnoxious rowers and their communal boat in his views of the Seine. In fact, the only time that Monet shows any rowers other than the single oarsman in *Regatta from Gennevilliers* is in his *Sailboats and Sculls* (fig. XVIII). But, like the view of the regatta, this picture may also have been influenced by Renoir, who again painted the same scene (fig. 79). In both of Monet's pictures, and in Renoir's also, there is no indication that the rowers

77. Claude Monet, *Regatta from Gennevilliers*, 1874. 59 × 99. Private Collection, New York.

78. Auguste Renoir, *Regatta from Gennevilliers*, 1874. National Gallery of Art, Washington, D.C.

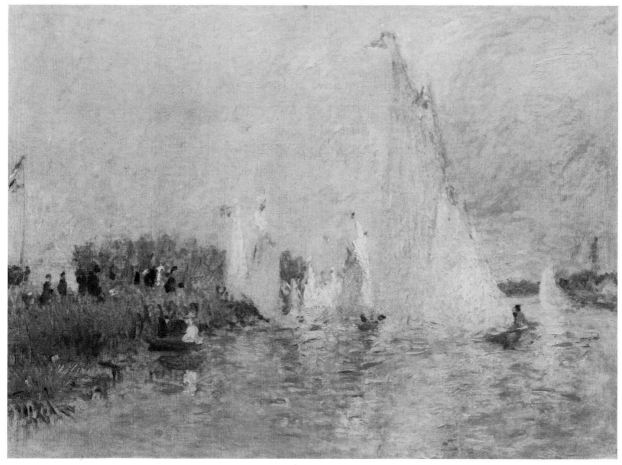

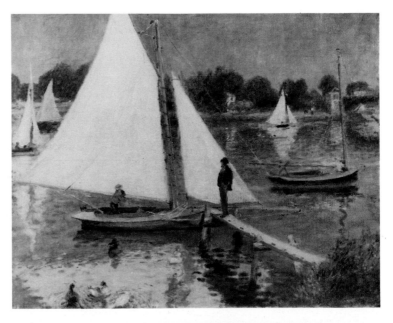

79. Auguste Renoir, *The Seine at Argenteuil*, 1874. Portland Art Museum, Oregon.

80. Edouard Manet, *The Seine at Argenteuil*, 1874. Private Collection, London.

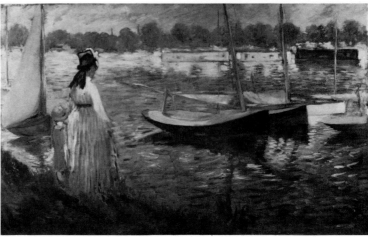

are anything but respectable people engaged in a respectable activity. There were, of course, plenty of good bourgeois boaters who came to Argenteuil; Manet portrayed two of them in his painting *Argenteuil* of 1874. Others filled popular prints. It was, therefore, simply a question of selectivity, and Monet, Renoir, and Manet selected the respectable bourgeoisie because they were closest to such people and were painting pictures for them.

While tied to their class and times, these three artists approached the subject of boating differently. In Manet's *The Seine at Argenteuil*, 1874 (fig. 80), a painting that is closer than his *Argenteuil* to the two views by Monet and Renoir (figs. XVIII, 79), Manet, standing near his friends' site, places a woman and child prominently in the foreground, adds many more boats, and pulls them all closer to shore. Although clearly set in the country with light, warmth, and fresh air, the scene has an impersonality that the other two views lack. Manet gives that impression by leaving the boats unoccupied, the basin inactive, and the figures aloof. Like the *Argenteuil*, Manet's view is more immediate than Monet's

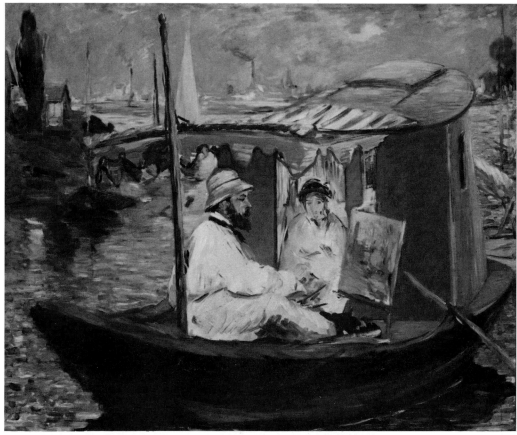

81. Edouard Manet, *Monet working in his Floating Studio at Argenteuil*, 1874. Bayerische Staatsgemäldesammlungen, Munich.
82. Claude Monet, *The Floating Studio*, 1874. 50 × 64. Rijksmuseum Kröller-Müller, Otterlo, The Netherlands.

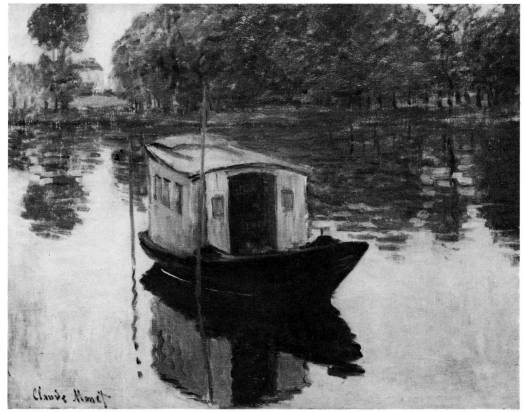

83. Claude Monet, *Argenteuil seen from across the Seine*, 1874. 42 × 70. Private Collection, United States.

or Renoir's and more dispassionate, which reveals his urban qualities and his closer ties to the city and the fact that he was a figure painter venturing into the genre of landscape.

Monet and Renoir, in contrast, increase the activity of the basin while they step back from the boats and allow the observer to absorb the view more casually. Although in both pictures there is a sense of a moment captured, Monet's moment will not pass as quickly; the view is so tightly composed "the moment" seems eternal.

Instead of crowding his view with sailboats as Renoir does, Monet allows the large triangular shape of the sail in the foreground to fill the left side of his picture, artfully having it end just below the shoreline in the background, which seems to raise it higher and give it a lightness that Renoir's lacks. To the right, where Renoir isolates a single sailboat, Monet places a boat just at the edge of the jib in the foreground. This locks the boat into the composition, flattens the picture space, creates a complex relationship between the two sailboats, and gives the background boat a greater sense of movement. Below, instead of Renoir's lone rowboat and unmanned sailboat, which simply fill the space, Monet places two long, thin, parallel sculls; they too fill the void, but they define the illusion of depth more subtly by continuing the horizontal lines of the foliage, bank, and foreground boom. Since one scull is further to the left than the other, there is a pleasing sense of variation, and as they are moving from right to left they also add an appealing note of contrast to the sailboats headed in the opposite direction. With the same sense of clarification and contrast, Monet separates the dock from the foreground boat and places both men in the ship. As a result, the relationship between the dock and

110

84. Claude Monet, *The Duck Pond*, 1874. 73.5 × 60. Sterling and Francine Clark Art Institute, Williamstown, Massachusetts.

85. Claude Monet, *Study for the Sailboats in the Boat Rental Area*, 1874. Musée Marmottan, Paris.

the boat is easier to read and therefore more effective. Similarly, his empty left foreground (Renoir's is cluttered with ducks) and his continuous band of foliage in the background (Renoir faithfully includes the white house) make his picture simpler and more abstract. When all of these factors are added up, it is apparent that Monet's picture is the more successful. And it is more successful because Monet was more selective and self-conscious. Renoir's busier and less ordered view is closer to what Argenteuil was like; Monet's view is a further transformation of the realities into a more private world of his art.

This tendency of Monet's to transform the public into the private, the real into the artful, is more apparent in another painting from 1874, *The Floating Studio* (figs. XV, 82); indeed it is the painting's subject and *raison d'être*. Neither Renoir nor Manet could have painted a picture like this. From the banks of Gennevilliers several hundred meters downriver from the boat rental area, Monet shows his floating studio moored to two stakes. The picture is more than just a view of his atelier, however; careful examination of the interior of the cabin reveals that Monet has included himself on the right by the door. With his hat on his head and presumably his brush in his hand, he sits in the shadows looking out onto the world. Isolated and alone, he is the modern Daubigny, searching for untrammeled nature; if Argenteuil was not exactly that, he could make it such. He could remove all other boats and people, and all evidence of modernity, and thus transform the Seine into a lake for meditation.

This is not the same person that Manet painted that summer (fig. 81). Shown working in the same floating studio near the same place he chose for his own picture, Monet here is portrayed as the confident, bourgeois artist confronting the contradictions of Argenteuil—its smoking factories and pleasurable pastimes—and rendering them with the conviction that these facts of modern life deserve to be painted. Granted, this is Manet's view of his friend, but it is one that Monet's pictures such as *Sunday at Argenteuil* (fig. XVII) support. *The Floating Studio*, therefore, being the antithesis of Manet's portrait and the image that Monet's own pictures propagate, is another side to the painter of modern life in the country.

112

As a view of Argenteuil transformed, and as a statement by Monet of his desire for peace and security, *The Floating Studio* should be a constant reminder that Monet's was an extremely conscious art, that all of his pictures were products of manipulation and introspection—that, in effect, he was always in his atelier, literally or figuratively, looking out onto Argenteuil and making art from it.

That Monet should state this so explicitly here is unusual, since he generally preferred subtler suggestion. However, considered in the context of the summer of 1874—when Monet stopped painting the railroad bridge, manipulated the highway bridge to make it a figurative bridge between the past and the present, and painted his greatest number of Barbizon-like pictures, such as *Argenteuil seen from across the Seine* (fig. 83) and *The Duck Pond* (fig. 84)—it is quite reasonable. The city–country dialectic of his life and art was asserting itself more strongly. The change over the two years is evident when *Sailboats in*

86. Claude Monet, *Weeds by the Seine*, 1874. 55 × 66. Formerly Miethke Collection, Vienna.

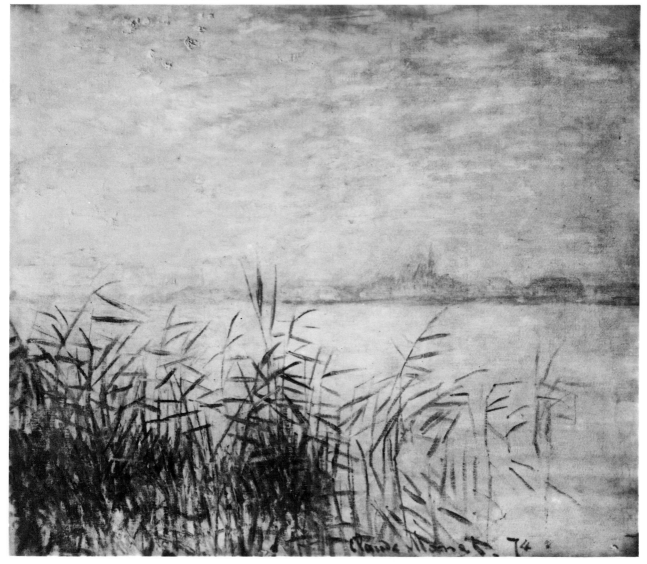

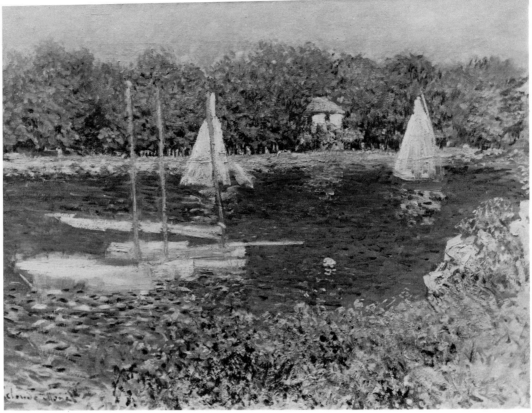

87. Claude Monet, *Argenteuil Basin with Two Sailboats*, 1874. 54 × 73. Rhode Island School of Design, Providence.

88. Claude Monet, *Argenteuil Basin at Sunset*, 1874. 49.5 × 65. Philadelphia Museum of Art.

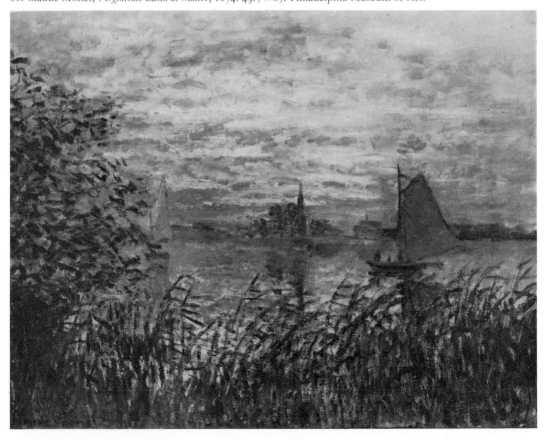

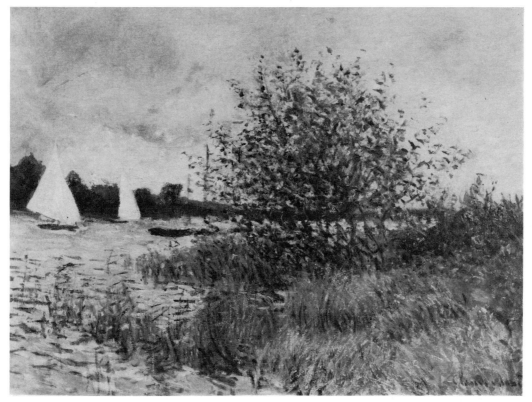

89. Claude Monet, *Argenteuil Basin from behind the Bushes*, 1874. 54 × 73. Whereabouts unknown.

90. Claude Monet, *Argenteuil Basin with a Single Sailboat*, 1874. 55 × 65. National Gallery of Ireland, Dublin.

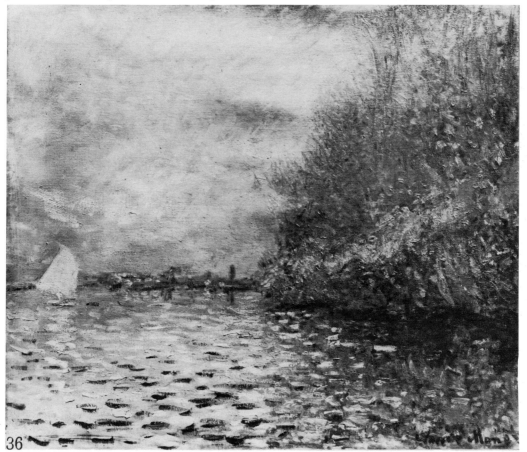

the Boat Rental Area, 1874 (fig. XIX), is compared with *The Boat Rental Area* (fig. XVI) of two years earlier.[25]

Instead of standing on the shore and viewing the flotilla from a distance, Monet sits among the moored ships, raises the horizon line, compresses the space, and pulls everything closer to himself. So close, in fact, are the boats that they become somewhat unnerving, as if they were challenging our space. The one in the bottom left, although unfinished, seems almost blurred by its proximity. The pressing sense of the boats, the numerous verticals, the wavy reflections, and the windblown sky give the scene a restlessness that *The Boat Rental Area* lacks. There is even an aggressiveness in the way the paint is handled, as evidenced in the clouds and water. The paint also is not thick enough to permit sensual pleasure and not colorful enough to allow for visual delights. In fact, the canvas appears throughout, even in the more impastoed sky, giving the scene a rough and gritty texture.

All of these effects separate this picture from *The Boat Rental Area* but Monet goes one step further and includes the factory chimneys that he had eliminated in the painting of 1872. Not only are they prominent, they are spouting trails of smoke that stream halfway across the picture. Crowded, shifting, and impersonal, figure XIX shows Argenteuil as the suburban town that it was in the 1870s.

The insular overtones of the scene imply that the uneasiness and isolation are due as much to Monet's own state of mind as they are to the particular qualities of the site. A drawing by Monet (fig. 85) that is closely related to the painting makes this more apparent. One of twenty-one drawings contained in a sketchbook now at the Musée Marmottan, it shows the same rental area with the Gennevilliers bank on the left. Although the space is not as compressed as in the painting, the forms are quite close to us. As in the finished work, we are sitting in the midst of the flotilla with the bow of our boat jutting out from the bottom of the sheet. A person wearing a hat sits on the left in front of us; to either side, lines indicate some kind of enclosure. The boat is Monet's floating studio, and the enclosure is the actual studio part of the boat. We are sitting inside looking out through the small door. The waving line at the top of the door is the canvas sunroof that cantilevered out from the atelier, as shown in Manet's portrait of Monet at work (fig. 81). In the painting, despite the absence of the studio, the proximity of the flotilla and the cagelike formation of the masts give us the strong sense that Monet is sitting in his little floating atelier looking out onto Argenteuil. Because this relationship is implied rather than stated, the painting, even more than the drawing, vacillates between two worlds—the boat rental area and the realm of Monet's art. The view emphasizes the fact that Monet is a part of this suburb, but that he is also distinctly removed from it. And it does so with greater insistence than was evident in *The Boat Rental Area*.

This greater pull between the public and the private is evident when *Sailboats in the Boat Rental Area* is compared with *The Floating Studio*, or, more poignantly perhaps, when it is compared with another painting from the same summer of 1874, *Weeds by the Seine* (fig. 86). Standing behind a screen of weeds, alone and meditative, Monet looks out across the empty Seine as if pondering his choices. The picture lacks the tension of *Sailboats in the Boat Rental Area*, perhaps because Monet has moved further downriver away from the boat rental area, perhaps also because he has not included the two factory

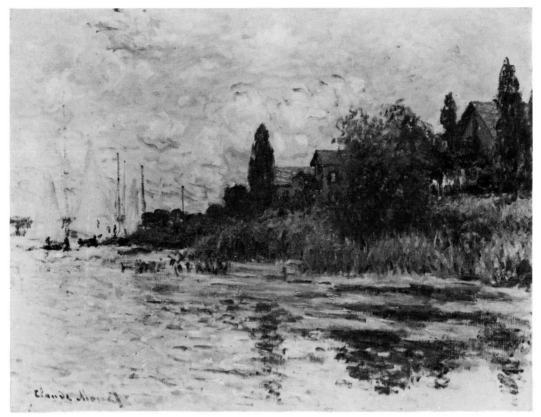

91. Claude Monet, *Sailboats by Gennevilliers*, 1874. 51 × 65. Private Collection, Paris.

92. Claude Monet, *Boats on the Banks of Gennevilliers*, 1875. 61 × 80. Private Collection, New York.

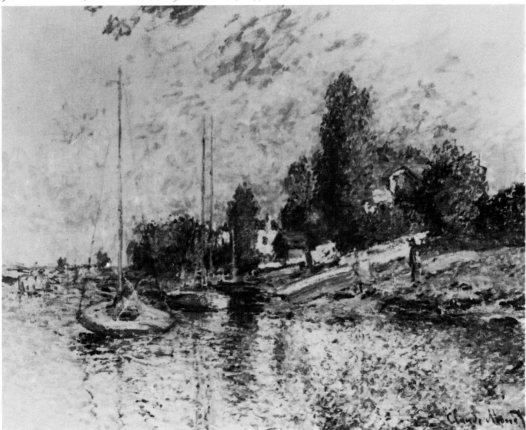

chimneys on either side of the turreted house. At the same time, however, the picture does not have the total tranquillity of *The Floating Studio*. It could be seen, therefore, as a statement of compromise: city and country, in tempered forms, could continue to coexist harmoniously and be the basis for Monet's art. On the other hand, the picture could be seen as a statement of direction: the emphasis is clearly on the weeds, river, and sky, with the town decidedly subordinate. "Modern" Argenteuil could perhaps be relegated to the background and the "country" side of the town could become the focus of attention.

If we examine Monet's other boating pictures, it is apparent that this latter interpretation is correct, for over the course of the summer of 1874 the boating activity in his views becomes less important than the surrounding environment until it can hardly be considered the subject. We can see this if we compare several pictures such as *Sailboats and Sculls* (fig. XVIII), *Argenteuil Basin with Two Sailboats* (fig. 87), *Argenteuil Basin at Sunset* (fig. 88), *Argenteuil Basin from behind the Bushes* (fig. 89), and *Argenteuil Basin with a Single Sailboat* (fig. 90). The sailboats and their skippers, so prominent in the first painting, gradually lose their significance until they are reduced to a single boat in the background. The progression is from the Seine as a site for leisure activity to the river as a source for a personal dialogue with nature.

Given this change, it might seem paradoxical that in the following summer of 1875 Monet took up the subject of boating in pictures like *Boats on the Banks of Gennevilliers* (fig. 92) that recall works such as *Sailboats by Gennevilliers* of 1874 (fig. 91), but are even more animated. He carried this apparent exuberance still further in his two versions of the *Red Boats* (figs. 93, XX). These are nothing less than allegories of Argenteuil's summertime delights, with sparkling sunlight, placid waters, ducks, pleasure-seekers, and pleasure boats. Although Monet is sitting among the ships, as he had in *The Boat Rental Area* and *Sailboats in the Boat Rental Area*, there are neither the urban tensions of the former nor the suburban contrasts of the latter. No smoke rises in the background; indeed, the chimneys are literally rubbed out. No rowdy boaters disturb the scene's serenity and no muddy banks or polluted water discolor this Seine. The restlessness of the city and the strain of modern existence are forgotten in the face of such natural radiance. The paintings are paradigms of modern boating life in the country, apt companions to Eugène Chapus's description of boating downriver at La Grenouillère: "boating is pure poetry, the Seine is the Adriatic; it's the Gulf of Naples and the deep blue sea; it's the life of contemplation; and it's reverie."[26]

It was this dream world that Monet too was painting, a world of romance and poetry that he wanted Argenteuil to be. By 1875, however, it was evident that Argenteuil was not such a place. It was also apparent, as one writer pointed out in the same year, that the people who came to the suburbs were not poets, dreamers, or Rousseau-like romantics: when Parisians invade the country on Sundays,

> nature is going to quit its role of the mysterious, silent nymph. She is going to become an inn maid, to whom traveling salesmen pay rather poor respect. They take over the country as if it were a huge "guinguette," a café-concert larger than the one on the Champs-Elysées. . . . All these people come to feel the hills as if they were breasts, to tuck the forests up to the knee and ruffle the river as if the Sunday ritual was to give nature a charivari. The mad Parisians have thrown nature into an uproar.[27]

118

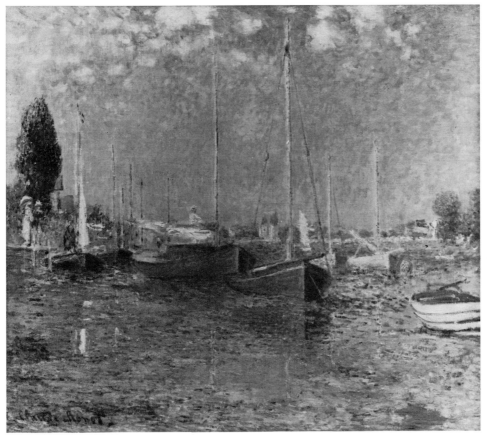

93. Claude Monet, *Red Boats I*, 1875. 60 × 81. Musée du Louvre, Paris.

94. Claude Monet, *Boats moored in the Boat Rental Area*, 1875. 54 × 65. Private Collection, United States.

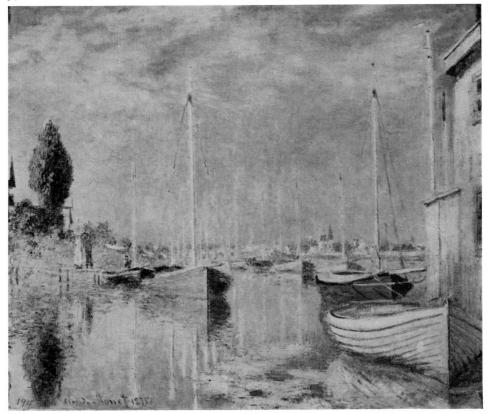

When these obnoxious people and Argenteuil's increasing developments began to punc-
ture Monet's myths, Monet tried even harder to preserve them; the *Red Boats* was his
dream world as well.

Two other paintings from the same summer of 1875, *Boats Moored in the Boat Rental
Area* (fig. 94) and *Boat Rental Area with Boat Rental House* (fig. XXI), indicate Monet's
alternative. In *Boats Moored in the Boat Rental Area*, although floating in the same general
area as in both *Red Boats*, Monet has pulled back from the center stage position to a place
in the wings. The "wing" is the side of the floating boat rental house. Pushing out into
the picture on the right, it closes off the scene and creates the sense that he is looking out
from a protective enclosure. Having retreated, Monet seems to be more meditative; even
the waters are more placid than in either *Red Boat* picture. He is not less vulnerable,
however, since the boats are headed toward him and one of them actually sits precariously
close in the foreground. There is a tension between the boat rental area and the area
where Monet is sitting; it exists here and not in the *Red Boats* because Monet has shown
that his world is separate from that of the basin. The tension is resolved in *Boat Rental
Area with Boat Rental House* where Monet has withdrawn even further. The boat house
and its reflection fill the right side of the picture, providing a substantial barrier between
Monet and the Seine. The Gennevilliers bank fills the left side, creating with the floating
house a Petit Bras–like alleyway that leads into the distance. The boat rental area is still
evident, but it has been considerably reduced from what it was in any earlier picture. And
it has been clearly defined as a separate place. The gangplank in the middleground,
leading from the bank to the floating house, divides the view horizontally and creates
two different areas—the public one beyond the gangplank, and Monet's in the fore-
ground. There is no tension between the two; the division is complete. Even the boat in
the middle of the foreground, which could have disrupted the view as the boat in *Boats
Moored in the Boat Rental Area* had, is turned away; the one to the right hastily sketched in
is also unaggressive, and appropriately so because it is Monet's floating studio. This
foreground area is indeed Monet's realm, just as the foreground in the Marmottan draw-
ing was his. But, unlike the drawing, Monet is no longer out among the jostling flotilla;
he has not only taken himself out of that public sector but tucked himself into the
furthest corner of the site. Gone is the exuberance of the *Red Boats*, the dazzling light, and
the sense of expansiveness. Cramped and introverted, the painting is bold in its execution
and direct in its implication. Although undoubtedly unfinished, it is on all counts a final
statement. Its sketchiness speaks for Monet's desire to present this view bluntly as evi-
dence of the process of art and as a statement of fact: Argenteuil was one world, Monet's
world another. With his back to the bridge, Monet could retreat no further. He could
abandon the site and the division and retreat into a world of his own making. The choice
had always been there. Now he took it. And in doing so, he directed his life and art
toward the garden.

XXII. Claude Monet, *Camille reading* (detail), 1872. 50 × 65. Walters Art Gallery, Baltimore, Maryland.

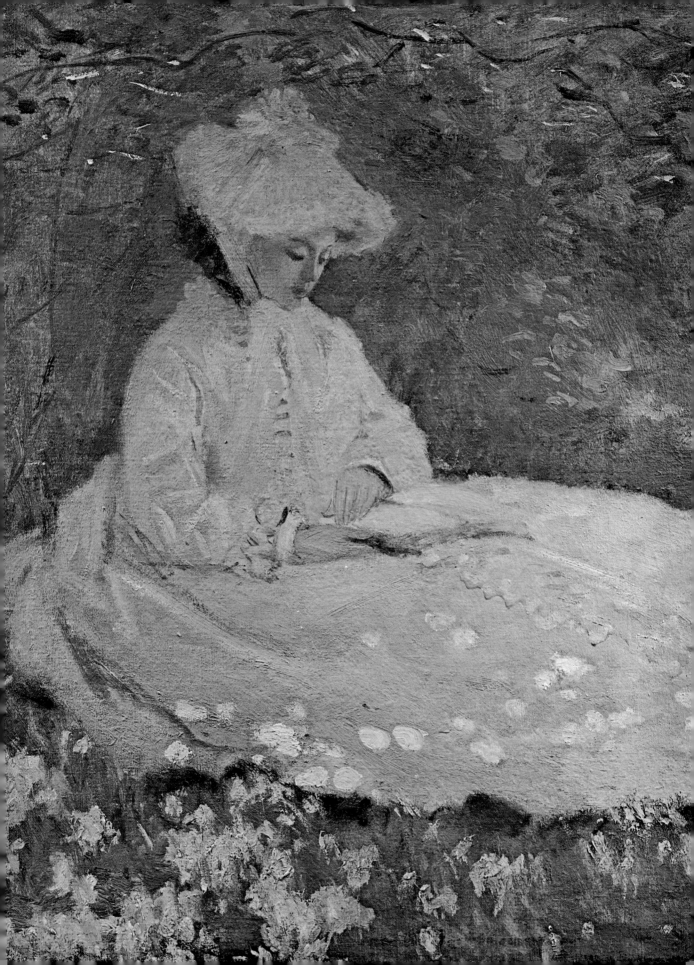

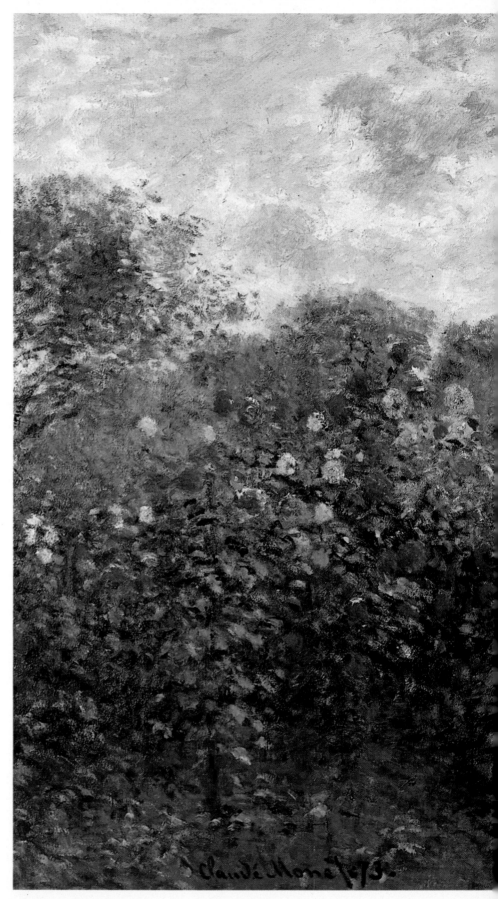

XXIII. Claude Monet, *A Corner
of the Garden with Dahlias*, 1873.
61 × 82.5. Private Collection,
New York.

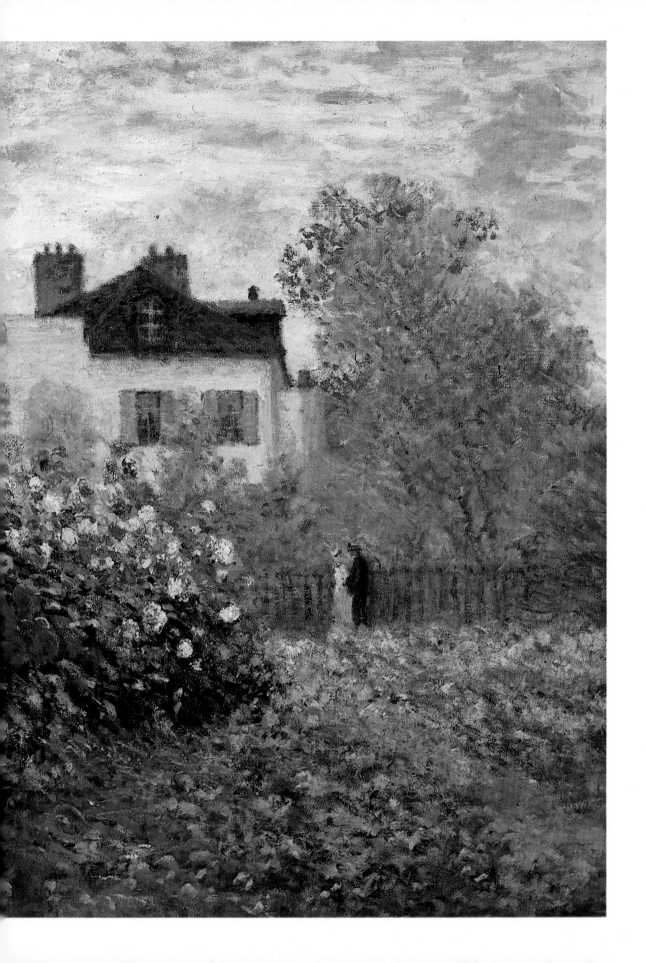

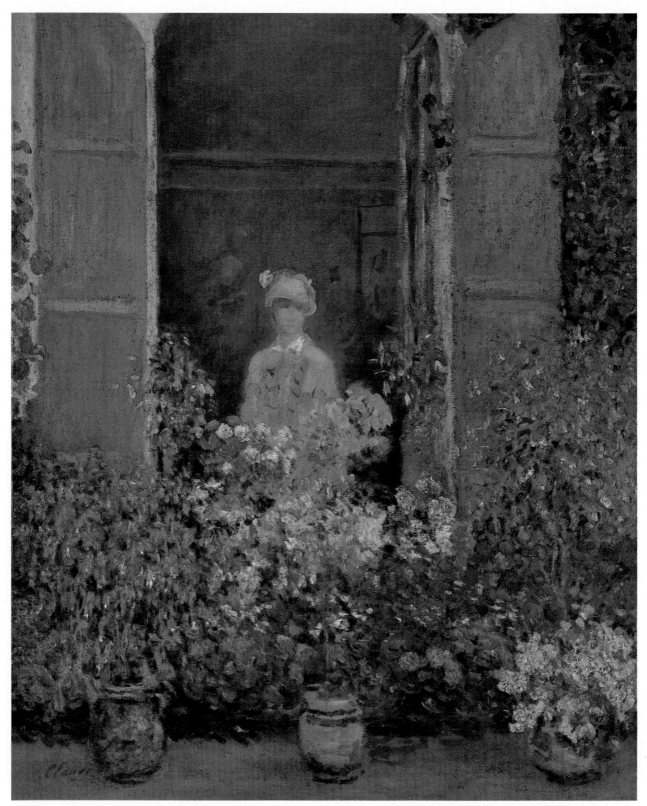

XXIV. Claude Monet, *Camille at the Window*, 1873. 60 × 49.5. Collection Mr. and Mrs. Paul Mellon, Upperville, Virginia.

5. Monet and his Garden

"ONE OF THE PRONOUNCED characteristics of our present Parisian society," wrote Eugène Chapus in 1860, "is that . . . everyone in the middle class wants to have his little house with trees, roses, dahlias, his big or little garden, his rural *argentea mediocritas*."[1] In order to satisfy this general need, which, as Chapus noted, "drives everyone out of the streets of the capital during the summer," speculators worked hard to furnish pleasant sites and cottages at reduced rates. "Go to the north, to the west, to the south, to the east, by the railroad which shoots out to all the horizons, and you will find [them] at work, cutting, demarcating, and constructing."[2] These speculators bought the small forests that dotted the suburbs and the sprawling parks of ancient seignorial estates, divided them up, and then resold the lots at what Chapus felt were "fabulously economical prices," fifty centimes to two francs a meter. "You don't have to have 20 écus of 100 sous in the bank," he added, "in order to become the owner of twenty trees and a cute house."[3]

Not everyone liked these new houses. Jules Janin, in his *La Normandie* of 1862, commented with biting satire on the developments around one of the great chateaux of France: "Look what the bourgeoisie have done to the Château de Maisons Laffitte, a royal residence! They have cut into a thousand parcels the admirable park which protected those paths filled with shadow and silence; and along its secluded avenues, at the most picturesque spots, the bourgeoisie have built their cardboard chateaux, cardboard chateaux which will see the Château de Maisons Laffitte fall!"

The demand for these cardboard chateaux and their rural *argenteas mediocritas* was so great, and the efforts of the speculators so earnest, that Chapus's remark two years earlier that "this parceling of land is the quiet agrarian law of the suburbs" was already in 1862 an understatement. By 1869 the practice was so commonplace that the picture dealer Arnoux, from Flaubert's *L'Education sentimentale*, considered investment in suburban building sites "absolutely safe."[5] When Malmaison, the residence of the Empress Josephine after her divorce from Napoleon, came up for sale in 1877, one journalist expressed the desperate hope "that this beautiful estate will not be carved up like so many of the other parks in the Paris suburbs in order to build cottages for businessmen and bankers infatuated with holidays." For by the 1870s, as the same journalist noted, the suburbs of Paris were "the prey of wholesalers, financiers, and employees."[6]

95. P. J. Linder, *On Holiday*, 1877. (Engraved in *L'Illustration*, LXX, 13 October 1877, 231.)

96. Claude Monet, *Women in the Garden*, 1866–67. 256 × 208. Musée du Louvre, Paris.

Argenteuil did not escape these speculators. On the contrary, from mid-century onward the town made a conscious effort to attract them. It devoted considerable funds to public projects like building new streets, widening, straightening, and lighting old ones, planting new trees, and improving promenades; it also expanded its health and educational services, and began supporting more elaborate town fêtes and new boating regattas. In 1856 a council member, urging the adoption of several proposals for improvement, summed up the purpose of this kind of investment: "If carried out with reasonable prudence, these [public works] should enlarge the population, increase the value of rural land so depressed in the last twenty years, attract here the citizens of Paris who search for air and promenades, give the greatest boost to the natural products of the fields and to the commercial affairs of the town and, in consequence, enrich the municipal tax coffers."[7] Besides, he pointed out, Argenteuil was competing with the other towns in the suburbs of Paris and thus had to provide the "comforts and amenities" that potential settlers could find elsewhere.

His proposals were approved and, as he predicted, the settlers came. With the growth in population, the number and variety of pleasurable distractions increased. In addition to the regattas and fêtes, Argenteuil could also boast a new pigeon shoot, established by a well-known Parisian gun dealer in 1864. Restaurants, cafés, and bars multiplied; there were even proposals being made for the creation of a private club to serve the upper stratum of Argenteuil, which consisted of new residents like the opera composer Ambrose Thomas and older residents who had grown wealthy on the town's development. Although the club never materialized, the hope that one town father expressed in 1845 had certainly been fulfilled. Writing about the changes that the railroad might bring, he observed, "Can't we hope that some *entrepreneurs de plaisirs champêtres* will come here,

especially since Paris today has lost all of its public gardens like Marboeuf, Beaujon, and Tivoli?"[8]

When Monet came to Argenteuil in 1871 he was seeking greater contact with nature, for the sake of his new family and of his art. The Paris he left behind had received during the Second Empire acres of new parks and thousands of new trees thanks to Napoleon III and Baron Haussmann. But during the Franco-Prussian War and the Commune, much of the Bois de Boulogne and many of the trees along the new boulevards were burned or chopped down. When Monet left he was escaping the city for greener pastures, just as thousands of others were who had moved to the suburbs before him. P. J. Linder, a relatively unknown artist, characterized them in his Salon painting of 1877, *On Holiday* (fig. 95). As one critic commented, "We all know this man. . . . With prodigious facility on his part, the entire universe disappears from his mind as soon as he sets foot in the garden. Or better yet, he creates it for himself. Every day there, he creates a little world

97. Claude Monet, *Garden with Potted Plants*, 1872. 64 × 81. Private Collection, New York.

apart, and this world is just for him . . . filled with emotions of all kinds."[9] His own garden in Argenteuil was this for Monet because among his roses and dahlias he could pursue a personal dialogue with nature, undisturbed (in theory at least) by the world beyond his walls.

The garden—or, more generally, figures in an outdoor setting—had been a long-standing subject for Monet, beginning with his *Déjeuner sur l'herbe* of 1865, an ambitious painting of monumental size, conceived as a challenge to Manet's recent version and to Courbet's machines of the 1850s. Monet's largest and most important garden picture of the decade was his *Women in the Garden* of 1866–67 (fig. 96), a canvas he began in the garden of a house he rented in Ville d'Avray, transported to Honfleur, and completed there in a studio the following winter. Intended for the Salon of 1867 (it was refused), it represents not only an extended labor but also the fashionable side of Monet's work of the 1860s. The elegantly dressed women with their new outfits and aloof, self-absorbed attitudes are emphasized more than the garden itself. Like the models for the chic magazine *La Mode Illustré*, these "daughters of our civilization," as Zola called them, are icons of the successful, mobile middle-class life, the epitome of leisure, luxury, and refinement.

When the *Women in the Garden* is compared with one of Monet's first garden pictures in Argenteuil, *Garden with Potted Plants*, 1872 (fig. 97), it is immediately apparent that intentions and orientations have changed. Besides being considerably smaller (64 cm. × 81 cm. versus 256 cm. × 208 cm.), *Garden with Potted Plants* has an intimacy that the earlier picture lacks. This is due to the fewer figures, their smaller size, and their greater harmony with the more open environment. Although the view still portrays a bourgeois life of comfort and grace, it does so with less blatant self-consciousness.

In this sense, it is closer to Monet's view of *Jeanne-Marguerite in the Garden*, 1868 (fig. 98), which represents a distant cousin of Monet's in her family garden at Sainte-Adresse. Like the Argenteuil view, this picture is airier than *Women in the Garden* and more of a landscape than a figure painting. It is also small like *Garden with Potted Plants* and, most important perhaps, it shows a site that had more meaning for Monet than the one in Ville d'Avray. But the garden at Argenteuil was the most important of all three, and, not surprisingly, *Garden with Potted Plants* is the most intimate of these works.

Occasionally, Monet could find the intimacy of that garden to be pure enchantment, as in *Under the Lilacs*, 1872 (fig. 100), where the figures blend into the shadows of the lush canopy of flowers, and the light falling like Zeus's shower of gold to Danae creates a sparkling starlit screen.

Sometimes that enchantment could become fantasy, as in *Three Figures under the Lilacs*, 1872 (fig. 99), where the light is more diffused and the figures appear to float in a green haze under the flowering bushes. With the path and potted plants gone, the area becomes even less recognizably part of Monet's garden. Containing three seemingly unrelated individuals—one well-dressed woman, another in kimono, and a casually dressed man stretched out in a relaxed pose—the scene appears to be not quite of this world, as if it were a moment from a dream. Indeed, the figures recall those fanciful players in the garden theaters of Watteau, an association that is not inappropriate, as Monet greatly admired Watteau's work.

Monet's new life and garden may also have provoked a painting like *Camille reading*,

98. Claude Monet, *Jeanne-Marguerite in the Garden*, 1868. 80 × 99. The Hermitage, Leningrad.

99. Claude Monet, *Three Figures under the Lilacs*, 1872. 48 × 64. Musée du Louvre, Paris.

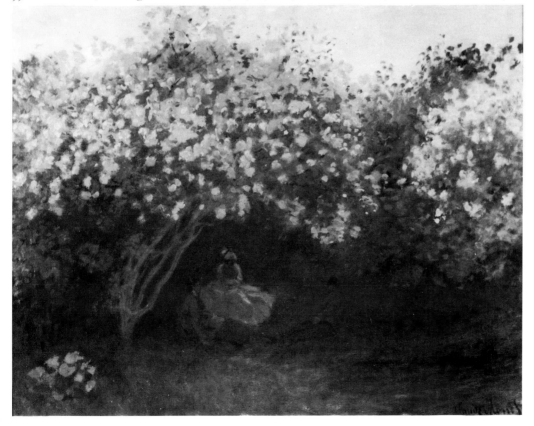

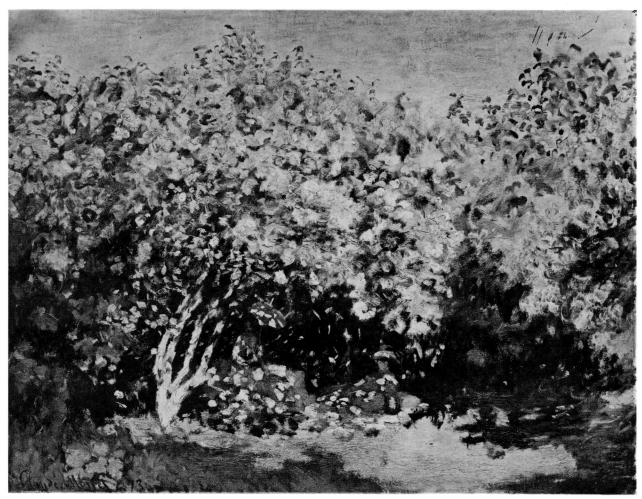

100. Claude Monet, *Under the Lilacs*, 1872. 50 × 65. Pushkin Museum, Moscow.

1872 (figs. XXII, 101). Bathed in a delicate, pink light, unconscious of our presence and unconcerned with the passage of time, Monet's wife Camille is in a world far removed from *Women in the Garden* or, for an even greater contrast, from *Camille in a Green Dress* (fig. 102), both from 1866. In this earlier portrait, she was, as one critic of the time commented, the "Parisian queen, the triumphant woman"; in her pink dress in *Camille reading*, she is the suburban princess, the ideal woman.[10]

The description by another contemporary critic of a woman in a painting of 1874 by Adrien Moreau, a student of the fashionable artist Toulmouche, could apply equally well to Camille: "I know the name by which we can baptize the scene; it is youth, springtime, dawn—all that is full of promise that life does not always hold, that life almost never holds. It is the seductive qualities of someone twenty years old and the charm of the springtime months."[11] Monet's painting, filled with this sense of enchantment and youthful promise—those "pleasant and charming things" so popular among his Salon contemporaries—could easily be considered part of what the critic called "the totally modern school of M. Toulmouche."

Toulmouche was a distant relative of Monet who had met the young artist when he

had first come to Paris in 1862 and had advised him to enter the studio of Charles Gleyre. Toulmouche's paintings of graceful, beautiful women, like Monet's view of *Camille reading*, extol females as precious, desirable objects reminiscent again of eighteenth-century genre pieces while at the same time representative of contemporary middle-class achievement. Although Monet's Camille in this picture might seem less elegant than Toulmouche's sleek, satin-wrapped women, it is clear that Monet is using Toulmouche, or his rival Alfred Stevens, as his point of reference, as can be seen when juxtaposed with the latter's *News from afar*, 1865 (fig. 103).

Yet Monet has not used any of Toulmouche's or Stevens's tricks. For example, Camille is simply reading. While a Parisian audience might see her as a symbol of spring, summer, youth, or love, Monet presents her without allegorical gestures or trappings as a kind of ode to the modern woman. Toulmouche or Stevens more often than not would have had her reading a letter so that the viewer could imaginatively participate in a narrative or incident, as in Stevens's picture. Monet likewise gives Camille no facial expressions, making her much less accessible than Stevens's woman. Formally, Monet gives his picture neither a slick finish nor a studio-like atmosphere. In fact, his outdoor setting was quite novel for the time (it became standard for less daring painters only in the 1880s).

All of these factors save his work from being a popular fashion piece—but just barely, because the picture is overly sweet if not sentimental and extremely limited within Monet's work in its implications, glorifying as it does femininity and the bourgeois ideals of country life without reference to a larger contemporary context. This indulgence on Monet's part may have been the result of his desire to paint a salable canvas. Toulmouche, after all, was a successful artist, someone who could be imitated profitably, and perhaps for this reason Monet included the picture in the Hôtel Drouot auction in 1875. But the painting can also be regarded in the context of Monet's move to Argenteuil; like the views of the lilac corner, it breathes the air of satisfaction and attainment.

That Monet had attained a measure of success is evident in nearly all of his garden pictures, but maybe never so subtly or so humorously as in *Jean on his Mechanical Horse* (fig. 104). Monet depicts his first-born dressed in his Sunday best, even down to his English boater. Conveying a playful spirit as well as Monet's own pride and pleasure, the painting shows that Jean is clearly not the son of a starving artist. He even has a fancy tricycle which he rides with the confidence of an accomplished equestrian. In fact, he strongly recalls the great equestrian portraits by Titian and Velázquez (fig. 105), although his pony is appropriately made of iron. The association with this tradition is telling; Monet and his middle-class contemporaries, with their new houses, land, and success, were using the forms of the aristocrats of old to confirm their own newly attained status.

Everything for Monet, however, was not as secure as it had been for the nobility. Although he earned more than twelve thousand francs during 1872, which by contemporary standards gave him the right to feel successful, he always spent what he had, making him constantly short of ready cash, sometimes to an embarrassing degree.

In contrast to his letters, which are filled with pleas of poverty, his paintings are full of the evidence of a prosperous middle-class life, sometimes presented as even a bit more prosperous than it actually was. In *Camille at the Window*, 1873 (fig. XXIV), set in his

backyard, the window is cropped at the top making the interior of the house seem cavernous; the tall honeysuckle, well-established on either side, creates the illusion of age. The potted fuchsias in the foreground, while communicating a sense of lush abundance, add to the impression of age and prosperity; they are old plants trained by greenhouse pruning to grow like trees instead of bushes. The profusion of other flowers, the begonias on the right, the several types of geraniums, and the yellow day lilies or irises, all of which had to have been kept indoors during the winter, enhance this illusion of prosperity.

On the other hand, the view is probably not untruthful. The house was a sizable, vine-covered cottage with an attractive, well-cared-for garden. And, given the accuracy with which Monet depicts his plants, they most likely existed as we see them. Unquestionably, the house and garden provided for Monet and his family a comfortable suburban existence.

To gauge its contemporaneity, Monet's view can be compared with two other views of life in the country from the 1860s and 1870s (figs. 106–07). The popular illustration from *Le Journal Amusant* of 1863 is the satirical extreme. Mocking the bourgeois dream, it would be an apt illustration to one journalist's assertions that "Parisians understand the

101. Claude Monet, *Camille reading*, 1872. 50 × 65. Walters Art Gallery, Baltimore.

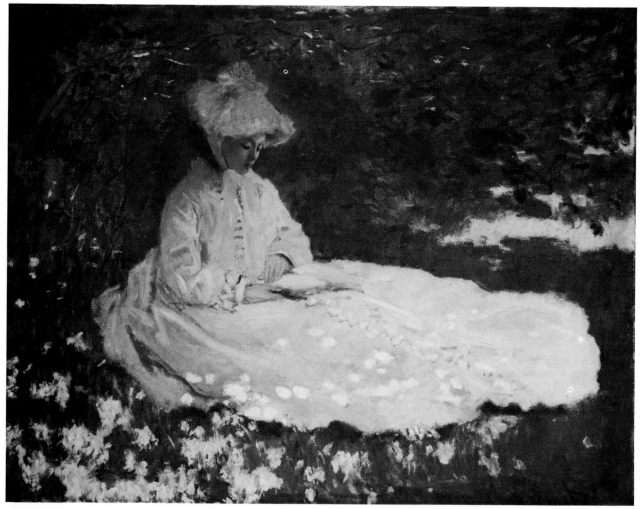

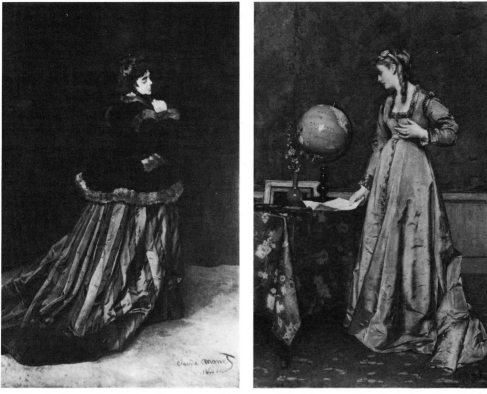

102. Claude Monet, *Camille in a Green Dress*, 1866. 231 × 151. Kunsthalle, Bremen.

103. Alfred Stevens, *News from afar*, 1865. Walters Art Gallery, Baltimore.

country a little like toy dealers; a cardboard cottage with three broomsticks around in the guise of trees and a pot of grass for a lawn—that's their ideal."[12] Karl Becker's *Le Matin* from the Salon of 1875, on the other hand, is just the opposite. With its emphasis on the "charmante, brune soubrette," Becker's painting understandably provoked in one critic associations with dawn, love, and the Italian Campagna.[13]

Compared to the illustration, Monet's view is lush and romantic; compared to *Le Matin*, it is unevocative and aloof. Thus, being both fanciful and frank, inviting and removed, the picture embodies the contrasting qualities of modern life. And since it is about Parisians in the country, it can be seen as the suburban version of Manet's *Balcony*, of four years earlier. Where Manet looked to Spain and Goya's *Majas*, Monet appropriately turned to the north and the *petits maîtres* like Nicolas Maes (fig. 108).

Comparison of Monet's picture with the "lowly" art of the democratic north makes the nature of Monet's subject matter clear. Camille is not a working girl, the house is not a woodsman's cottage, and the garden is not a wild undergrowth, or even the kitchen-garden found in most middle-class houses. The picture is about urban values in the country, not about rustic simplicity.

This theme is essential to Monet, since modern life in landscape ultimately means modern urban life transposed to the suburbs, as Zola made clear in 1868.[14] And most of Monet's pictures emphasize this. In fact, Théodore Duret, in *Les Peintres Impressionnistes* of 1878, would even go so far as to assert, "Monet is not at all attracted by rustic scenes. You scarcely ever see cultivated fields in his canvases. You won't find any sheep there, still less any peasants. The artist feels drawn to embellished nature and urban scenes."[15] This,

133

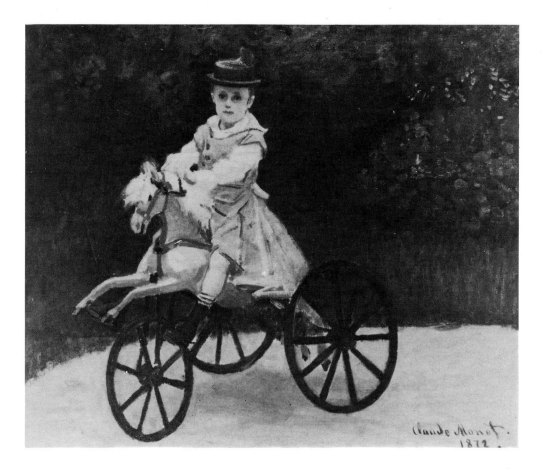

of course, was not entirely true, for in the 1860s Monet painted *Woodgatherers in the Forest of Fontainebleau* and *Farmyard in Normandy* (fig. 21), complete with cows and ducks; and in the 1870s he painted the vineyards around Argenteuil and an occasional view of a path through the woods. But these subjects began to appear less frequently from 1865 onward, and during the 1870s they took a decided second position to views of boats, bridges, and meadows. Even when he did paint the fields in Argenteuil, he never included any laborers although there were hundreds of them there. The reason for this is simple: cultivated fields, sheep, and peasants were remnants of the past; Monet was concerned with the present. While wanting to make nature "likeable and charming," as George Rivière noted in 1877, he wanted to paint the nature that man made modern.[16] And one of the most striking examples of that was the modern suburban garden, the new *hortus conclusus*.

Monet's views of his own garden, therefore, such as *The Bench*, 1873 (fig. 109), not only show middle-class Parisians as opposed to rural folk, but also reveal the sites to be miniature chateaux or urban parks. Unlike *Camille at the Window*, *The Bench* has no domestic charm and no encircling vegetation. The garden is so large and proper, the earthen path so wide, and the people so aloof that the scene could be mistaken for one set in the corner of the Jardin du Luxembourg. Even the bench is the type found in a public place. The woman with the engaging look in the foreground is Monet's wife; the identity of the man behind her and the woman beyond remain a mystery but, friends, relatives, or neighbors, their attitudes and positions, consciously planned by Monet, contribute to the urban ambiance of the picture.

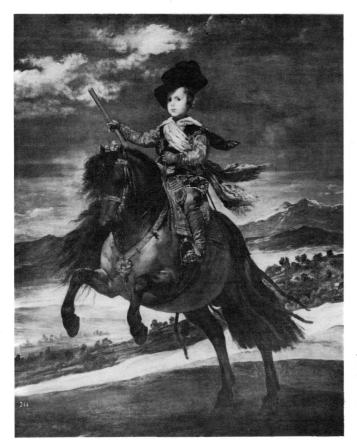

104. (far left) Claude Monet, *Jean on his Mechanical Horse*, 1872. 59.5 ×73.5. Nathan Cummings Collection, New York.

105. Diego Velázquez, *The Infante Don Baltasar Carlos on Horseback*, 1635–36. The Prado, Madrid.

Even when Monet paints both Camille and Jean in the garden, as in *Monet's Family in the Garden*, 1873 (fig. XXV), he evokes city associations. These are not "country" natives. Besides their refined attire, everyone has an urban reserve, especially Camille. She does not turn to stare at us as in *The Bench*, but her frontal position and her isolation in the foreground make her gaze even more engaging. And since she blocks the path—our entrance to the scene—she has an assertive quality as well. This assertiveness is enhanced by her physical and familial distance from Jean and the maid. She is the lady of leisure who does not have to bother with domestic chores. She sits, the maid stands; she holds her parasol, the maid, Jean's hoop. And from the stares of Jean and the maid, it is clear, as in *The Bench*, that we have suddenly interrupted their activity; we are made to feel the foreigner, the intruder. This is different indeed from the typical family scene in the suburbs as depicted by Gustave Doré (fig. 110). It is much more like a small-scale version of Bazille's monumental *The Artist's Family on the Terrace of their Summer House outside Montpellier* (fig. 111), which portrays Bazille and his *haute bourgeois* relatives with similar directness and veracity.

The Bench and *Monet's Family in the Garden*, however, are not simply about urbanites in the country; they are also about the emptiness and boredom that city-dwellers frequently experience once they leave the city. No action is taking place in either picture. In the family portrait, one might imagine Jean beginning to play with his hoop, but Camille will do nothing; in *The Bench*, Camille and the mysterious man might continue their conversation, but only to fill the time or break the silence that hangs over the scene.

106. *The Family at Asnières.* (From *Le Journal Amusant*, CCCXCVI, 1 August 1863, 4.)

Even when Monet presents his family in a more informal encounter, as in *Monet's House and Garden at Argenteuil*, 1873 (fig. 112), it appears that something is missing. The scene is filled with radiance, warmth, and charm; the house seems substantial, and the garden resplendent. Yet the broad empty path in the center, the lack of connection between Monet and his family (Jean has his back to us and Camille is barely visible in the doorway), and the lack of action all imply that Monet wanted not only to eliminate the usual anecdotes, but also to show that Argenteuil and the suburbs had their empty moments.

Peace and tranquillity were, of course, the desired qualities of life in the "country," but they could only go so far to make that life fulfilling. One needed activities, like Doré's family gardening (fig. 110) or like the thousands of projects that Flaubert thought up for Bouvard and Pécuchet. With unmitigated energy and enthusiasm, Flaubert's Parisian-clerks-turned-country-gentlemen attacked everything from philosophical treatises to farming; yet they eventually became bored in their country retreat. "They yawned in front of each other, consulted the calendar, looked at the clock, waited for meals; and the horizon was always the same, fields facing them, the church on the right, a screen of poplars on the left, tops swaying in the mist, perpetually, mournfully."[17] They did not have wives and families, of course, but we need only recall *Madame Bovary* to realize that those were by no means saving graces.

The relief for many had long been the trip to the seaside, but, as Eugène Chapus had to admit in 1874, "A stay at the seaside has become something so banal that we will not at all be surprised if soon the elegant people suddenly resolve to come here no longer except by formal order of the doctor." He predicted that, instead of wasting their time around the "boring and bored," those who were "blessed by fortune" would make a bigger effort and go further away.[18]

136

 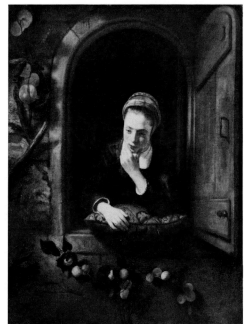

107. Karl Becker, *Le Matin*. (Engraved in *L'Illustration*, LXV, 27 March 1875, 207.)

108. Nicholas Maes, *Young Girl leaning on a Window Sill*, 1653. Rijksmuseum, Amsterdam.

For those less fortunate, the suburbs and the Seine had to suffice. Bouvard and Pécuchet had thoroughly enjoyed their Sunday walks through Meudon, Belleville, Surèsnes, and Auteuil before they moved to the real country. "They roamed about all day in the vineyards, picked poppies from the edge of the fields, slept on the grass, drank milk, ate beneathe the acacias of little inns and came back to Paris very late, dusty, exhausted, delighted."[19] Indeed, these excursions were so invigorating that they made the following day intolerably dull; with the wisdom of Solomon, therefore, Bouvard and Pécuchet gave them up.

While many with more discriminating tastes found the suburbs "un peu trop arrangé" (Barbizon was their ideal),[20] thousands like Flaubert's clerks, and like Monet, flocked to the suburbs hoping that a house and garden would remove the feelings of isolation and estrangement that apartments and Paris living provoked. Just the smaller size of suburban towns would make it easier to get around and contribute to the sense of belonging to the place, while the fields and open space, the light and fresh air, would rejuvenate the spirit. The suburbs, despite their drawbacks, still offered the possibilities of a complete, full life, the ideal integration of people and their environment.

Monet's garden pictures give ample evidence that this ideal was indeed attainable. In addition to their lushness and beauty, they show how closely aligned the figures are with their surroundings. Whether they have adapted to it or altered it to fit their style, the prim and proper family members in figures XXV and 109 are just like the well-groomed garden, while Camille in *Monet's House and Garden in Argenteuil* (fig. 112) is clearly an integral part of her house.

Many people felt the need for this kind of union with their worlds whether in the city or in the country, a need that was only natural for a time of such rapid change. Attuned to their era, realist writers such as Edmund Duranty even espoused the idea of integration

as a formal concern. In his *La Nouvelle Peinture* of 1876, Duranty asserted, "We will no longer separate the figure from the background of the apartment or the street; in life he never appears to us on neutral, empty, or vague backdrops; around him are the furniture, fireplace, hangings, or walls, a setting that expresses his wealth, his class, his profession."[21] Monet has substituted his suburban garden for the apartment or city street, and although it does not specifically indicate his profession as landscape painter, its trappings certainly express his wealth and class.

Because the integration of figures and environment had been one of Monet's interests throughout his career, parallels with realist literature could be found in his work prior to the 1870s—*The Luncheon (Etretat)* of 1868, for example, or *Women in the Garden* of 1866–67. But with the Argenteuil years these parallels become more common and more explicit. This is not surprising since it was the first time Monet had settled down; in painting the place he considered his own, he would naturally include all of the evidence of his new life.

As autobiographical works, then, these garden pictures strongly suggest that Monet may have been experiencing some domestic difficulties, for their emptiness and hints of boredom together with the engaging but indifferent gazes of Camille and Jean could be

109. Claude Monet, *The Bench*, 1873. 60 × 80. Collection Walter Annenberg, Palm Springs, California.

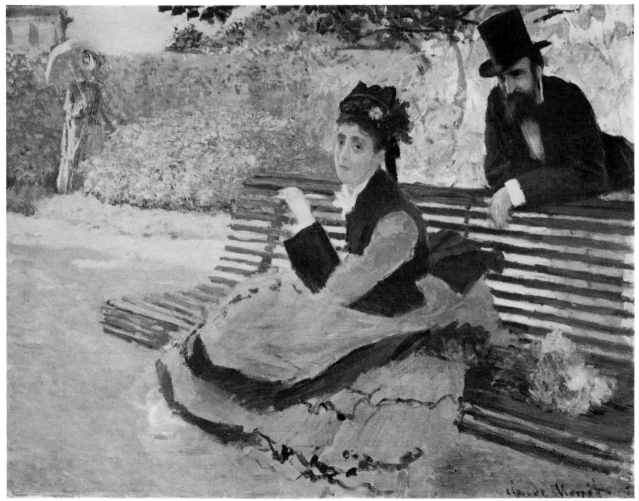

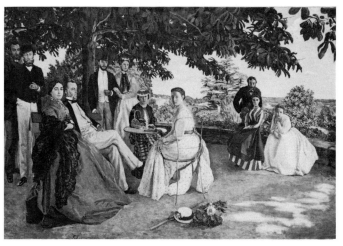

110. Gustave Doré, *The Family at Auteuil*. (From Emile Labédollière, *Le Nouveau Paris*, Paris, 1860, 248.)

111. Frédéric Bazille, *The Artist's Family on the Terrace of their Summer House outside Montpellier*, 1867. Musée du Louvre, Paris.

interpreted as signs of familial estrangement. A popular theme with realist writers, this alienation, evident in part in *Jean on his Mechanical Horse* (fig. 104), is more clearly expressed in *Monet's Family in the Garden* (fig. XXV) and *The Bench* (fig. 109).

Camille and Claude's relationship had always been a source of trouble to their families, especially during the four years they lived together before they were married (from 1866 to 1870). Their parents did not approve of the arrangement and were not at all pleased to become unauthorized grandparents. Indeed, Claude's father flatly refused to support them, causing the new family considerable personal and financial difficulties. Monet's marriage in 1870 could, therefore, have been one of compromise as much as one of love. While he painted Camille frequently during the Argenteuil years, the results always seem to imply a divided attachment. In his letters, he referred to her only when she fell ill in 1876, and when she died in 1879 his recollections of his reactions show that he did not experience the profound sense of loss that most loving husbands would have felt. "Finding myself at the deathbed of a woman who had been and was still very dear to me, I caught myself with my eyes focused on her tragic temples in the act of automatically searching for the succession, the arrangements of colored gradations that death was imposing on her motionless features."[22] Indeed, Monet had not been a completely committed husband. Several years before her death, he had established a relationship with Alice Hoschedé, which lead to a *ménage à trois* when Alice and her children moved to Vétheuil to join Monet and his family in 1878.

This element of estrangement paradoxically receives one of its stronger expressions in a picture that also takes the theme of figures submerged in the environment to an extreme, *Camille and Jean* (fig. 113). Painted in the same garden of Monet's first house, it shows Camille standing in a veritable sea of green, her lower half hidden by the undergrowth, her upper half encircled by a mandala of leaves. Jean is less merged with the foliage, but he has lost all of the stiffness of figures XXV and 112. Stretched out on his back in an extremely casual pose, gazing off into space in an other-worldly manner, he is more a part of this setting than he was of the others.

As a representation of Monet's material success, this view is less informative than the others. Instead of allowing us to admire his horticultural handiwork, Monet crops the

scene so radically that we can hardly recognize the site as the corner of the garden. There is just the slightest indication of a house in the background, clearly not enough to impress us. And while Camille and Jean are not country natives, they also are not "proper" bourgeois Parisians; their informality, indeed their lack of decorum, is striking. It is echoed and enhanced by the equally informal ordering of the whole picture. Besides the radical cropping, none of the elements—the potted plant in the background, the folding chair to the right, or Jean himself—has any explicit formal relation to any other or to the central figure of Camille. And there is no apparent logic to the distribution of light and shade (the strip of strong sunshine on the right seems neither to balance the mass of shadow on the left nor to aid in the unification of the picture). Even the broad, patchy application of paint adds to Camille's and Jean's sense of hedonistic abandonment.

On another level, however, the picture tells us a great deal. The radical cropping and lack of internal harmony make the scene appear to be a true slice of life; the warmth and lushness of the setting convey the beauty of the suburbs; and the reverie of the figures confirms the happiness that you can find in your own backyard.

112. Claude Monet, *Monet's House and Garden at Argenteuil*, 1873. 60.5 × 74. Art Institute of Chicago.

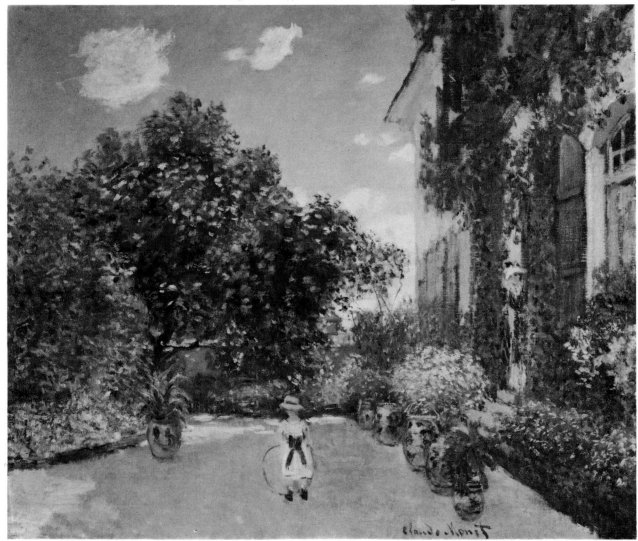

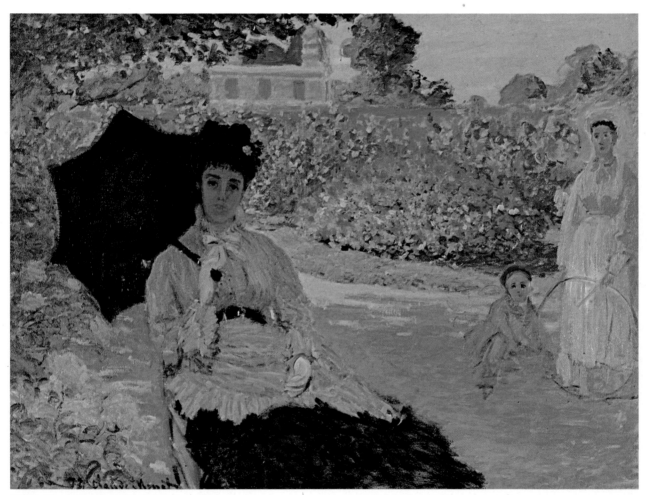

XXV. Claude Monet, *Monet's Family in the Garden*, 1873. 59 × 79.5. Hortense Anda-Bührle Collection, Zurich.

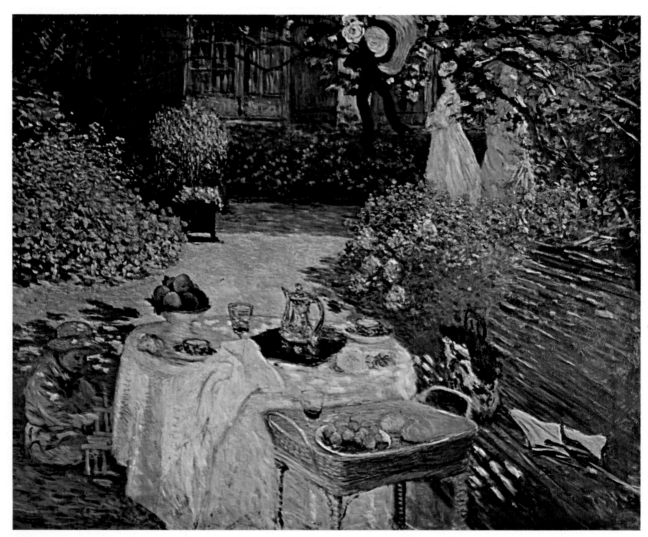

XXVI. Claude Monet, *The Luncheon (Argenteuil)*, 1873. 162 × 203. Musée du Louvre, Paris.

The seductiveness of the garden corner, evident even in Camille's suggestive, Venus-like pose, does not disguise the peculiarities of the scene. What is the relationship between this modern Flora and us the viewers, or on another level between Camille and Claude, or between Camille, Claude, and Jean? It is difficult to determine, in contrast, for example, to a view of a mother and child by Tissot (fig. 114) where the empathy, provoked perhaps by bereavement, is painfully obvious. Tissot's family is undeniably modern, the mother being even less Grecian and more aloof than Camille. But there is no question as to their attachments, where in *Camille and Jean* everyone's relationship is uncertain. While promoting the myth of happiness in the suburbs, these pictures show that even the "country" garden, the controlled, private, ideal little world, was not always what it was purported to be; it was the realm for domestic exchange and therefore by no means immune to the strains of modern domestic life.

Nor, of course, was it removed from Argenteuil. While sitting among the roses, Monet could hear the rumble of trains passing in front of his house; he could see the other houses in the neighborhood; he could even watch new houses being built, like the one in the background of *Monet's Family in the Garden*, which is only partially completed since it lacks a full second story and a roof. His garden was not P. J. Linder's world apart, although he frequently would make it appear to be such, as in *A Corner of the Garden with Dahlias* (fig. XXIII), also from 1873. The manicured path and bushes of *Monet's Family in the Garden* here have become a windswept mass of flowers and greenery. While held together by an underlying compositional order, it seems almost as unstructured as *Camille and Jean*. Like *Camille and Jean*, the figures are submerged in the setting, but instead of standing out they are nearly overwhelmed by the wave of flowers to the left and dwarfed by the bending tree to the right and the house beyond. Clearly, the setting has the upper hand; it also has a vitality that Monet had generally exhibited only in views of the surrounding countryside, such as in *Orchard in Springtime*, 1873 (fig. 115), implying that the garden could be an equally invigorating place.

When Monet's picture is compared with one by Renoir showing Monet working in his garden (fig. 116), Monet's artifice becomes evident. Painted in the same year in the same garden, looking in the same direction, Renoir's view reveals that what lay beyond Monet's garden is not what figure XXIII suggests. The house on the left-hand side of Renoir's picture is the same one that appears in the center of Monet's view, but the jumble of other houses that Renoir faithfully includes on the right are nowhere to be found in Monet's version. Monet judiciously cropped them out of his scene and enlarged the trees and undergrowth on the right. Whether the flowers he includes on the left were borrowed from his neighbor's via artistic license is unknown, but Monet has clearly diminished the evidence of encroaching suburbia and made his *argentea* more appealing.

Although his garden might have inspired thoughts of windswept meadows, the houses that surrounded Monet would have been a constant and, from Renoir's rendering, a pressing reminder that what he was really dealing with was a standard suburban plot that was susceptible not only to the noise of the *quartier* but also to the surveillance of the neighbors. While Renoir makes Monet appear perfectly content to live and paint in this environment, it seems evident from the way Monet has manipulated the site that this is not entirely true. The energy of his view seems to derive from the conflict between myth and reality, between what Monet wanted the site to be and what it was.

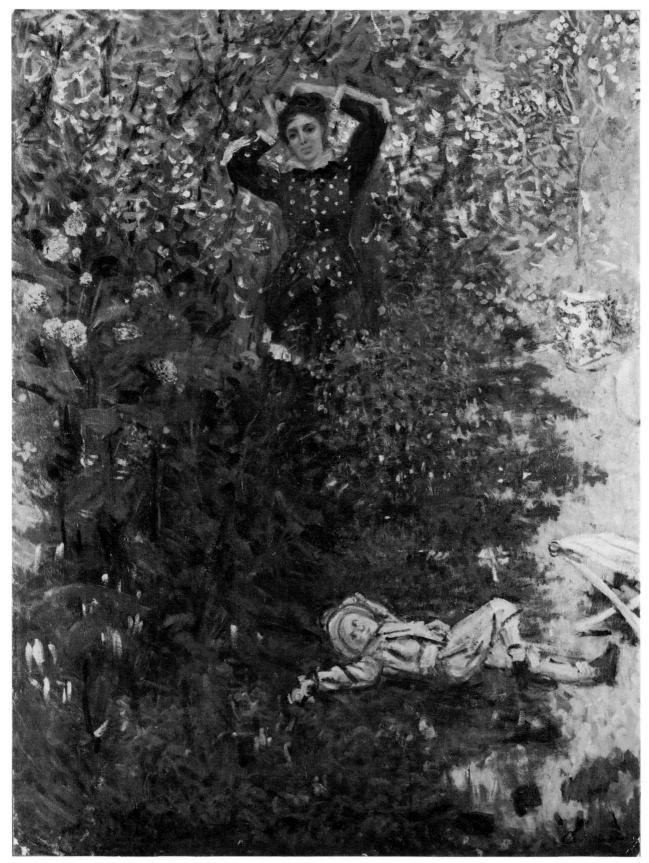

113. Claude Monet, *Camille and Jean*, 1873. 131×97. Private Collection, United States.

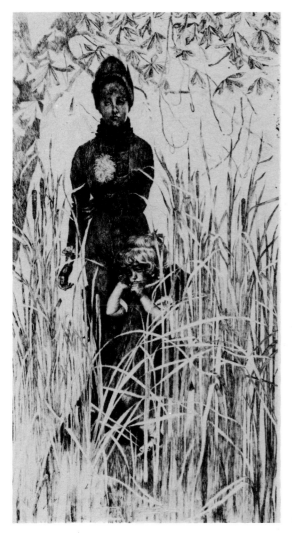

114. James Tissot, *Mother and Child, c.* 1880. Cabinet des estampes, Bibliothèque Nationale, Paris.

If Monet turns his back on the town, however, and looks toward his own house, as he does in his largest and most important garden picture of his Argenteuil years, *The Luncheon* (*Argenteuil*) of 1873 (fig. XXVI), he shows that the conflict can be forgotten and that his house and garden can provide all the makings of the myth. The fullness of the scene, the tranquillity, warmth, and freshness, the substantial house, the well-dressed and well-fed people, make this picture an ode to the good life in the country. Nothing is wanting. In fact, everything is so tangible that we can become completely absorbed in the setting. The bench on the right juts out so radically that we are almost obliged to sit down. The cart with fruits and bread is so close that we could sample one of the peaches. The house, although in the background, covers the length of the canvas, closing off the scene and pushing everything forward. Set against its dark facade are two women; unlike the two figures in *A Corner of the Garden with Dahlias* (fig. XXIII), these two women emerge from their surroundings—their light-colored dresses contrast with the foliage and the house, their movement to the left leads them down the path to the middleground, and the parasol, purse, and bonnet in the immediate foreground pull them to the table. But they are pinned in their position as is everything else in the scene. Remove the parasol on the

right and the bench shoots out of the picture; remove the teapot from the table and there is a hole in the center; remove the fruit and there is no transition between Jean, the table, and the bushes in the left background; remove the bonnet from the branch in the foreground and the women appear more in the distance. The order of the picture, like the tangibility of the objects, contributes to the harmony of the whole and the sense of bourgeois contentment.

Yet something is missing; it is difficult to determine what, but there is an unsettling sense of emptiness or incompleteness that the beauty and veracity of the scene cannot disguise. It derives in part from the lack of connection between the figures. Jean is totally absorbed in his toys, the women in the background in their promenade. None of them acknowledges another, even the two women are not closely joined. Likewise none of the figures acknowledges us, which counters the welcoming immediacy of the setting.

The incompleteness also derives from the uncertainty surrounding the story being told. A modest meal has been consumed, but by whom? Do the two wine glasses and two coffee cups indicate two, three, or four people? If more than two, where are the rest? If the piece of bread, the coffee cup, and the napkin on the left side of the table should be read as a former place setting, what has happened to the chair? If both of the women have their bonnets on, whose is that in the tree? And what is it doing there?

The fact that the meal is finished is extremely important. In terms of the story, of course, that is why Jean and the women are not sitting at the table as in Monet's *Luncheon (Etretat)* of 1868 (fig. 117). That is also why the table is not correct and orderly. In terms of significance, that is why there is the sense of emptiness and finality; the pretext for the painting passed when the meal ended. What Monet shows is the remnants of the event, and although they are enticing they constitute the aftermath.

To see just how final the scene actually is, we must juxtapose it with an outdoor banquet view by Jan Steen (fig. 118). Monet's picture is almost funereal in comparison. Even if we come closer to Monet's time and substitute for the Steen a luncheon scene by Louise Abbema (fig. 119) from the Salon of 1877, Monet's scene is still empty and inactive. And yet it is as lavish as Abbema's interior and perhaps more enticing. This combination of opposites is analogous to other genre scenes by Steen or to still lifes by Kalf or de Heem where worldly elements of great desire are presented with some reminder of their temporality. Monet's picture shows us all the prized elements of the bourgeoisie. While he indicates that they can produce a decided measure of happiness, he also makes it clear by the scene's finality that that happiness and fulfillment are as temporal as the meal, that if one moves out of one's little garden and confronts the modern world, indeed, if Monet simply looks behind him in this picture, the idea of the harmonious life in the "country" can be shown to be only partially attainable. Like the pictures by Steen and Kalf, therefore, *The Luncheon (Argenteuil)* is a *memento mori*, not to man and his life on earth but to modern man and his existence in the suburbs.

It is perhaps not surprising then that in 1874, after moving to his new house on the boulevard Saint-Denis, Monet painted its garden only once. Because it may not have been finished by the time he took occupancy (he signed the papers in June but did not move in until October), its impact may have been reduced. However, the following year, after works like *Snow at Argenteuil I* (fig. 22) and *The Bridge as a Single Pier* (fig. 57), Monet turned to his garden with renewed interest.

146

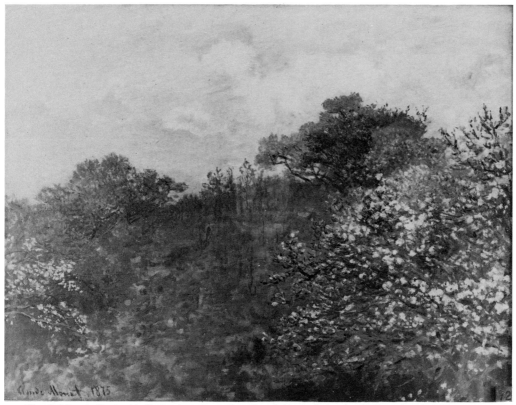

115. Claude Monet, *Orchard in Springtime*, 1873. 58 × 78.5. Johannesburg Art Gallery, South Africa.

116. Auguste Renoir, *Monet working in his Garden at Argenteuil*, 1873. Wadsworth Atheneum, Hartford, Connecticut.

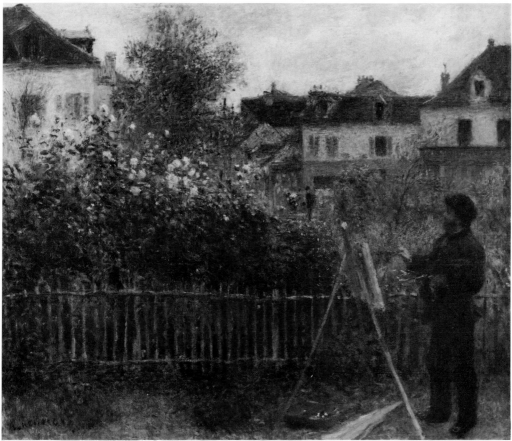

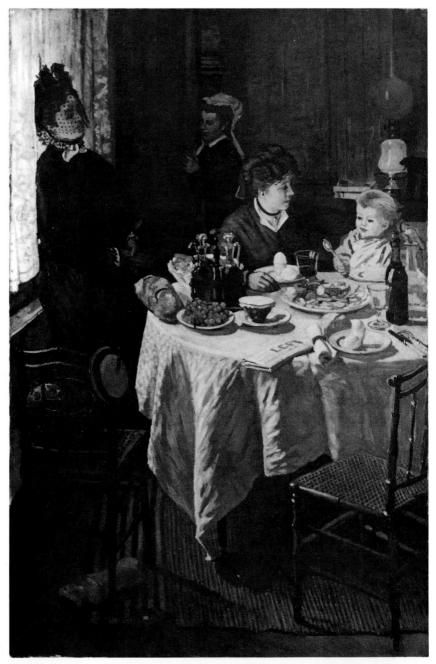

117. (right) Claude Monet, *The Luncheon (Etretat)*, 1868. 230 × 150. Städelsches Kunstinstitut, Frankfurt-am-Main.

118. (below) Jan Steen, *An Outdoor Banquet*, 1660. National Gallery of Art, Washington, D.C.

119. (below right) Louise Abbema, *Luncheon in the Conservatory*, 1877. Musée des Beaux-Arts, Pau.

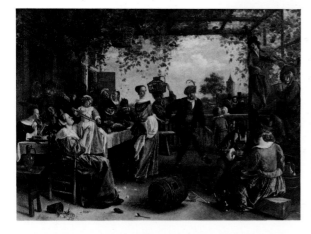

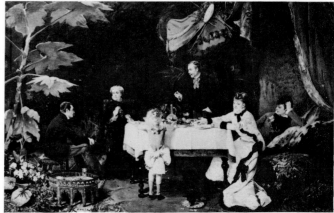

Unlike the views from 1873, those from 1875, such as *In the Garden* (fig. XXVIII), have no evidence of strain, no sense of impersonality, no hint of the complexities of Argenteuil and modern life. Jean, Camille, and the maid are submerged in a lush, tranquil setting, as the three figures had been in *Three Figures under the Lilacs* (fig. 99). This is the stuff of dreams—no encroaching neighbors, no change other than the flickering of light and the swaying of flowers. The same can be said of *Camille with a Parasol in the Garden*, 1875 (fig. 120), where the garden becomes the floating world of a Japanese Ukiyo-e garden complete with Camille in full kimono, or *Camille and a Child in the Garden*, 1875 (fig. 121), where it becomes a *mille fleurs* tapestry, a backdrop for a charming domestic scene.

All of these are undeniably modern. *Camille and a Child in the Garden*, for example, is an updated version of Millet's numerous views of women knitting (fig. 122). Instead of being indoors we are outside, and rather than a peasant we have a well-cared-for bourgeois woman. This painting is also the suburban equivalent of Manet's *Gare Saint-Lazare* of 1873 (fig. 123). It is flowers and fresh air versus iron bars and railroad steam, self-containment and sentimentality as opposed to worldliness and dispassionate inquisitiveness.

When Monet leaves his garden to paint the boats on the Seine that summer, as in the *Red Boats* (figs. 93, XX) or the meadows across the river as in *The Summer Field* (fig. XXVII), he renders the sites with an unprecedented intensity, as if to confirm their powers to revive the spirit. Although *The Summer Field* is less windblown and free-flowing than *Orchard in Springtime* (fig. 115), it has the same brilliant light and radiant palette as the two views of the boat rental area, conveying "the whole blinding effects of the midday sun shining on a summer's day" (noted in 1885 about another version of the picture).[23]

It is perhaps surprising, however, knowing Monet's concern for diversity, to learn that during this summer he painted no fewer than four versions of this picture. Since none of them was sold right away, popular demand was not a motivation; and since they do not differ significantly in their weather conditions or time of day, Monet was not trying to capture a series of changing effects. In fact, just the opposite seems true, for these pictures appear to represent not only summer personified, but also summer preserved—the invigorating splendor of waving fields, freshly cut hay, blue skies, and fleecy clouds captured forever. To emphasize the site's appeal, Monet makes the expanse of pure countryside seem limitless; nothing breaks the horizon except tall trees. Unlike *The Promenade with the Railroad Bridge* of 1874 (fig. XIV), there are no reminders here of the march of progress. On the contrary, the haystacks in the background are reassuring evidence of agrarian continuity.

Yet to create this idyll Monet has been extremely discriminating, for he is actually standing only a short distance away from where he stood to paint *The Promenade with the Railroad Bridge*. The poplars to the left in the four views line the left bank of the Seine just up from his site of the previous year. Monet simply has moved further inland and turned to the east. In doing so he has turned his back on the railroad bridge, the town, and the town's industries. The results are pictures that are modern in every respect—we need only think of Millet's views of the plains around Barbizon—but they are pictures which present only the poetry of the suburbs, avoiding the more prosaic contrasts.

Ironically, these sun-drenched fields were the focus of considerable debate between government officials in Paris and residents of the suburbs. And it is perhaps because of

120. Claude Monet, *Camille with a Parasol in the Garden*, 1875. 75 × 100. Private Collection, United States.

121. Claude Monet, *Camille and a Child in the Garden*, 1875. 55 × 66. Museum of Fine Arts, Boston.

this that Monet painted the four pictures. The debate concerned Haussmann's sewer system and the disposal of the capital's waste. In the 1850s Haussmann had built an elaborate disposal network in the capital, replacing the antiquated medieval system with two hundred miles of new pipe. All of the pipes fed into two main collectors which carried the waste several kilometers outside the city to Asnières and Saint-Denis. These collectors were not processing plants, however; the untreated waste was simply dumped into the Seine. Government studies conducted in 1874 estimated that over 450,000 kilograms of waste was flushed into the river every day, five-sixths of it at Asnières and one-sixth at Saint-Denis. The Seine at both of these points was, according to these reports, "a caldron of bacteria, infection and disease."[24] The stench was frequently unbearable and the banks of the river were often littered with solid waste. In 1874 Haussmann's solution was under considerable attack by the people who lived along the river from Asnières to Saint-Germain. Some pressure had been brought to bear in the 1860s, and the government, in response, had tried using the waste as fertilizer. With the consent of the town of Gennevilliers, they first rented and then bought five acres of land near the Seine, laced it with irrigating pipes and pumped some 10,000 kilograms of material into the soil.[25] Public reaction to the system was mixed, but those who tended the fields found that their crops grew well. In 1870 the acreage was increased to twenty-one. The war halted further experimentation, but in 1872 Thiers's new government granted a private enterprise permission to flood four hundred acres of the présqu'île Gennevilliers. This brought so much protest that permission was retracted. During the same year, however, the irrigated acreage on the plains of Gennevilliers was increased to fifty. That number more than doubled over the next two years, so that by 1874 it stood at one hundred and fifteen. In December 1874 a government commission created by the minister of public works to study the problem submitted its report. It called for the construction of a massive irri-

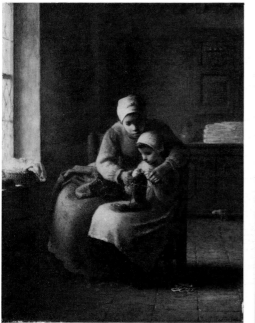

122. Jean-François Millet, *The Knitting Lesson*, 1858. Sterling and Francine Clark Art Institute, Williamstown, Massachusetts.

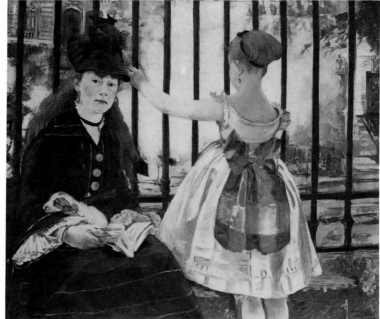

123. Edouard Manet, *Gare Saint-Lazare*, 1873. National Gallery of Art, Washington, D.C.

gating pipe that would run from the collector at Asnières to the forest of Saint-Germain. Beginning with Gennevilliers, towns along the way could tap the pipe and irrigate a predetermined amount of open land. In July 1875 the prefect of the Seine proposed a similar solution but suggested secondary conduits to irrigate more acreage. According to both plans, the amount of irrigated land in Gennevilliers would jump from one hundred and fifteen acres to an astonishing twelve hundred.[26] As a map of the area with the flooded sections demarked by darker tones indicates (fig. 124), Gennevilliers was to be covered almost in its entirety. Whatever material could not be absorbed by the soil would be dumped into the Seine through two pipes, one across from Epinay and another across from Argenteuil.

Argenteuil, of course, was "one of the communities most interested in seeing this state of infection disappear," as the municipal council stated several months after the prefect's report. If the *vaseuses* water were to be dumped into the Seine opposite the town, the slow current of the river at that point would facilitate "the buildup of a thick sludge comprised of organic debris." More importantly, they protested with "the liveliest insistence . . . against . . . seeing near our town the entire plain of Gennevilliers transformed into a veritable fertilizer factory." The surrounding area would become "unhealthy and offensive" and thus something "strongly to be feared."[27]

Their protests were joined by others from almost every town through which the proposed pipe would run. One critic of the plan observed that on the plains of Gennevilliers

the roads and paths are bordered by a conduit open to the sky in which flows black and infectious filth. From these conduits the water seeps out into the fields, sometimes in torrents, sometimes unseen in furrows in the ground. The winding circuit of this stinking water emits something repulsive. During the real heat of the summer, from sun up to sun down, a fetid stench rises from these fields. Should our countryside, whose general appearance is so radiant, be a victim of this transformation, so little to its advantage?[28]

Although there were more conduits and filth on the plains during the time he was writing than there were during the previous summer when Monet was painting, the question he posed was one that crossed the minds of most Argenteuil residents in 1875 when the public works commission and the prefect both called for the flooding of Gennevilliers. Argenteuil was legitimately threatened with contamination and the plains of Gennevilliers with a mandate to become the cesspool of Paris. Monet's four views of the "riant campagne," therefore, are indeed representations of the suburban idyll.

Like all major government undertakings, however, the irrigation of Gennevilliers did not occur immediately. (By 1880 the number of acres had only risen to 422.) But the fact that such a proposal could be made and that such a change could be effected was undoubtedly further proof to Monet that this glorious "vie moderne" had its profoundly negative aspects. And while the residents of Argenteuil recognized that fact in this particular case, they were not as discriminating when it came to ruling on new industries and housing developments for their own town. By 1876, when the population had increased by more than twenty-five hundred people since 1850, when the number of industries had more than quadrupled, when the third iron works was opening across from

124. Map of Gennevilliers showing projected irrigation. (From Le Rapport de la Commission d'assainissement de la Seine, 1874. Argenteuil, Town Archives.)

Monet's house, when plans were already being made to expand the railroad plaza to accommodate the increased commuter and commercial traffic, and when proposals were being made to bring a second railroad through the town, it was clear that Argenteuil's country calm and natural beauty were being renounced as the town marched forward to the beat of progress.[29]

Monet's paintings from 1876 are not in step with this cadence. There are no views of the town's boulevards, bridges, boats, promenades, or waving fields. His efforts are concentrated on his garden, where, among his roses and dahlias, he tries to reinstate his idyllic *petite ville*. He does not simply turn his back on the town as he had in *The Summer Field* of the previous year, he literally walls it out. This had been one of his options since his arrival, and, as we have seen, he took it frequently. But now it became not an option but an apparent necessity.

In June 1876, in a letter to Georges de Bellio, one of his new patrons, Monet said that he had worked a great deal and had "a whole series of rather interesting new things."[30] He was most likely referring to some of the garden scenes that date from that spring, as garden views dominate his work of these months to the near exclusion of everything else. Monet had embarked on a new path, one that would eventually lead him from Argenteuil to the more rural town of Vétheuil. In fact, from his garden in Argenteuil to his garden at Giverny was only a matter of six and a half years.

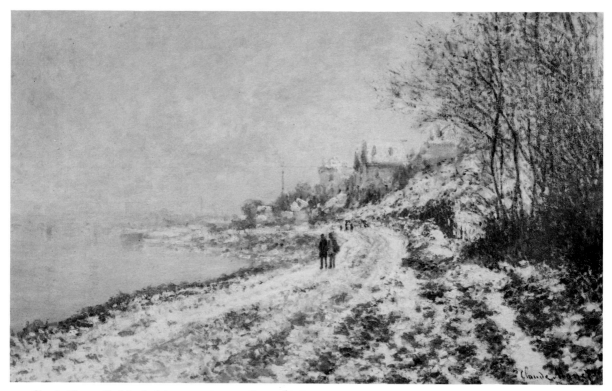

125. Claude Monet, *Path by the Seine*, 1875. 61 × 100. Private Collection, Boston.

126. Claude Monet, *Entrance to Vétheuil*, 1879. 60 × 81. Museum of Fine Arts, Boston.

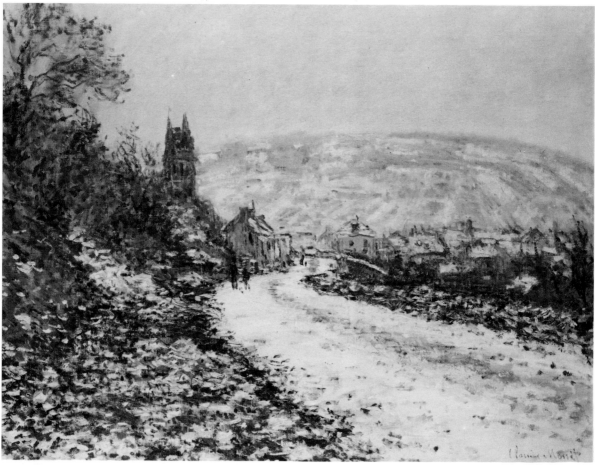

6. Argenteuil Abandoned

IN THE WINTER OF 1875–76 Monet stood on the road that ran along the right bank of the Seine from Argenteuil to Epinay and painted two views, one looking to the west, *Path by the Seine* (fig. 125), and the other to the east, *The Towpath at Argenteuil, Winter* (fig. XXIX). Nearly identical in size, composition, color scheme, and style, they could by every traditional criterion be considered pendants. And like such pairs they depict two sides of an ensemble or two related entities. The view to the west shows the road leading into town, the view to the east the road leading away from town. In the westward view, Monet has included all of Argenteuil's characteristic features: a well-trodden path, to let us know the town is "rural"; a row of houses, to let us know it is a suburb; factory chimneys and the railroad bridge, to let us know that it is industrialized. This clearly is not the ageless hamlet of *Argenteuil seen from across the Seine* (fig. 83).

In the view to the east, there are no houses, factories, or railroad. So untainted is it that until recently art historians had identified the site as Vétheuil.[1] Comparison with Monet's view of Vétheuil from 1879, *Entrance to Vétheuil* (fig. 126), shows that this mistake was reasonable. Although the earlier picture lacks evidence of a town, it has the same rural tranquility and, more importantly, the same sense of unaltered nature. The view toward Argenteuil, on the other hand, bears ample evidence of change, making it (within a limited range of comparison) the iconographic counterpart to the view toward Epinay. As a pair, therefore, these pictures represent not only the two contrasting themes of pastoral and modern Argenteuil, but also the contrasting directions that Monet's art could take. He could face the town, even if from a distance, and continue to paint it, or he could turn his back on it and look to a less complicated world. The options were clear.

During the following year Monet made his choice—a choice that is implied even in the view toward the town. Despite the presence of the railroad bridge and factory chimneys in the background, the picture is hardly a direct confrontation with the town's progressive side. Wrapped in a thick wintry mist, the bridge and chimneys are barely visible in the distance, and the traditional seventeenth-century composition which recalls Monet's view of *The Seine at Bougival*, 1869 (fig. 127), is neither innovative nor dynamic. Compared to a view of Argenteuil in 1877 by a relatively unknown artist, S. Burn

(fig. 128), it is apparent that Monet's is an idealized version of the scene. Burn includes with graphic clarity all of the elements that Monet suppresses—chimneys belching smoke, well-dressed women, barges, boaters, even a dredge; although the season has changed, there is no grove of trees to screen the view and no misty atmosphere to soften the harsh industrial notes that intrude.

Monet's picture, not surprisingly, is similar to Daubigny's timeless river scene (fig. 129), with its winding road, distant town, and uncomplicated landscape. The road in Monet's picture, as in Daubigny's, is an old towpath, where for decades mules and horses had pulled barges up and down the river. With the development of the steamboat, however, and the advance of the railroad, the Argenteuil path, although still associated with traditional barge activity, had become less of a route of commerce and more of a public promenade, as Burn makes evident. Monet, in contrast, without making any direct reference to the path's origins, emphasizes the rustic character of the site, indicating his desire to evoke the past rather than depict the present.

This is confirmed by Monet's two views of Argenteuil from the spring of 1876, the only views of the town that he painted the entire year. In *The Mall* (fig. 130), the town, framed by a vault of trees and foliage, is presented as a quaint, provincial village; its pace, as evidenced by the horse-drawn carriage on the left and the few people strolling through the scene, is slow and casual, and the arch of leaves and filtered sunlight emphasize its country character. The same can be said for Monet's second view, *Houses under the Trees* (fig. 132). Instead of a charming hamlet, however, this part of town appears to be an almost unpopulated country retreat. Monet shows only two houses which, despite their size, are dwarfed by the bulbous trees. He includes only a handful of people on the distant bank and no boats in the broad stretch of water in the middleground. He closes off the scene on either side with screens of foliage which give the whole a sense of privacy. He also captures the water in such a state of stillness that the reflections of all the elements on the far bank are completely undisturbed. This privacy and calm make the site seem like a private estate, with the equivalents of lake, personal hunting grounds, and chateau, as in Constable's view of Malvern Hall, Warwickshire (fig. 131).

Monet did not falsify the areas in either picture; he simply selected a vantage point so as to avoid showing anything that would give them their proper contextural significance. The body of water is of course the Seine, and the woods at the right is the Champs de Mars. The heavily traveled river has been caught at a rare moment. If he had included commercial or pleasure craft he would have upset the picture's sense of seclusion. Obviously the river extended far beyond the foliage, but by widening his view Monet would have been forced to include the unsightly *bateaux lavoirs* that were moored to the opposite bank just to the right of the picture's frame. Even less pleasant sights were on the left. Beyond the bush on the opposite side of the river were the saw mill and the building supply company of Monsieur Bouts, the tannery of Monsieur Dulon-Alboy, the brewery of Monsieur Coutelet, and the Commartin iron works that had just opened in 1874. Although only two years old, the iron works employed over 170 people, making it one of the largest factories of its kind in the suburbs of Paris. Not only was there industry to the left of Monet's view, there were also the *cités* of new houses referred to above. This was the neighborhood that was growing without bounds so fast that one resident, who was

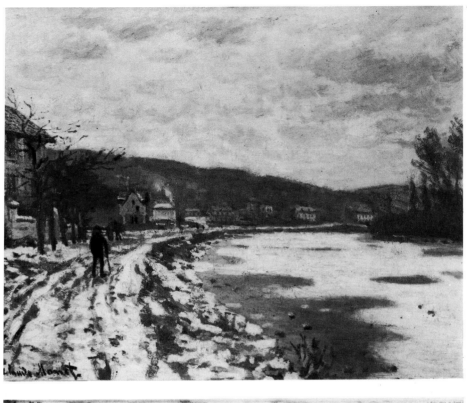

127. Claude Monet, *The Seine at Bougival*, 1869. 51×65. Formerly Peto Collection, London.

128. S. Burn, *La Seine à Argenteuil*, 1877. Musée du Vieil Argenteuil.

129. Charles Daubigny, *Path along the River*. Hazlitt Gallery Archives, London.

concerned about communications between Argenteuil and its western neighbors, expressed the fear that in a short time the town would not be able to find room for a straight road from the towpath to Sartrouville.[2] The two buildings in Monet's picture, though appearing as a secluded country estate, were actually a product of this boom and had only recently been built.

In *The Mall*, Monet is standing just to the right of the Route Nationale 48. Behind him to the left is the highway bridge that led to Paris, and in front, the rue du Port that led to the heart of town. The street that crosses the view horizontally is the boulevard Héloïse. Out of the picture to Monet's left is the popular riverside restaurant that was packed every summer weekend with Parisian boaters and promenaders; behind him to the right is the port of Argenteuil. Monet's vantage point obviously excludes the latter two elements, but it also severely limits those in front of him. By setting up his easel so close to the end of the mall, he has not been able to include much of the Route Nationale, the boulevard Héloïse, or the town; reduced in size and screened by trees, they appear unsubstantial and insignificant.

More important is the simple fact that Monet is standing in the *allée* of the mall and not on the Route Nationale itself. When compared to his earlier *Boulevard Héloïse* (fig. VI), it is obvious that he has moved out of the mainstream of the town, off the broad urbanized street and into the enclosed, countrified mall. He has thus minimized the fact that the Route Nationale was one of Argenteuil's most important ties to the suburbs and to Paris, being the only road that crossed the Seine. And he has given little indication that the rue du Port was one of the more heavily trafficked streets in town, and the only one that led directly to the bridge. It had recently been straightened, but here it merely slips out from in between unordered buildings. Indeed, nothing in the scene appears new or modern. Even the trees are old. Just that spring new saplings had been planted to Monet's left and right, but clearly he did not want to include even such small evidence of change.[4]

The Mall and *Houses under the Trees* seem appropriately paired, for together they present a composite of the traditional medieval community—the lowly village in one, and the lordly manor in the other. For Monet, as for most of his Parisian bourgeois contemporaries, an estate such as the one in *Houses under the Trees* would have been unattainable, although everyone romantically imagined his cardboard chateau and postage-stamp garden to be his ideal. That perhaps is why Monet painted a fictitious estate instead of moving further downstream and painting the one noble compound that still existed in Argenteuil, the Château du Marais,[5] an estate that covered several thousand square meters and was formerly owned by Mirabeau.

During all of the first half of that year, Monet painted only scenes that were similarly restricted, among them *Camille in the Grass* (fig. 133) or *Two Figures in the Garden* (fig. 134). There are ten such garden pictures from these months, more than Monet had done at any other period. They are filled with the beauties of summer sunlight, but nine of them are also limited to the confines of Monet's backyard. The painter of the modern countryside was retreating into a more reassuring world.

This move affected Monet's style as well as his subject matter; most of these garden pictures are not up to his usual level of compositional innovation or painterly strength. His view of *The Garden from the House* of 1875 (fig. 135), for example, with its elevated

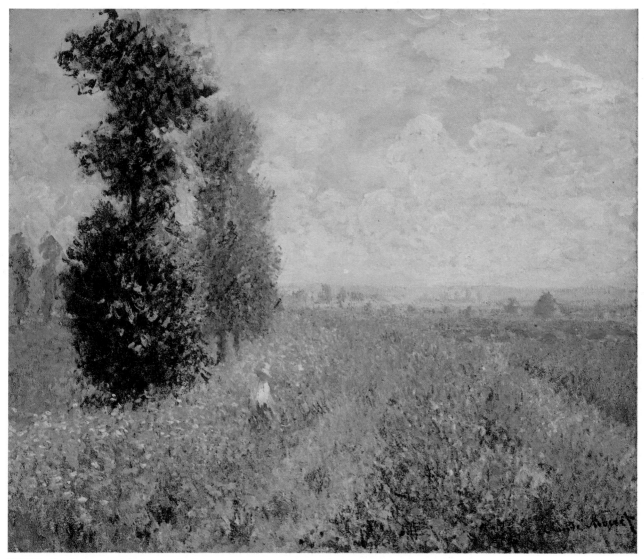

XXVII. Claude Monet, *The Summer Field*, 1875. 54.5 ×65.5. Museum of Fine Arts, Boston.

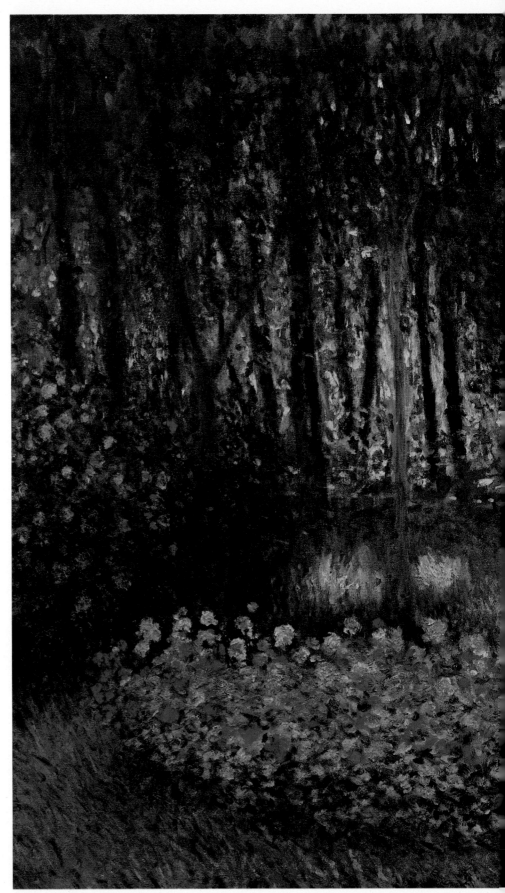

XXVIII. Claude Monet, *In the Garden*, 1875. 61 × 80. Private Collection, United States.

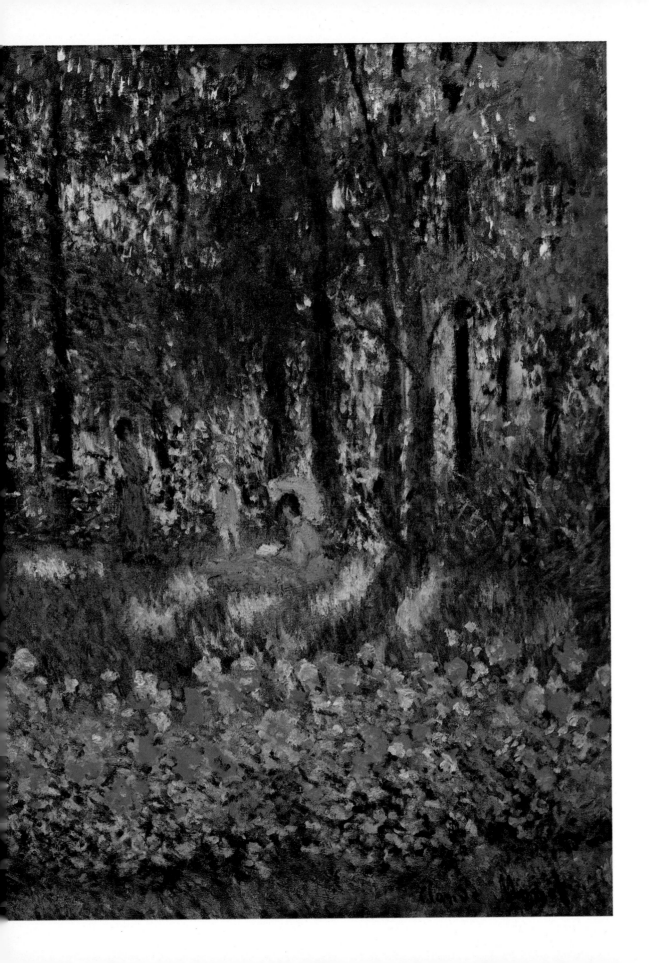

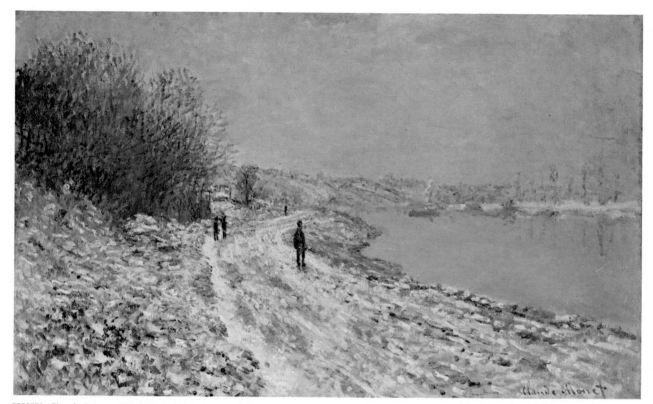

XXIX. Claude Monet, *The Tow Path at Argenteuil, Winter*, 1875. 60 × 105. Albright-Knox Art Gallery, Buffalo, New York.

viewpoint and tentatively balanced elements, or *In the Garden* (fig. XXVIII), with its foreground sweep of flowers and dramatic backlighting, are more original and daring than *The Garden* of 1876 (fig. 136). *Camille and Jean on a Hill* of 1875 (fig. 137) is more dramatically composed than *Camille with a Green Parasol* of 1876 (fig. 138), and more confidently painted. The same comparison can be made between *Camille and Jean* from 1873 (fig. 113) and *Camille in the Grass* or *Two Figures in the Garden*.

Monet must have felt the need for fresh subject matter because in 1876, for the first time in three years, he left Argenteuil and returned to Paris to work. In February, through the intercession of Cézanne, Monet had met and dined with the collector Victor Chocquet.[6] Several months later, perhaps in April when the second Impressionist exhibition was taking place at Durand-Ruel's, Monet visited Chocquet in his apartment on the rue de Rivoli. It was from the balcony of this apartment that he painted four views of the Tuileries, the first pictures of the capital that he had attempted since his two views of the boulevard des Capucines in 1873 (fig. 139).

It is significant that he chose the gardens and not the boulevards. In 1875 Monet was still painting public sites and pleasure-seekers. But in 1876 such subjects were no longer a part of his repertoire. In Paris, as in Argenteuil, he was limiting his range of subjects—and by implication, his involvement with modern life—to the garden. And once again he very consciously defined the perimeters of his world. Just to the left, outside the frame of *The Tuileries* (fig. 140), for example, was the Tuileries palace, still in ruins after the Commune (fig. 141). Monet avoids the ruins and the politics, immersing himself instead in the natural beauties of the site.

In addition to Le Nôtre's eighteenth-century creation, Monet turned to paint the Parc Monceau, the only English-style park in Paris. Originally the private garden of the duc d'Orleans, it was sumptuous, popular, and picturesque. Monet is again quite careful in what he shows, avoiding the grottoes, cascades, antique ruins, or twisting paths. One of his four views, *The Parc Monceau* (fig. 142), is so intimate that it almost recalls those views of his own backyard such as *Monet's House and Garden at Argenteuil* (fig. 112). While it is clearly urban, elegant, up-to-date Paris, it is also personalized, free of the crowds, strains, and pace of the downtown area. Indeed, the painting could be, as one writer recently asserted, the *Parc* as described by Jean-Jacques Rousseau.[7]

Sometime in July or August Monet was invited by Ernest Hoschedé, the department store owner and art collector, to paint four decorative panels for his chateau in Montgeron, and Monet accepted.[8] Although only seven kilometers further from Paris than Argenteuil, Montgeron was a totally different world. It had no industries, no mining operations, no housing developments, and no Sunday crowds. Hoschedé's sumptuous Château de Rottenbourg rivaled Argenteuil's Château du Marais. Furthermore, Hoschedé had a studio on the property where Monet could work, and a fishing cabin on the Yerres River fifteen minutes away where Monet could be alone in unspoiled nature.

Taking advantage of the luxurious accommodations, Monet stayed in Montgeron until December. And, not surprisingly, none of the four decorative panels has modern life as a subject. Instead, they all are based on traditional themes for country house decoration. *The Turkeys* (fig. 143) and *A Corner of the Garden* (fig. 144) are modernized versions of the standard views of the chateau and gardens; *The Hunt* (fig. 145) is the

130. Claude Monet, *The Mall*,
1876. 55 ×65.5. Formerly Private
Collection, Switzerland.

131. John Constable, *Malvern
Hall, Warwickshire*, 1809. Tate
Gallery, London.

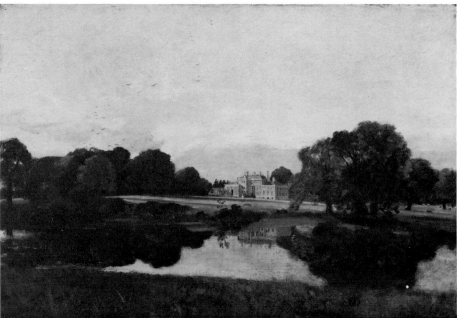

traditional hunt scene *à la* Oudry, and *The Pool* (fig. XXX) is the traditional sky view, only reversed as a reflection. Having assumed the role of patron's painter (even to the extent perhaps of painting *modelli* for Hoschedé of at least three of the panels), Monet clearly assumed the challenge of redoing time-honored themes.

That the garden should figure largest is reasonable, since it was an important part of Hoschedé's chateau and of the tradition of chateau decoration. And as a landscape painter Monet would naturally have found the subject most attractive. However, the concentration on the garden must also be seen as a continuation of Monet's concern with the subject in Argenteuil and Paris. Nearly as large as the Parc Monceau and yet as private and peaceful as Monet's own little plot in Argenteuil, Hoschedé's grounds would have been the perfect refuge, as *A Corner of the Garden* and *The Pool* confirm. Indeed, the latter is even more of a retreat than the Argenteuil views and more enrapturing than the Paris pictures. Working on a scale that he had tried only once before in the 1870s — *The Luncheon* (*Argenteuil*) of 1873 — Monet fills two-thirds of the canvas with the pool and its reflection and the top third with a screen of trees and foliage. Closed off in the background, the scene has no outlet and very little depth. In fact, if the female figure to the right were eliminated and some waterlilies added to the pool, the view could almost be mistaken for

132. Claude Monet, *Houses under the Trees*, 1876. 60 × 81. Private Collection, Switzerland.

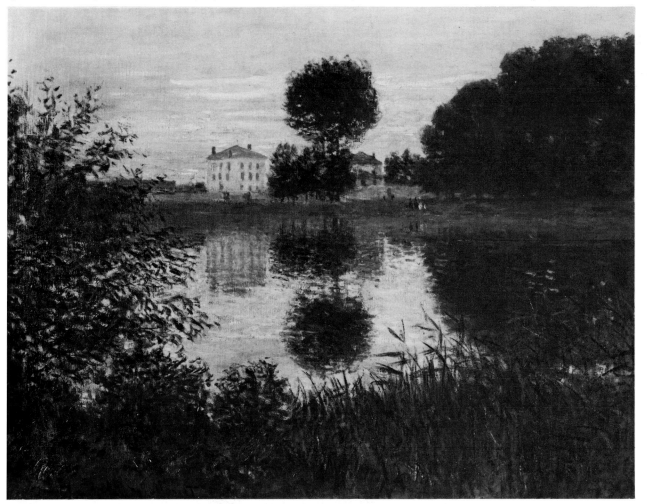

133. Claude Monet, *Camille in the Grass*, 1876. Private Collection, France.

a work done at Giverny (fig. 146). Like those later paintings, Monet here is concerned with rendering his impressions of the pool's shimmering surface, capturing the fluctuations of light filtering through the trees, and creating his own private world. These concerns, of course, had long been a part of his art, but now, with nearly all reference to modern life eliminated, they come close to being the entire subject.

This can also be seen in Monet's views from that summer of the Yerres River, such as the *View of the Yerres* (fig. 147). Although less enveloping than *The Pool*, they are pictures of a private, pastoral world, silent, isolated, and reassuring. While looking back to Daubigny, they look forward to Monet's later views of the Seine at Vétheuil. And, like *The Pool*, they also can be associated with views from Giverny (fig. 148); the differences are in style, not in content.

There are several paintings from 1876 of the Seine at Argenteuil in autumn, such as *The Petit Bras in Autumn* (fig. XXXI), that indicate that Monet made at least one trip home from Montgeron. These paintings are evidence of his orientations as well as his travels. They show not the boat basin of the Seine, but the idyllic Petit Bras which he had painted that spring for the first time in three years. Consciously anti-modern, these paintings attempt to recapture the naïveté of an eroded rural tradition. They also recall the real

166

134. Claude Monet, *Two Figures in the Garden*, 1876. 81 × 60. Private Collection, New York.

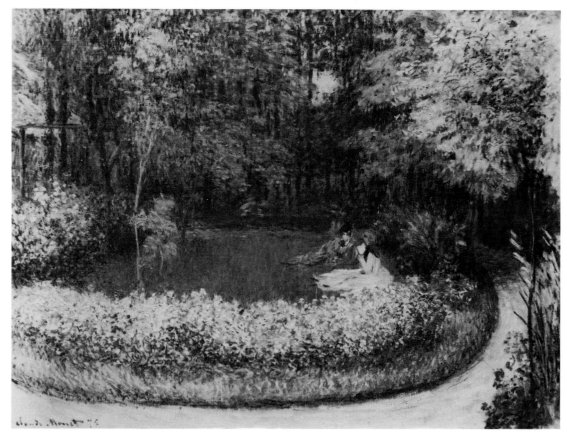

135. Claude Monet, *The Garden from the House*, 1875. 60 × 81. Private Collection, United States.

136. Claude Monet, *The Garden*, 1876. 50 × 65. Whereabouts unknown.

retreats in Montgeron; only the sparser undergrowth and the prominent poplars separate them from the *View of the Yerres*. And they too predict Monet's work in the years to come.

With such unchallenging pictures dominating his work in the last half of 1876, it is perhaps curious that, upon his return from Montgeron in early December, Monet did not settle back into Argenteuil and paint sites like the Petit Bras. Instead he made arrangements to rent an apartment in Paris with the intention of painting the Gare Saint-Lazare. Nothing would seem further from Montgeron and the Yerres.

It was not by chance that Monet chose the Gare Saint-Lazare over the other five railroad stations in Paris: it was the one that serviced Argenteuil. It also had the lines that ran to Bougival, Chatou, Louveciennes, Ville d'Avray, Rouen, and Le Havre, so he would have long been familiar with it.

By mid-January Monet was installed in his one-bedroom apartment on the rue Moncey, just a few blocks from the station. By late March he had finished most if not all of his twelve views—a remarkable feat considering the complexities of the paintings.[9] He may have been pressured by the fact that the third Impressionist exhibition was scheduled to open the first week of April and he had no new modern paintings to show. Whatever the reasons, the views are the ultimate odes to the city. Indeed, one critic felt they were so impassioned that he believed Monet "had wanted to cause," not simply capture, "the impression produced on the traveler by the noises of the machines at the hours of departure and arrival."[10] George Rivière, writing in *L'Impressionniste*, found the series to be "enormously varied despite the monotony and aridity of the subject." The subject had considerable power, however, as Rivière's description makes clear.

> In one of the biggest paintings, *The Gare Saint-Lazare* [fig. 149], the train has just pulled in, and the engine is going to leave again. Like an impatient and temperamental beast, exhilarated rather than tired by the long haul it has just performed, it shakes its mane of smoke, which bumps against the glass roof of the great hall. Around the monster, men swarm on the tracks like pygmies at the feet of a giant. Engines at rest wait on the other side, sound asleep. One can hear the cries of the workers, the sharp whistles of the machines calling far and wide their cry of alarm, the incessant sound of ironwork and the formidable panting of steam.[11]

Having immersed himself in this steam and noise for what was obviously a concentrated and productive period, Monet returned to Argenteuil where during the next nine months he virtually stopped painting, producing only four pictures. This was unprecedented. It is also difficult to explain. Perhaps he was drained from painting the Gare Saint-Lazare series in so short a time; he may have wanted to devote his efforts to selling his large stock of canvases (a possibility given credence by the number of sales he contracted during the year); he also may have been preoccupied with his ailing wife, or with improving his relationship with Alice Hoschedé. But it does not seem coincidental that this hiatus should occur immediately after an unprecedented experience of absolute opposites—the sublimity of Montgeron and the flurry of the Gare Saint-Lazare. And as Hoschedé's estate was in fact what Monet in the fiction of *Houses under the Trees* had made the western end of Argenteuil appear to be, he undoubtedly found himself unable to

137. Claude Monet, *Camille and Jean on a Hill*, 1875. 100 × 81. Collection Mr. and Mrs. Paul Mellon, Upperville, Virginia.

138. Claude Monet, *Camille with a Green Parasol*, 1876. 81 × 60. Private Collection, New York.

reinstate his former fantasy of Argenteuil, precisely because, more than at any time before, it had been shown to be exactly what it was—a myth, an unreality.

Monet had to have been more aware of the town's contrasts upon his return, which alone would have made it more difficult to reconcile them; but changes in the town itself would have contributed to the problem. A third iron works had just opened, in front of his house, the year before; by late 1877 it was employing over 250 workers and was operating, on the average, eleven hours a day; the Joly factory was up to 500 workers on a similar eleven-hour schedule; and at the end of the promenade the town's second iron works, which had only opened in 1874, was employing 170 people ten hours a day. In total, these industries had grown by more than 350 people since the last quarter of 1876. Other industries could claim similar growth.[12]

There were changes on other fronts as well. In January 1877 the minister of public works had approved the plans proposed by the Chemin de Fer de la Grande Ceinture de Paris calling for a new line that would cross Argenteuil on its way from Epinay to Pont de Maisons sur Seine. In March of the same year Argenteuil's municipal council agreed to the plans but demanded changes with regard to the placement of the line. The railroad as proposed "would cross not just part of the town but its entire length from northeast to

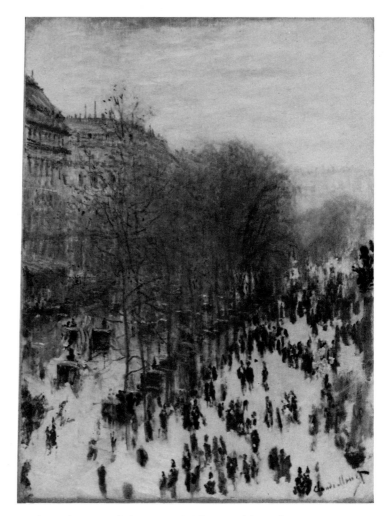

139. (left) Claude Monet, *Boulevard des Capucines*, 1873. 80 × 60. Nelson Gallery–Atkins Museum, Kansas City, Missouri.

140. (facing page top) Claude Monet, *The Tuileries*, 1876. 54 × 73. Musée Marmottan, Paris.

141. (facing page bottom) Photograph of the Tuileries palace in ruins, 1871.

northwest over a distance of nearly seven kilometers." The resulting changes were not taken into account, so in December, "after a thorough examination and prolonged discussion" of the plan, the Council declared its steadfast opposition.[13] Their protest met with little success; the minister of public works and the department prefect approved the unrevised plans the following year and work began in August. More of Argenteuil's fertile acreage again fell prey to progress.

While fighting the imposition of new railroads, the council, in an apparent about-face, approved several proposals over the next few months that altered the town's appearance in undesirable ways. They passed legislation that would establish new *tramways à vapeur* between Argenteuil and Paris and Argenteuil and Mantes.[14] They allowed Madame Bouts to rent public land at the end of the promenade in front of her sawmill, not recognizing that it would spoil the area's appeal. They approved the purchase of land for a road in the same neighborhood at twice the price others paid in 1874.[15] Most important, they approved the establishment of two new industries—a distillery that would be located in the heart of town and a chemical concern that would reopen and enlarge an older plant next to the iron works across the railroad tracks from Monet's house.[16]

All of these changes were only further proof of Argenteuil's continuing development, a development that had already seen the population of the town grow between 1872 and

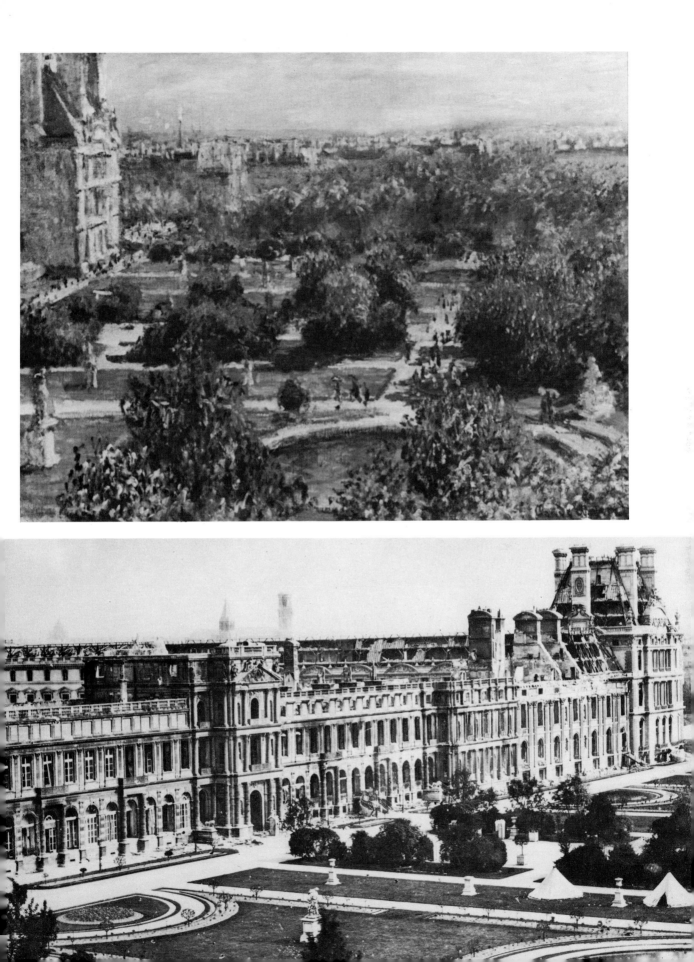

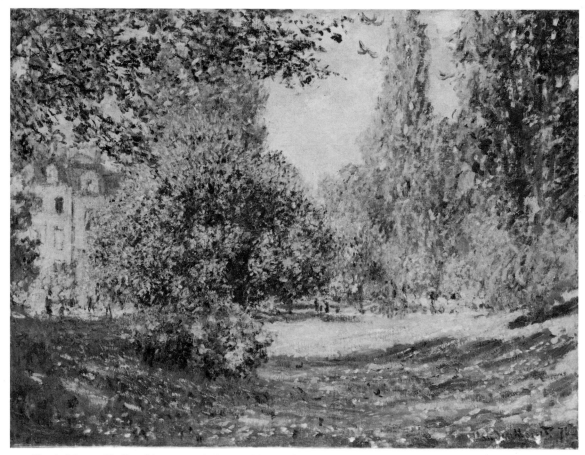

142. Claude Monet, *The Parc Monceau*, 1876. 60 × 81. Metropolitan Museum of Art, New York.

1876 by more than nine hundred people. Over the next five years it increased by an average of six hundred people a year.[17] Most of these new inhabitants were itinerant workers in search of a job, for the number of permanent residents actually declined, indicating that Argenteuil was becoming a working-class town. In 1878, in fact, the number of workers had grown to such an extent that the department prefect, provoked by reports of problems with them, wrote to the mayor about the possibility of creating a board to handle labor disputes. The mayor responded to his inquiry on 8 October 1878:

> The greater and greater number of workers employed in Argenteuil could make one think that the creation of a *Conseil de Prud'hommes* is indispensable. However, the nature of the divers industries which operate in Argenteuil does not seem to me to necessitate, at the present at least, the creation of this jurisdiction. The difficulties between owners and workers are infrequent because work is done by the day and very little by the job; the regulations of the ateliers are generally sufficient to avoid difficulties and I do not think that the disputes which were able to arise every so often degenerated into disagreeable situations.
>
> If new industries come to Argenteuil in the future and increase the already considerable number of workers, the implementation of a *Conseil de Prud'hommes* will become necessary, but at this moment that institution could be deferred without inconvenience to the maintenance of good rapport between owners and workers.[18]

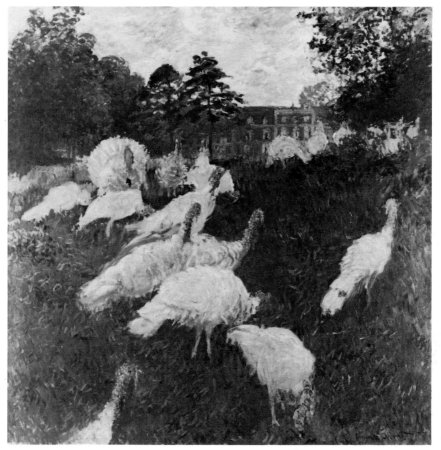

143. Claude Monet, *The Turkeys*, 1876. 172 × 175. Musée du Louvre, Paris.

144. Claude Monet, *A Corner of the Garden*, 1876. 172 × 193. The Hermitage, Leningrad.

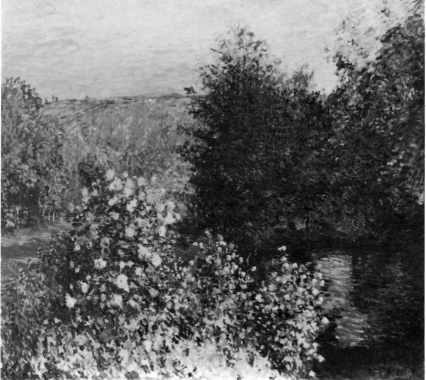

The implications of this letter are clear: there had been problems between workers and owners in the past which were solved either by firing the worker (since he was paid by the day, not by the job) or by applying the "regulations interieurs des ateliers"; the workers lacked a central organization or voice, so disputes "were able to arise" only every so often; if the workers grew more numerous, there would be cause for concern.

Of course, Monet would not have been involved in the town's labor disputes, nor would he necessarily have been aware that they existed. But he could not have failed to notice the decided growth of the town's industries and its working-class population. And since his socialist inclinations were bourgeois, like his friend Pissarro's, he undoubtedly found the changes to be contrary to his taste and discouraging to his fantasies.

When he picked up his brush again in late summer, however, he attempted to reassert precisely those fantasies. He went back to the promenade along the right bank of the Seine, a site that he had not painted since his first year in the town. He probably chose this site because in 1872 it had embodied for him all the poetry of Argenteuil, as we saw in *The Promenade along the Seine* (fig. I).

Monet's earlier response had not been unjustified; this site, as Monsieur Chevalier pointed out in 1863, was "the pleasantest promenade of the city and consequently the most frequented. . . . There are rows of trees, in the shadows of which we love to breathe the air that the flow of the river makes so pure. It is our Champs-Elysées, where we find green grass and even elegant benches to sit on."[19]

The area was not without its unpleasant aspects, however. Almost every year, after the Seine overflowed its banks, inundating the promenade and most of the Champs de Mars, the area became marshy and during warm days emitted an extremely unpleasant odor. In the opinion of the municipal council, "the noxious vapors that these areas exhale are perhaps of a nature that would compromise the health of the inhabitants."[20] Efforts were made to level the Champs but the problem was never completely solved. You either avoided the area on warm days after the flood or turned your nose to the river and inhaled the refreshing breezes off the surface.

The river, however, was not always pleasant-smelling either. In fact, Chevalier's observations about the promenade in 1863 were only prefatory remarks in a discussion of the public health problems caused by dead dogs along the banks of the Seine. "A few days and we will be unmercifully blown away. It's already happening. . . . What? Dead dogs in a complete state of putrifaction. Come the heat, and the evening stroll along the promenade will be forbidden to people endowed with too sensitive a sense of smell."[21]

Dead dogs were not the only problem; there was also the 450,000 kilograms of filth that poured into the Seine every day from the sewer collectors at Asnières and Saint-Denis. In July 1872 the mayor of Argenteuil wrote the department prefect:

Between the [highway] bridge and the floating laundry houses which are along the promenade, sludge has built up all along the banks. Above these boats, the earth has been consolidated; even a garden was created and this garden completely stops up the part of the river between the bank and these boats; . . . the water for a rather long distance no longer moves; there is an accumulation of filth, dogs, and cats in putrefaction; the traffic on the promenades becomes unpleasant.[22]

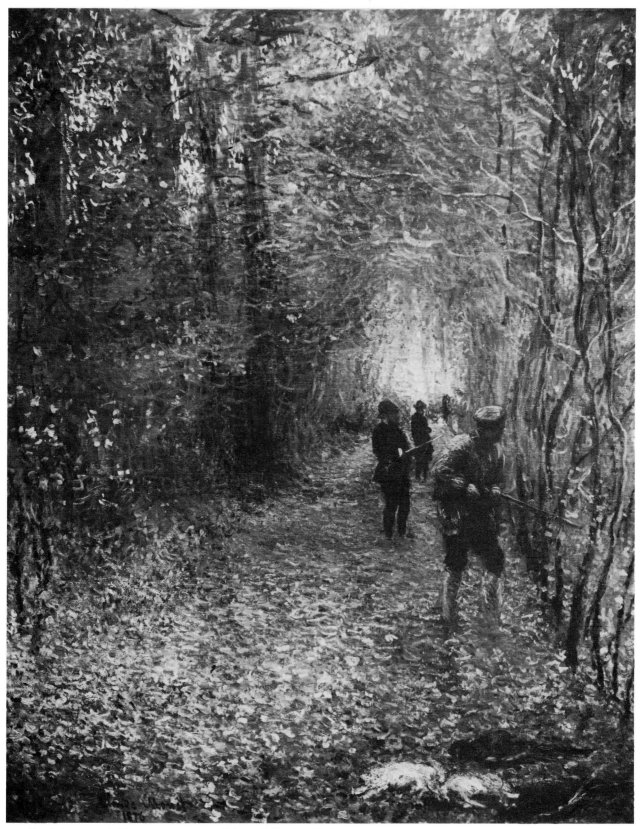

145. Claude Monet, *The Hunt*, 1876. 173 × 140. Private Collection, Paris.

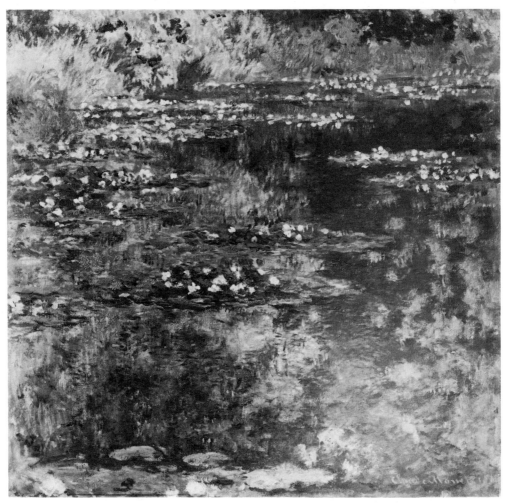

146. Claude Monet, *The Pond at Giverny*, 1903. 90 × 92. Musée des Beaux-Arts, Caen.

The mayor strongly insisted, that the prefect rectify this unhealthy situation. The following year, the director of the Company of the Asnières and Argenteuil Bridges insisted with equal strength that the mayor take similar measures to clean up the area around the Argenteuil bridge because it was "the receptacle of filth of all kind which during the hot and stormy weather not only affects the air unpleasantly but could even have serious consequences for the health of the public."[23] Obviously, it was not a problem that the mayor or prefect alone could solve, and it was not one that went away with time. Time made it worse, for the sludge kept pouring into the river. In 1874 the mayor complained about the insufferable state of the promenade again, finding it impossible to describe. "Before long, maybe in several days with the heat, the water level is going to drop again and expose a considerable area of chokingly smelly slime."[24] And in 1878 the mayor wrote to a government lawyer to say that

> the pollution of the river is complete. . . . If the complaints are less lively and less frequent, it is because people are tired of complaining uselessly and because they have lost all hope of seeing the realization of the project of the city of Paris which aimed to

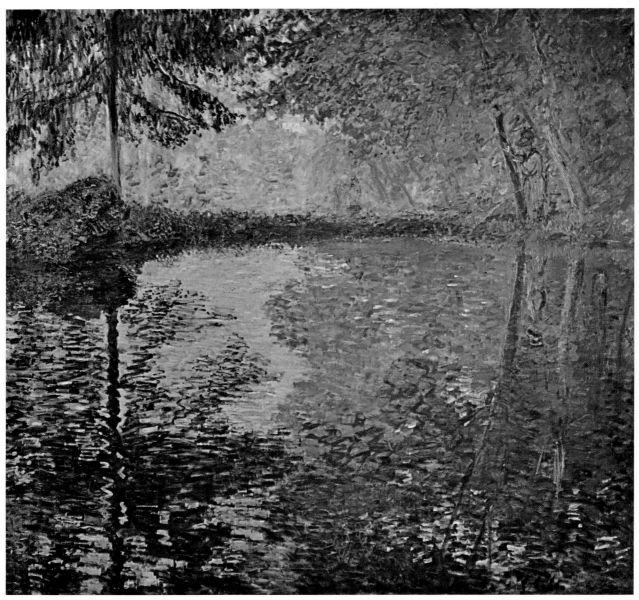

XXX. Claude Monet, *The Pool*, 1876. 172 × 193. The Hermitage, Leningrad.

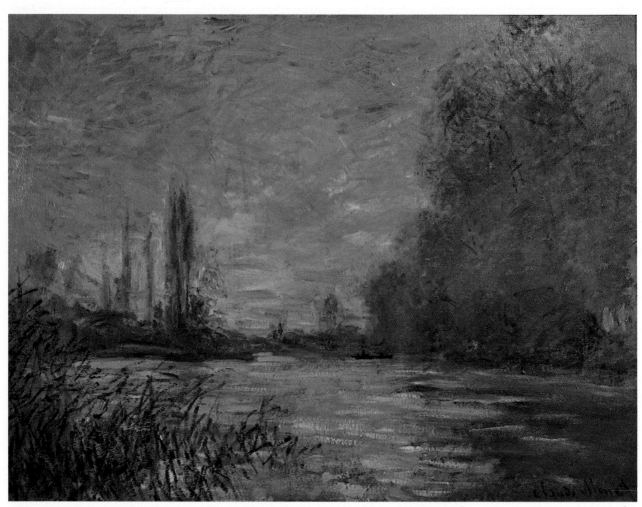

XXXI. Claude Monet, *The Petit Bras in Autumn*, 1876. 54 × 70.5. Private Collection, United States.

carry the sewer water further away by means of a large irrigation pipe. . . . The left half of the river [that opposite Argenteuil] which seven or eight years ago was a little cleaner than the right [in front of town] has become just as thick with material of all kinds. . . . we observe there during the summer the enormous swellings of *boues de vas* which take place under the pressure of gases.[25]

In 1872, six years before the bubbling of the left half of the Seine, Monet like so many others had strolled along the right bank and found that side to be idyllic, despite the putrefaction and the sludge from the Paris sewers. This was the country, with broad open skies, towering trees, sunlight, shade, and amusements like sailing or rowing. The contradictions seem irreconcilable, but everyone with a *joie de vivre* and a touch of romance could overlook the filth and enjoy the delights. Maupassant did so throughout the 1870s, as he described in his reminiscences of a rowing man:

> For ten years my great, my only absorbing passion was the Seine, that lovely, calm, varied, stinking river, full of mirages and filth. I think I loved it so much because it gave me the feeling of being alive. Oh, those strolls along the flower-covered banks, with my friends the frogs dreamily cooling their bellies on lily pads, and the frail, dainty lilies among the tall grasses, which parted suddenly to reveal a scene from a Japanese album as a kingfisher darted past me like a blue flame! How I loved all that, with an instinctive passion of the eyes which spread through my whole body in a feeling of deep and natural joy![26]

This "lovely, calm, varied, stinking river" that brought Maupassant's dreams to life must have inspired similar feelings in Monet. For when he returned to Argenteuil in 1877 and finally picked up his brushes once again, he went to paint the Seine, "full of mirages and filth"—and he went back to paint the same view four times. The significance of this statistic might be overlooked if it were not for the fact that these were the only pictures he painted in the town that year (figs. II, 150–52).

The four include all the appealing aspects of the site: flower covered banks, tall trees, green grass, refreshing water, and open sky. People stroll along the path while others guide their boats on the river. The *petit château*, colored a rich purple, sits on a carpet of green in the background. Across the water is the charming Ile Marante, and nearer the foreground is the floating laundry house. Although less charming, the house does not appear unattractive. Individually and as a group, therefore, these pictures, like the earlier *Promenade along the Seine*, 1872 (fig. I), seem to reaffirm the idyllic qualities of Argenteuil.

There are a number of differences, however, between these pictures and Monet's earlier rendering. No Hobbema-like path invites us into any of them; *The Argenteuil Promenade II* provides easier access than the other two since the promenade continues further into the foreground, but in all of them the flowers complicate the entrance. While extending the line of the bank on the left, the flowers create a barrier across the picture and make the division between foreground and background more distinct than in *The Promenade along the Seine*. The horizon line in all of them is considerably higher than in any of the pictures from 1872, making the scenes more compressed and immediate. In keeping with the change in style between 1872 and 1877, there is less description of specific elements in the later works. The *petit château*, for example, in all the earlier pictures was

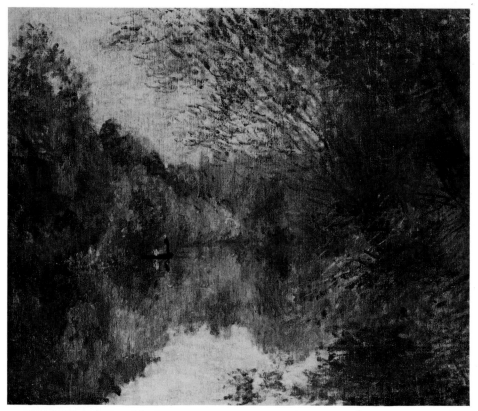

147. Claude Monet, *View of the Yerres*, 1876. 54×65.5. Whereabouts unknown.

148. Claude Monet, *A Branch of the Seine near Giverny*, 1897. 87×98. Museum of Fine Arts, Boston.

rendered in considerable detail; in the views from 1877 it is far more generalized. A change in style, however, does not explain why Monet did not include the factory smoke-stacks in *The Argenteuil Promenade I* and *II*. In *The Promenade and the Basin* (fig. 74) of 1872 he had omitted the chimney to the right probably because he felt that it interrupted the recession of the path and complicated the area between the house and the trees in the background. Yet he did not hesitate to include the one to the left and to depict it spouting smoke. Here, in these two pictures from 1877, he edits both of them perhaps because they disrupt what he wants the site to be—the countryside that Chevalier and Maupassant romantically described.

But, of course, in 1877 there were even more smokestacks in the distance than there had been in 1872, since the second iron works had opened in 1874 on the property adjacent to the carton factory whose chimney is the one to the left. Beyond the trees and the turreted house to the right were the *cités* of new houses whose population, like most of the town's, was becoming more and more working-class. The site itself, with the Seine bubbling from gaseous waste, was not as fragrant as the thicket of flowers would lead one to believe. These views, therefore, are not dispassionate renderings, nor are they fleeting moments caught on the run; they are memories, hopes, and dreams made real.

In the fourth view, *Argenteuil—the Bank in Flower* (fig. II), perhaps Monet's last paint-ing of Argenteuil, this romance is particularly apparent. Unlike any of the other three, this rich and glorious picture is visually divided in half. In the foreground are the flowers, so close they could almost be touched. In the background, bathed in a misty golden light, are the turreted house, the smoking factory chimneys, and a puffing steamboat. There is no path connecting these areas; the flowers are so thick and high that they bar our entrance to the scene. As if to emphasize the separation, Monet even places the wooden fence at the bottom right. Just above the fence the flowers dip, providing a view of the promenade. Unlike the other pictures, the promenade here seems to be a little hill rising above the water. Perched on top of it are several promenaders and the same set of trees. Below it are several people in a rowboat, while to the left the river stretches silently into the distance. The tranquillity of the water, the rigidity of the horizon, and the blurry image of the buildings in the background contrast with the agitated mass of flowers in the foreground. They are two different worlds juxtaposed. Monet, standing behind this barrier of flowers, makes the foreground his garden of resplendent nature. Beyond is the world "out there," a mélange of smoking factories and steamboats, houses and pleasure-seekers. One is private, the other public; one is Argenteuil as pure country, the other, Argenteuil as industrial suburb; one is Argenteuil of the past, the other of the present; one is myth, the other reality. These were the contrasts that Monet had always worked with, but here the radical division of the picture makes it clear that the two are no longer reconcilable; the idyll of the other views along the promenade has now become a clash of opposites.

The picture, while all of this, is something else as well. First, it could be argued that, since Monet is standing behind his barrier of nature, he could be saying that so long as he stays within his world and keeps the undesirable elements in the background he could survive and make art in Argenteuil. Furthermore, since those undesirable realities are actually enveloped in a beautiful Claudian–Turneresque light, they are not unattractive.

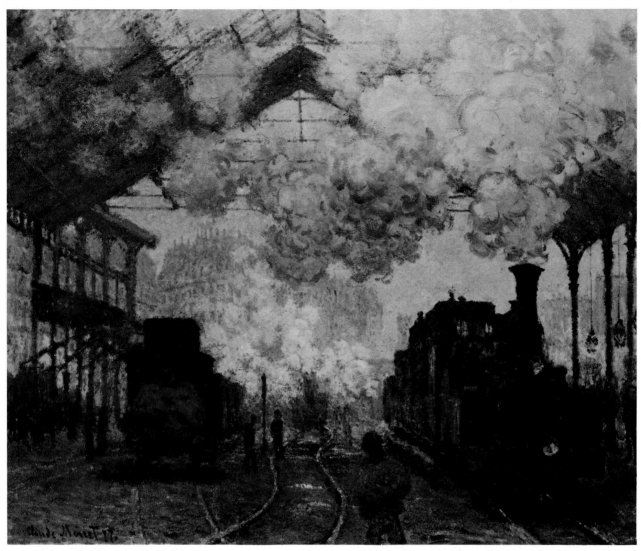

149. Claude Monet, *The Gare Saint-Lazare*, 1877. 82 × 101. Fogg Art Museum, Harvard University, Cambridge, Massachusetts.

Indeed, they float in a limpid, Venetian mist that makes them seem to be a mere mirage, especially in comparison to the tangible, detailed flowers in the foreground.

The flowers, of course, were real in the sense that they did exist where Monet shows them. True also could be Monet's assertion that the resplendent garden was his realm and the rest was tolerable, uninspiring, or simply less important. He had stated the former already in the views of his own garden and he had either made the factories attractive additions to the landscape or placed barriers of all kinds between him and them, and had continued to make art in the town.

He had only once before juxtaposed the two worlds so decisively, in *Weeds by the Seine* of 1874 (fig. 86), and that had been during a similar period of vacillation between city and country extremes, but he had not even then tried so hard to make both sides so lush. Comparison with the earlier painting shows how intense the two sides of the dialectic had become. The town in the background of *Argenteuil—the Bank in Flower* looms larger while the flowers in the foreground are thicker and more energized. With the space in the

later picture more compressed and the flowers more of a barrier, the struggle is clearly less resolvable.

The energy expressed in the flowers of *Argenteuil—the Bank in Flower* is reminiscent of that in *A Corner of the Garden with Dahlias* of 1873 (fig. XXIII). There it derived in part from Monet's struggle between his transformation of the garden into a private place and his awareness that beyond the trees to the right was the encroaching town. The same struggle is taking place in figure II, but with greater acuity. Monet is still trying to create a private world, but now from a public place, not from the security of his garden, or from the less frequented left bank of the Seine as in *Weeds by the Seine*. And, of course, he is doing so four years later.

There is one final reason why Monet could not reconcile these two worlds in *Argenteuil—the Bank in Flower*. The tangle of flowers is actually the same garden that the mayor had complained about in 1872 and 1874. It was, therefore, not a protective barrier but an integral part of the glowing background, a product of progress as much as the trails of smoke above. In fact, those trails are rendered in the same swirled strokes as the flowers. Pulling the smoothly painted distance forward, they remind us that all of this is one world, a fact that is underlined by the fence on the right. Initially emphasizing the separation between the two areas, the fence now clearly separates us from the flowers; they are on the other side with the pleasure-seekers and the town. The flowers are even tied to the background by the two long-stemmed buds that rise above the thicket in the center of the picture. These "buds" are spent flowers—roses that bloomed earlier and now have lost their petals.

This painting, then, unlike the other three, is about the realities of Argenteuil and the fantasies of Monet's art. What it shows is the town as the modern industrial suburb, which, although filled with smoking factories, could still give birth to golden illusions and still attract pleasure-seekers with its semblance of seductive nature. But it required of both its residents and its weekend visitors belief in the beauty of modernity and the positivism of progress. And Monet in 1877 no longer had that faith. He had seen Argenteuil's open land developed by speculators, its skyline punctured by new industries, its population expanded by factory workers, and its stretch of the river polluted by filth. He had overlooked all of that for nearly five years and had painted the myth of modern life in more than one hundred and seventy canvases; but he knew that what he had been painting was a fantasy—that, in fact, industry and progress were the antithesis of nature, that modernity was a romantic enthusiasm for the advances of the age and a compensation for the loss of traditional ties to nature, and that Argenteuil was not only torn apart by the conflict of country versus city but clearly headed toward the latter. Monet had propounded the myth because he too wanted to believe in it; he was a part of the age and he was committed to rendering it. But he was also a landscape painter who loved pure nature and was committed to painting its beauty. And when Argenteuil became more industrialized and less idyllic, more city and less country, the balance between his commitments was upset and the myth became untenable. Paintings like *Men unloading Coal*, *The Bridge as a Single Pier*, and *Boat Rental Area with Boat Rental House*, and Monet's gradual retreat into the garden and the Petit Bras all had predicted this; but here, *Argenteuil—the Bank in Flower* assures it.

On 25 October Monet wrote to Chocquet inviting him to come to the studio at 17, rue Moncey: "Starting tomorrow, I will always be [there] from one o'clock to four."[27] He had given up Argenteuil; two and a half months later, he and his family left permanently. The problem was not financial, for they moved into a spacious six-room apartment in Paris that cost 1,350 francs a month.[28] It was simply that both Argenteuil and Monet had changed.

After half a year in Paris, Monet left again to find another place to live in the country. On 1 September he "had planted his tent," as he wrote to a patron, Eugène Murer, "in a ravishing spot on the banks of the Seine at Vétheuil."[29] Undoubtedly it was ravishing; it still is today. In 1878 it had a population of only 622, the majority of whom were farmers. It had no industries, no railroad, no pollution, and no Parisian pleasure-seekers. It was everything that Argenteuil was not. Its Rousseau-like retreats were natural, not fabricated; its rusticity was real, not Monet-made. Here Monet could be alone in front of his motif, pursuing not the dialectic of city and country, but the dialectic of vision and nature.

150. Claude Monet, *The Argenteuil Promenade I*, 1877. 60 × 73.5. Private Collection, United States.

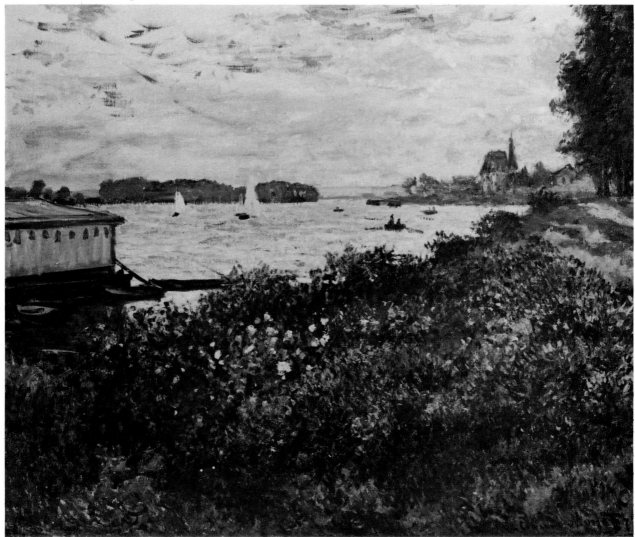

151. Claude Monet, *The Argenteuil Promenade II*, 1877. 60 × 73. Private Collection, France.

152. Claude Monet, *The Argenteuil Promenade III*, 1877. 54 × 66. Harris Whittemore Collection, Connecticut.

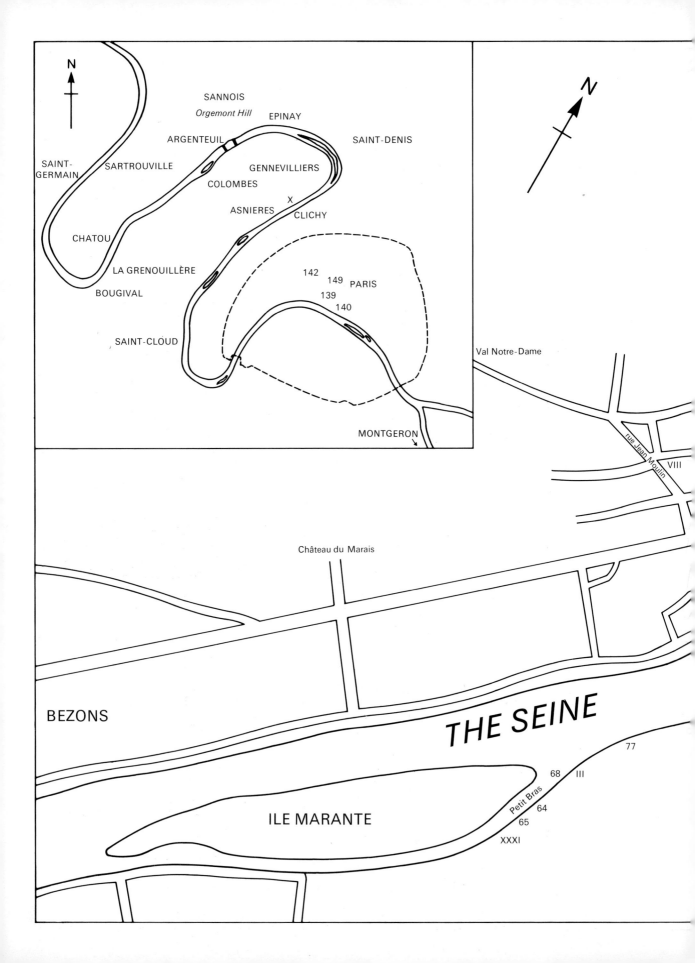

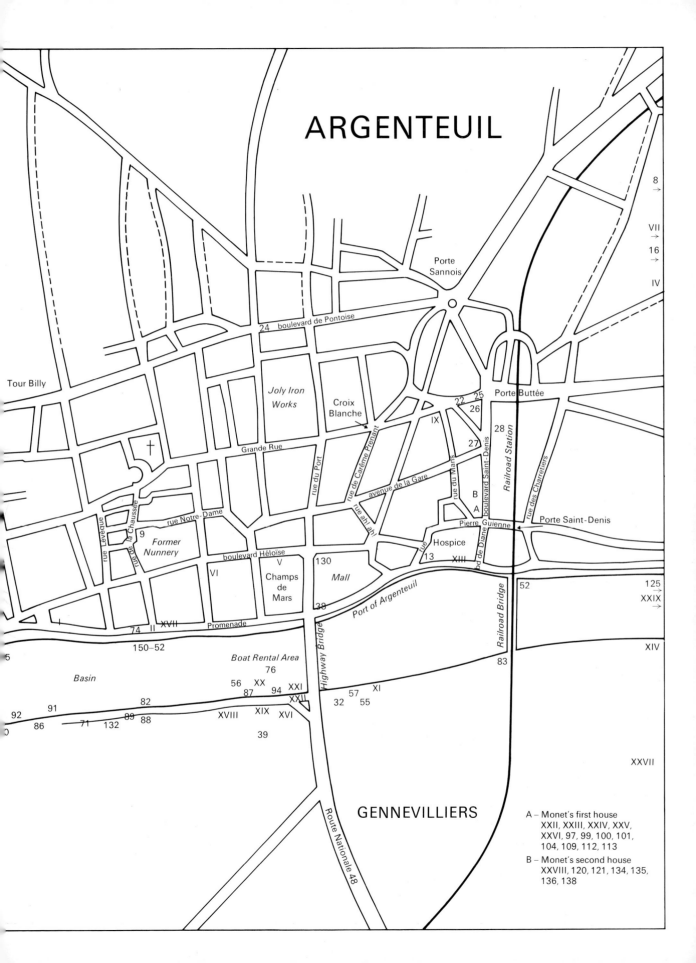

ARGENTEUIL

8 →

VII →

16 →

IV

Porte Sannois

Tour Billy

24 boulevard de Pontoise

Joly Iron Works

Croix Blanche

22 25
26

Porte Buttée

IX

27

28

Grande Rue

rue du Port

rue de Carême Prenant

avenue de la Gare

rue du Mars

boulevard Saint-Denis

Railroad Station

rue des Charretiers

rue Léveque

rue de la Chaussée

rue Notre-Dame

9

rue ah! ah!

B

A

Porte Saint-Denis

Former Nunnery

boulevard Héloïse

V

130

Pierre Guienne

Champs de Mars

rue d'od de Diane

Hospice

13

XIII

VI

Mall

38

Port of Argenteuil

Railroad Bridge

52

125 →

XXIX →

74 II XVII

Promenade

150-52

83

XIV

Boat Rental Area

76

56 XX

87 94

XXI

XXII

Basin

82

XI

57 55

92 91

89

86 71 132 88

XVIII XIX XVI

32

39

Highway Bridge

XXVII

Route Nationale 48

GENNEVILLIERS

A – Monet's first house
XXII, XXIII, XXIV, XXV,
XXVI, 97, 99, 100, 101,
104, 109, 112, 113
B – Monet's second house
XXVIII, 120, 121, 134, 135,
136, 138

ABBREVIATIONS

AA	Archives d'Argenteuil
AN	Archives Nationales
AYSO	Archives du département des Yvelines et de l'ancien département du Seine-et-Oise, Versailles
BL/BCEL	Baux à loyers, 1812–1915, 7.N.², in Biens Communaux, Echanges, Locations
DEA	Dossiers d'enquêtes et autorisations, 1836–79
DW.I,II	Daniel Wildenstein, *Claude Monet:*

	Biographie et catalogue raisonné, Lausanne–Paris, 1974–79; I (1840–1881), II (1882–1886), III (1887–1898)
LIVRP	Logements insalubres. Visites, rapports, plaintes
RAM	Registre des arrêtés du maire
RDCM	Registre des délibérations du conseil municipal
SICSO	Situation industrielle et commerciale de Seine-et-Oise

NOTES TO THE INTRODUCTION

1. Emile Zola, "Mon salon: IV. Les Actualistes," *L'Evénement Illustré*, 24 May 1868.
2. Frédéric Chevalier, "Les Impressionnistes," *L'Artiste*, 1 May 1877, 331.
3. Steven Z. Levine's *Monet and his Critics*, New York, 1976, is the best source for critical writings on Monet, but unfortunately Levine is selective in his citations. He includes parts of Chevalier's review of the third Impressionist exhibition, but not, for example, the section quoted here.

NOTES TO CHAPTER I

1. A. Bonnevalle, "Chronique," *Journal d'Argenteuil*, 26 August 1866, 2. The history of Argenteuil is found in many sources. The best modern compilations are Edmond Réthoré, *Argenteuil et son passé*, 3 vols., Saint-Gratien, 1968–72; Monique Coornaert and Claude Harlaut, *Ville et quartier: Argenteuil*, Paris, 1965; Paulette Leheu, "Le Développement d'une banlieue, Argenteuil," *Urbanisme et Habitation*, July–December 1954, 195–220; and Commission municipale d'histoire locale, *Argenteuil: images d'histoire*, Argenteuil, 1977. There are two important early histories of the town: Etienne-Olivier Chevalier, *Notices sur la commune et sur l'hospice d'Argenteuil*, Saint-Denis, 1859; and Abbé Lebeuf, "Histoire de la ville d'Argenteuil," in *Histoire de Paris et ses diocèses*, Paris, 1749. Nineteenth-century histories of the Paris suburbs generally include lengthy sections on Argenteuil. The best of these is Emile de Labédollière, *Histoire des environs du nouveau Paris*, Paris, 1861, which supplants J. A. Dulaure's groundbreaking *Histoire physique, civile, et morale des environs de Paris*, Paris, 1825. A. Martin's four volume opus, *Les Environs de Paris*, Paris, 1891–93, complement's Labédollière's work. Guidebooks of the period are likewise rich sources of information. The best of these are three by Adolphe Joanne: *Les Environs de Paris illustrés*, Paris, 1868; *De Paris à Saint-Germain à Poissy et à Argenteuil*, Paris, 1856; and *Paris illustré en 1870*, Paris, 1870. The collection and archives of the Musée du Vieil Argenteuil in Argenteuil contain much valuable information, some of which has been published over the years in the *Bulletin*

de la Société historique et archéologique d'Argenteuil et du Parisis. Finally, the Argenteuil town archives, located in the present town hall, is an invaluable source of unpublished material on nineteenth-century developments.

2. Peter Worms, "Une promenade à Argenteuil," *Journal d'Argenteuil*, 30 March 1869, 2–3.

3. During these years Monet lived in Paris, Chailly, Ville d'Avray, Honfleur, Bougival, Etretat, Fécamp, Trouville, Le Havre, London, and Holland.

4. That Monet was poverty stricken during the 1870s is standard in all writings on the artist. Recently, however, Daniel Wildenstein, using Monet's account books conserved at the Musée Marmottan in Paris, patiently calculated Monet's earnings over these years and presented his findings in his *Claude Monet: Biographie et catalogue raisonné*, Lausanne–Paris, 1974, I (1840–1881) (hereafter cited as DW.I). I have gathered the figures and presented them below (see Chapter 2, note 33). On the salaries of professionals in Paris see DW.I, 87, note 617.

5. G. Touchard-Lafosse, *Histoire de Paris et de ses environs*, Paris, 1850, V, 136.

6. C.P.D., "Les Environs de Paris: Argenteuil," *L'Illustration*, LIV, 25 September 1869, 208.

7. Rapport de la Commission nommée pour examiner la demande faite par MM. Christian d'acquérir un terrain communal, 17 May 1834, Archives d'Argenteuil (hereafter cited as AA), Baux à loyers, 1812–1915, 7.N.², in Biens Communaux, Echanges, Locations, 6.N.–7.N. (hereafter cited BL/BCEL).

LeBlanc de Ferrière in his *Paris et ses environs description historique, statistique et monumental*, Paris, 1844, 415, states that it employed 100 workers.

On the Joly forge see Edmond Réthoré, *Argenteuil et son passé*, Saint-Gratien, 1968–72, III, 243–47.

References to other industries are found in AA Dossiers d'enquêtes et autorisations, 1836–79, 65.I.² (hereafter cited as DEA); AA Déclarations de machines à vapeur, 1836–1905, in DEA; AA Statistiques commerciales et industrielles, 1858–1929, 6.F., in Commerce et Industrie 3.F.–6.F.; and Archives Nationales, Situation industrielle et commerciale de Seine-et-Oise, 1869–87, F.¹² 4538 (hereafter cited as AN; SICSO).

On Argenteuil's mining concerns see AA Declarations de fours à plâtre, 1818–1909, 65.I.⁵, in DEA 65.I.³–65.I.⁸.

8. Letter to mayor of Argenteuil from M. Hervel, distillery proprietor, responding to complaints

of residents of the rue du Port, and rue de Carême Prenant, in AA Logements insalubres, Visites, rapports, plaintes, 1808–1922, 63.I. (hereafter cited as LIVRP).

For other letters of protest see notes 13, 14.

9. Population figures are from the census records conserved at the Archives du département des Yvelines et de l'ancien département du Seine-et-Oise, Versailles (hereafter cited as AYSO).

10. See Paulin, "Inauguration du chemin de fer d'Argenteuil le 27 avril 1851," *L'Illustration*, XVII, 8 April 1851, 288.

11. For the sale and transformation of the silk factory see AA DEA.

12. Réthoré, *Argenteuil*; AA Chemins de halage an XII, 1804–1910, 34.O.⁵; AA DEA; Le Musée du Vieil Argenteuil, dossier 47 Industries.

13. On the oil refinery see AA Enquête sur M. Canonage et Cie: établissement d'une usine pour l'épuration et le depôt d'huiles minérales à peu de distance de la gare du chemin de fer, porte Buttée près de la Route d'Enghien in DEA.

On the closing of the tallow factory see AA Suppression d'une fonderie de suif en branche, 9 December 1868; traité entre M. Julien et la Ville d'Argenteuil, 29 December 1868, in DEA. Also Frédéric Larouche, "Correspondance," *Journal d'Argenteuil*, 14 July 1867, 1.

On complaints against the distillery see AA Letter to mayor from residents between rue du Port and rue de Carême Prenant, 29 October 1834, in LIVRP, 1808–1922, 63.I.

On complaints against the chemical plant see AA Letter to mayor of Argenteuil from citizens living on the rue de Sannois (1869) in LIVRP, 1808–1922, 63.I.; and letter to mayor of Argenteuil from department prefect, 31 January 1867, in DEA.

14. Testimony of M. Cobecq living at 103 Grande Rue at the hearing on the Delon-Alboy tannery problem, 27 December 1858–7 January 1859, AA Enquête sur Delon-Alboy, in DEA.

15. A. Bonnevalle, "Moeurs de la banlieue de Paris," *Journal d'Argenteuil*, 23 March 1862, 1.

16. Minutes of Argenteuil Municipal Council meeting, 6 April 1845, from Registre des délibérations du conseil municipal, 1844–46, I.D.¹⁸ (hereafter cited as RDCM).

17. *Ibid.*

18. A.-C. Chevalier, "Le Progrès," *Journal d'Argenteuil*, 20 April 1862, 2.

19. F. Lebeuf, "Le Journal d'Argenteuil," *Journal d'Argenteuil*, 9 March 1862, 1.

20. A. Bonnevalle, "Deux mariages pour une noce," *Journal d'Argenteuil*, 28 June 1862, 2.

21. Paris population figures frequently differ from one source to another. I have relied on those compiled by Louis Chevalier in *La Formation de la population parisienne au XIX*ᵉ *siècle*, Paris, 1949. For other demographic charts and analyses of the population movement see Eugène Bonnemère, *Histoire des paysans depuis la fin du moyen âge jusqu'à nos jours, 1200–1850*, Paris, 1856; Léonce de Lavergne, *Economie rurale de la France depuis 1789*, Paris, 1866; and S. C. Valny, *Etudes sur la dépopulation des campagnes*, Auch, 1862.

22. H. Lemoine, "Le Département de la Seine-et-Oise de l'an VIII à 1871," *Revue de l'histoire de Versailles et Seine-et-Oise*, July–December 1943, 4.

23. Archives Nationales, *Le Parisien chez lui au XIX*ᵉ *siècle, 1814–1914*, exhibition catalogue, Paris, 1976, 61. Also see David H. Pinckney, *Napoleon III and the Rebuilding of Paris*, Princeton, 1972, 3–24.

24. The exact figures according to *Le Parisien chez lui au XIX*ᵉ *siècle* are 27,488 demolished and 102,487 constructed.

25. Maxime DuCamp, *Paris: Ses organes, sa fonction et sa vie dans la seconde moitié du XIX*ᵉ *siècle*, Paris, 1869, I, 10.

26. Eugène Chapus makes the ties to Saint-Cloud clear in "La Vie à Paris: Saint-Cloud," *Le Sport*, 16 September 1866, 2.

27. B.-R., *Le Guide du promeneur aux barrières et dans les environs de Paris*, Paris, 1856, 17.

28. For a further discussion of this see pp. 195–6 and Chapter 5, notes 24–26.

29. Manet's family had owned property in Gennevilliers since the beginning of the eighteenth century. Both his grandfather and great-grandfather had been mayors of the town. For a discussion of his lineage and of his ties to the area see Robert Quinot, *Gennevilliers, évocation historique: I. Dès origines à la fin du XIX*ᵉ *siècle*, Gennevilliers, 1966, 279–301.

30. Emile Zola, "Mon salon: IV. Les Actualistes," *L'Evénement Illustré*, 24 May 1868.

31. Monet to Bazille, Etretat, December 1868, cited in full in DW.I, 425–26.

NOTES TO CHAPTER 2

1. Monet to de Bellio, Argenteuil, 25 July 1876, cited in full in DW.I, 431.

2. X.Y.Z., "Les Côtes de Sannois," *Journal d'Argenteuil*, 14 June 1863, 1.

3. P. Worms, "Une promenade à Argenteuil," *Journal d'Argenteuil*, 30 March 1862, 2–3.

4. On the opinions of Abbé Lebeuf and the Abbé de Marolles see Edmond Réthoré, *Argenteuil et son passé*, Saint-Gratien, 1968–72, II, 219–22.

5. Minutes of Municipal Council meeting ("Marché traité avec MM. Cordonnier et Delaplace"), 1 August 1868, in AA RDCM, 1867–70, I.D.²³.

6. On the history of the street and its name see Réthoré, *Argenteuil*, I, 155.

7. Etienne-Olivier Chevalier, *Notices sur la commune et sur l'hospice d'Argenteuil*, Saint-Denis, 1859.

8. On Barbizon art see Robert Herbert, *Barbizon Revisited*, exhibition catalogue, Museum of Fine Arts, Boston, 1962.

9. Bachaumont, "La Vie à Paris: Paris qui part et Paris qui reste," *Le Sport*, 10 July 1878, 2.

10. Victor Fournel, *Paris nouveau et Paris futur*, Paris, 1865, 15, as cited in Joanna Richardson, *La Vie parisienne, 1852–1870*, London, 1971, 215.

 Maxime DuCamp, *Paris: Ses organes, sa fonction et sa vie dans la seconde moitié du XIX*ᵉ *siècle*, Paris, 1876, VI, 401.

11. Edouard Gourdon, *Le Bois de Boulogne*, Bourdilliat, 1861, 85–87, as cited and translated in Richardson, *La Vie parisienne*.

12. Benjamin Gastineau, *Sottises et scandales du temps présent*, Pagnerre, 1863, 152, as cited and translated in Richardson, *La Vie parisienne*.

13. For Argenteuil's fête see: AA Fêtes publiques, 1833–99, 5.I.⁰–5.I.⁷; L. F. Guerin, "Compte rendu des fêtes en l'honneur de la Sainte Tunique à Argenteuil," *Journal d'Argenteuil*, 31 May 1863, 2–3; "Excursion sur la fête d'Argenteuil," *Journal d'Argenteuil*, 7 June 1863, 2.

14. AA Fêtes publiques, 1833–99, 5.I.⁰–5.I.⁷.

15. E. Chapus, "La Vie à Paris: Fêtes partout aux environs de Paris," *Le Sport*, 8 June 1870, 3; N.L., "Faits divers," *Journal d'Argenteuil*, 29 April 1866, 1.

16. The boulevard Héloïse had been paved and straightened in the early 1850s by M. Channdet, a Parisian contractor who had already paved the Champs-Elysées, the boulevard de la Madeleine and the boulevard des Capucines. See letter to mayor of Argenteuil from Ingénieur des Ponts et Chaussées chargé de la 1ᵉᵐᵉ section du service municipal de la ville de Paris, 13 July 1850, in AA Boulevard Héloïse, 1855–1925, 4.O., in Dossiers des rues H.-K., 4.O.

17. Gas lighting only came to Argenteuil in 1861 when the department prefect authorized M. Caranza to open his gas factory on the rue des Grandes Fontaines. In the years prior to this authorization, many proposals for artificial street lighting had been made but the Argenteuil Municipal Council had turned them down. In addition to the cost, the primary reason given

was "presque tous les habitants se couchent de très bonne heure après le retour de leurs champs. . . . dès lors, l'éclairage n'a pour eux aucun avantage." (Minutes of Municipal Council meeting, 21 May 1844, in AA RDCM, 1844–46.) By the 1860s this latter reason was clearly no longer tenable. In fact, in 1869 residents of the western end of town near the Porte Saint-Germain wrote the mayor asking that their neighborhood be given street lights. "Cette amélioration urgente que nous réclamons loin de grever le budget d'une dépense considérable sera plutôt une avance que fera la ville et dans laquelle elle rentrera et au delà par les droits d'octroi de voierie et autres impôts qu'elle prélèvera sur les nouveaux constructeurs et habitants." (Letter to mayor of Argenteuil from residents of Porte Saint-Germain, 10 August 1869, in AA Gaz, éclairage; Fourniture d'appareils; demandes de lanternes, 1852–1903, 12.O.[4], in Eclairage. Gaz. 11.O. – 12.O.) Requests for lighting continued to be made into the 1870s. (See, e.g., Minutes of Municipal Council meeting, 20 November 1873, in AA RDCM, 1870–76.) The outer reaches of the town did not receive lighting until the end of the decade. The street lamps in Monet's *Boulevard Héloïse* and *Boulevard de Pontoise* are, therefore, cogent symbols of Argenteuil's progress.

18. See Registre de l'Enquête relative à la demande formée par M. Roelly, 12 June 1872, and letter to mayor of Argenteuil from department prefect authorizing the establishment of the factory, 2 October 1872, in AA DEA.

19. A. Bonnevalle, "Moeurs de la banlieue de Paris," *Journal d'Argenteuil*, 23 March 1862, 1.

20. On Millet see Robert Herbert, *Jean-François Millet*, exhibition catalogue, Grand Palais, Paris, 1975.

21. Minutes of Argenteuil Municipal Council meeting, 8 April 1835, in AA RDCM, 1832–35, I.D.[15].

22. Letter to mayor of Argenteuil from residents of Porte Saint-Germain neighborhood, 10 August 1869, in AA Eclairage. Gaz.

23. Eugène Chapus, "La Vie à Paris," *Le Sport*, 20 March 1864, 3.

24. Gustave Flaubert, *Sentimental Education*, trans. Robert Baldrick, Harmondsworth, 1974, 16.

25. On these two establishments see AA Enquête sur M. Delon-Alboy, in DEA; Affaire Bouts in AA BL/BCEL; and Affaires Bouts in Usurpation de terrain de long de la Seine, 1747–1883, 15.D.[6], in AA Contentieux, 15.D.–16.D.

26. Letter to mayor of Argenteuil from M. Drouet in AA DEA.

27. Avis du Maire, 4 November 1859, in AA DEA.

28. In a letter to the mayor of Argenteuil, 25 April 1872, several developers declared: "Nous sommes dans l'intention d'ouvrir dans ces terrains [the Saint-Denis neighborhood] un nouveau quartier qui viendra donner un débouché facile à la gare du chemin de fer où se produit tout le mouvement de circulation de la Ville d'Argenteuil." They were referring to the very block, as we shall see, to which Monet would move. They successfully carried out their intentions over the next two years. See Actes d'échanges entre la commune et divers, 1846–1924, 6.N., in AA Biens communaux, Echanges, Locations, 6.N.–7.N. The new avenue that opened (in 1874) was the avenue de la Gare (present avenue du Maréchal Foch) and the older avenue that was widened was the Grande Rue. See page 49 and note 34. For the improvement of other streets see page 158 and Chapter 6, note 4. In 1872 residents of the area had finally succeeded in removing M. Lebeuf's "fabrique d'albumine par serum frais du sang" from the rue de Carême Prenant. Not only had the smell been overwhelming but the toxic gases the factory emitted actually tarnished the neighbors' copper utensils. See letter to mayor of Argenteuil from residents of the rue de Carême Prenant, 28 February 1872, in AA DEA.

29. For the facts about this new house and Monet's lease see Rodolphe Walter, "Les Maisons de Claude Monet à Argenteuil," *Gazette des Beaux-Arts*, LXVIII, December 1966, 333–42; and DW.I, 71–72.

30. Monet to Manet, Argenteuil, 1 April 1874, cited in full in DW.I, 429.

31. On his wine and maids at Argenteuil see DW.I, 87. On Durand-Ruel's suggestion see letter to Monet from Durand-Ruel, 10 September 1884, cited in full in DW.II, 255. On Monet's niggling about money see for example letters to Durand-Ruel from Monet, 24 December 1885 and 11 August 1886, cited in full in DW.II, 270. On comments by Gimpel see René Gimpel, *Diary of an Art Dealer*, New York, 1966, 56–57, 76, 154.

32. For this complicated issue see DW.I, 64.

33. Monet's earnings, recorded in his own hand in his account books, are strikingly different from what we have traditionally believed. They have been tabulated by Wildenstein, and the totals for the years in Argenteuil are as follows:

1872—f12,100	1875 — f9,765
1873—f24,800	1876—f12,313
1874—f10,554	1877—f15,197

On the workers salaries in Argenteuil see AA

Statistiques commerciales et industrielles, 1858–1929, 6.F.m, in Commerce et Industrie, 3.F.–6.F. On those for the Paris area see Louis Chevalier, *La Formation de la population parisienne au XIX^e siècle*, Paris, 1949, 92–98. David H. Pickney, *Napoleon III and the Rebuilding of Paris*, Princeton, 1972, 160, notes that in 1860 "the usual wages for construction workers ran between 3 and 5 francs a day and the daily wage of a mason might go as high as 12 francs." In the Creuse Department in 1859, a prosperous year, "the daily wage for men in agriculture was 1.53 francs and in industry, where there were few jobs, 2.40 francs." Emile Zola in *La Bête humaine* of 1890 makes it clear that even twenty years later many people were living on incomes of two to three thousand francs a year. He speaks, for example, of a "young man, Henri Dauvergne, a guard who lived there [in Paris] with his father, a deputy stationmaster on the main line side, and his two sisters, Claire and Sophie, charming blondes of eighteen and twenty who, on six thousand francs from the two men, kept house in a continual burst of gaiety." (Trans. Leonard Tancock, London, 1977, 20.)

34. See AA Description de la propriété de M. Bray (Benjamin) Grande Rue no. 9, 20 July 1872, in Chemin de grande communication no. 15 (Grande Rue) ancienne route départementale no. 48, 1791–1915, 15.O.¹, in Chemins de grande communication, 15.O. On the acquisition of the estate see AA Arrêté du Maire, 14 March 1874, in Registre des arrêtés du Maire, 1854–83, 3. D.⁴ (hereafter cited as RAM). On the need for street improvement see for example AA Architects report on the traffic flow from the railroad, 30 June 1872, in Rue de la Gare, Avenue Foch (ancienne avenue de la Gare), 1853–1914, 4.O., in Dossier des rues F., 4.O. On the widening and aligning of the rue du Mans and Quai de Seine (boulevard Héloïse) see AA Quartier de Pierre Guienne, in Rue de Pierre Guienne, 4.O., in Dossiers des rues Gl.-Gu., 4.O. On M. Aubry's property see AA Arrêté du Préfet, 25 March 1865, in Quai de Seine, 1844–1925, 4.O., in Dossiers des rues R.-S., 4.O.

35. Letter to M. Forest, mayor of Bezons, from residents of Porte Saint-Germain area, 20 October 1873, in AA BL/BCEL. The factory was approved on 21 April 1874, see AA DEA. For Municipal Council proceedings on the issue see in particular Minutes of the meeting, 11 November 1873, in AA RDCM, 1870–76. The company had its offices in Paris at 68 rue de la Victoire. M. Commartin, the head admin-

istrator, was the former mayor of Carrières Saint-Denis.

36. Zola, *La Bête humaine*, 58.

37. Monet to Durand-Ruel, Etretat, 15 February 1883, cited in full in DW.II, 226.

38. As noted by George Lafenestre in the preface to the sales catalogue of the Desfosses Collection, 26 April 1895, as cited by Gustave Geffroy, *Claude Monet: sa vie, son oeuvre*, Paris, 1924, I, p. 214.

NOTES TO CHAPTER 3

1. Edwin Child, as quoted in Alistair Horne, *The Fall of Paris: The Seige and the Commune, 1870–1871*, New York, 1973, 402. Théophile Gautier was more poetic. Viewing the destruction in his neighborhood, he wrote: "A silence of death reigned over these ruins. In the necropolis of Thebes or in the shafts of the pyramids, it was no more profound. No clatter of vehicles, no shouts of children, not even the song of a bird. . . . An incurable sadness invaded our souls." (*Tableaux du Siège de Paris, 1870–1871*, Paris, 1886, as quoted and trans. by Horne, *Fall of Paris*, 420.)

2. On Argenteuil and the Franco-Prussian War, and the Commune insurrection, see Gustave Desjardins, *Les Allemands en France: 8 jours dans la Seine-et-Oise*, Paris, 1872; AYSO Series M., Administration Général et Economie du Département du Seine-et-Oise (An VIII–1940), 4.M.1/70. Guerre de 1870–71, notes sur la guerre—Canton d'Argenteuil, 1871; Léon Janrot, "L'Invasion prussienne dans le canton d'Argenteuil en 1870–1871," *Le Vieil Argenteuil*, IV, 16–26; Edmond Réthoré, *Argenteuil et son passé*, Saint-Gratien, 1968–72, II, 333–43.
 On the two bridges see AA Ponts, 5.O.–6.O.; AYSO Series M., 1.S.3¹ᐥ² Pont d'Argenteuil, 1831–74; AN Etat des dommages causés aux chemins de fer par la guerre de 1870–71; Réthoré, *Argenteuil*, III, 228–32.

3. AN, Etat des dommages, Letters to minister of public works from department prefect and Reports of l'Ingénieur en Chef des Chemins de fer d'Ouest sur l'état des lignes composant le réseau de l'ouest.

4 On Argenteuil's port see AA Trafic et Aménagements du Port à Marchandise, 1826–1922, 37; and AA RDCM diverse meetings.

5. Adolphe Joanne, *De Paris à Saint-Germain à Poissy et à Argenteuil*, Paris 1856, 158.

6. Unlike many of the bridges around Paris, Argenteuil's bridge was not destroyed during

the uprisings of 1848. However, it was burned during the Franco-Prussian War and when rebuilt its wooden arches were replaced by metal ones. These new supports, while compromising the purity of the comparison between the highway bridge and the railroad bridge, by no means invalidate the contrast. Besides being fabricated to fit the dimensions of the openings between the stone pylons, the arches were designed to imitate the form and appearance of the older wooden ones; they were even perforated, giving them a decorative hand-crafted appeal which like the wooden arches stood in marked contrast to the stripped-down, impersonal appearance of the railroad structure.

7. Monet to Pissarro, Zaandam, 2 June 1871, in DW.I, 427.

8. *Ibid.*

9. Manet was certainly struck by the sight of the area around Gennevilliers in 1870 as he made clear in a letter to his wife Suzanne, Paris, Thursday, 15 September 1870: "Je suis allé ce matin avec Gustave à Gennevilliers et nous sommes revenus par Asnières. C'est vraiment triste à voir. Tout le monde est parti. On a abattu tous les arbres. On brûle tout, des meules brûlent dans les champs, les pillards cherchent les pommes de terre qu'on n'a pas enlevées. Des camps retranchés partent des mobiles. Enfin, on attend, on ne porte plus que chassepots et revolvers. Je crois qu'on est prêt à se défendre énergiquement." (A. Tabarant, ed., *Une correspondance inédite d'Edouard Manet: Les Lettres du Siège de Paris, 1870–1871*, Paris, 1935, n.p.)

10. See note 2.

11. The first sale of government bonds was on 27 June 1871; they were oversubscribed by two and a half times the amount necessary. A second sale occurred on 29 July 1872; it was oversubscribed by four times the amount. According to contemporary estimates, instead of 5 billion francs, France could have raised 43 billion. See Roger L. Williams, *The French Revolution of 1870–71*, New York, 1969, 163ff.

12. Benjamin Gastineau, *Histoire des chemins de fer*, Paris, 1863, 1.

13. Alphonse Esquiros, *Paris ou les sciences, les institutions et les moeurs au XIXᵉ siècle*, Paris, 1847, I, 263.

14. Pierre Lachambeaudie, *Fables de Pierre Lachambeaudie*, 10th ed., Paris, 1852, 76.

Oui, le génie est roi de la création.
N'écoutant qu'une noble et sainte ambition,
Il parcourt son domaine et soumet la matière;
Il impose des lois à la nature entière;

Tout obéit, tout cède à ses constants efforts.
La terre sous ses pas tressaille d'allégresse,
Et se parant de fleurs, étalant sa richesse,
A son fils, à son maître elle ouvre ses trésors.
Dieu ne se voile plus de ses mystères sombres;
A Prométhée absous il prête son flambleau;
La Presse des esprits a dissipé les ombres
Chaque jour nous révèle un élément nouveau;
Et la vapeur enfin reliant ces conquêtes
Ramène l'âge d'or tant cher des poètes.

15. The myth that Monet never drew will finally come to an end when Daniel Wildenstein publishes Monet's eight sketchbooks in the fourth volume of his catalogue raisonné of the artist. These carnets contain some two hundred drawings spanning Monet's entire career.

16. See *Japonisme: Japanese Influence on French Art, 1854–1910*, exhibition catalogue, Cleveland, 1975; and Colta Fella Ives, *The Great Wave: The Influence of Japanese Woodcuts on French Prints*, New York, 1974.

17. There is a possibility that a painting (now lost) which Monet described as a "tableau chinois où il y a des drapeaux" (W. 107) and that one writer referred to as "le japonais aux petits drapeaux" (DW.I, pièce justicative no. 26, 445) was a work that drew on Japanese sources. However, as Monet also used the word "chinois" when referring to his *Terrace at Sainte-Adresse*, this possibility is only slight.

18. Jules and Edmond de Goncourt, "Journals," 29 October 1868, as quoted in Colta Fella Ives, *Great Wave*, 12.

19. Jules Janin, *La Normandie*, 3rd ed., Paris, 1862, 521–22.

20. Jules Beaujanot, "Argenteuil 15 mars 1862," *Journal d'Argenteuil*, 16 March 1862, 1.

21. *Chantes et Chansons (Poésie et Musique) de Pierre Dupont*, Paris, 1853, III, 67.

22. Charles Price, "Naturalism and Convention in the Paintings of C. F. Daubigny," doctoral dissertation, Yale University, 1967, 18–20.

23. Amédée Guillemin, *Les Chemins de fer*, 3rd ed., Paris, 1869, 86.

24. *Ibid.*, 89.

25. Amédée Achard in Eugène Guinot's *L'Eté à Bade*, Paris, 1861, viii, made much the same point in his description of the Kehl bridge and the surrounding area: "Au pont du Kehl, le fleuve est large et profond; les eaux vertes se précipitent le long des rives qu'elles rongent avec une ardeur folle et un bruit confus; de grands peupliers en suivant le cours, derrière de vastes prairies semées de villages et de clochers; sur la rive gauche, la chaîne des Vosges. La

flèche gigantesque et légère du monstre de Strasbourg domine l'horizon. C'est un chef-d'oeuvre de l'art dans un coin de terre merveilleux; et non loin de ce monument glorieux du passé, le pont sur le Rhin."

26. F. Lebeuf, "Le Pont du chemin de fer d'Argenteuil," *Journal d'Argenteuil*, 30 March 1862, 1.

27. Jules Beaujanot, "Le Viaduc de chemin de fer d'Argenteuil," *Journal d'Argenteuil*, 21 September 1862, 2.

28. For the Kehl bridge see Guinot, *L'Eté*, xi; and Louis Figuier, *Les Merveilles de la science*, Paris, 1862, I, 346–47. Also Guillemin, *Chemins de fer*, 90, 99.

29. F. Lebeuf, "Ouverture de la nouvelle gare d'Argenteuil," *Journal d'Argenteuil*, 7 June 1863, 2.

30. Claude Collas, "Sur le nouveau chemin de fer d'Argenteuil," *Journal d'Argenteuil*, 28 June 1863, 2.

31. M.V., "Le Nouveau Pont d'Argenteuil," *Le Monde Illustré*, XIII, 29 August 1863, 140.

32. Gustave Flaubert, *Sentimental Education*, trans. Robert Baldrick, Harmondsworth, 1974, 298. Pellerin's picture had three titles, *La République, Le Progrès,* or *La Civilisation,* and it showed Christ driving a locomotive through a virgin forest! In his famous letter of April 1879 to the prefect of the Seine, Manet included the railroad as part of the decorative program he proposed for the new Hôtel de Ville in Paris. See Etienne Moreau-Nélaton, *Manet raconté par lui-même*, Paris, 1926, II, 97. The call for painters to take up the railroad as the subject for a new art was made as early as 1848 in an article by Théophile Gautier, "Du beau antique et du beau moderne," *L'Evénement*, 8 August 1848. It was repeated by Thomas Couture in his *Méthode et entretiens d'atelier*, Paris, 1867, 254–56, and later by Jules Claretie in *Peintres et sculpteurs contemporains*, Paris, 1882.

33. Minutes of Argenteuil Municipal Council meeting, 10 November 1856, in AA Vicinal ordinaire no. 8, in Voie des bancs, 1856–1924, 16.O.⁹, in Chemins Vicinaux Ordinaires no. 8–no. 9, 16.O.

34. Gastineau, *Chemins de fer*, 50.

35. Augustin Cochin, *Paris, sa population, son industrie*, Paris, 1864, 19.

36. Esquiros, *Paris*, 271.

37. See Chapter 2, note 35.

NOTES TO CHAPTER 4

1. The two best works on the development of boating in France are Alphonse Karr, *Le Cano-tage en France*, Paris, 1858, and Philippe Daryl, *Le Yacht, histoire de la navigation maritime de plaisance*, Paris, 1890.

2. Jules de Leers, "La Vie aux eaux," *Le Sport*, 13 August 1869, 3. In speaking about the transformations of Paris and the improvements made in many suburban towns, B.-R. in *Le Guide du promeneur aux barrières et dans les environs de Paris*, 1856, Appendice, noted "Ce mouvement de transformation, cette aspiration de la population vers l'air, la lumière, le beau, et le confortable peuvent être considéré comme le caractère distinctif de notre époque." The criticisms of the inferno Paris are from Augustin Cochin, *Paris, sa population, son industrie*, Paris, 1864, 20.

3. Frédéric Lecaron, "Canotage: La Société des régates parisiennes," *Le Sport*, 17 February 1858, 2–3.

4. Lecaron, "Régates Remoises," *Le Sport*, 10 June 1857, 2.

5. Eugène Chapus, *Le Sport à Paris*, Paris, 1854, 184.

6. Lecaron, "Canotage," 17 February 1858, 3.

7. G.V., "Canotage," *Le Sport*, 18 October 1855, 4.

8. "Canotage," *Le Sport*, 25 August 1858, 2. On the establishment of the Cercle de Voile see "Canotage," *Le Sport*, 9 December 1857, 2, and *ibid.*, 24 March 1858, 2.

9. In fact, when one writer for *La Vie Parisienne* rented a boat in Normandy to go from Le Havre to Trouville, he was struck by the condition of the craft: "Etait-ce un yacht? Albert affirmait que oui. Moi, j'aurais parié qu'il n'avait jamais flotté que sur la Seine entre Argenteuil et Bezons." He gained confidence, however, when he saw the skipper: "le matelot, qui à la verité ressemblait à un loup de mer; il était d'Argenteuil." (Claude, "Navigation de plaisance," *La Vie Parisienne*, 15 August 1874, 463.)

10. Monet to Bazille, Sainte-Adresse, 25 June 1867, as cited in DW.I, 423–24.

11. Adolphe Joanne, *Paris illustré en 1870*, Paris, 1870, 644–45.

12. See for example the article entitled "Les Environs de Paris: Argenteuil, Porte de Clippers," *L'Illustration*, XXXII, 30 October 1858, 278.

13. Marc Le Gal, "Navigation de Plaisance," *Journal d'Argenteuil*, 5 April 1868, 1.

14. "Nouvelles locales: Régates d'Argenteuil et le Société des carabines," *Journal d'Argenteuil*, 22 February 1863, 1.

15. Guy Lefevre, "L'Ancienne 'Ile du Moulin Joly' d'Argenteuil devenue 'île marante' autrefois un lieu enchanteur," newspaper clipping, 30 July

1955, Service de documentation du Musée de l'Ile de France, Château de Sceaux, Dossier: Argenteuil; also see *Pays d'Illusion: Les Jardins Français, 1760–1800*, exhibition catalogue, Paris, 1977.

16. Guy de Maupassant, "Two Friends," trans. Roger Colet, in *Selected Short Stories*, Harmondsworth, 1980, 147.

17. On Argenteuil's boat builders see AYSO Census of 1872 and 1876; *Le Sport*, 1 July 1868; and Daryl, *Yacht*, 48.

18. "Yachting," *Le Sport*, 10 June 1874, 2.

19. Eugène Chapus, "La Vie à Paris: Progrès de la navigation de plaisance à Paris," *Le Sport*, 25 October 1865, 3.

20. *Ibid.*

21. Daryl, *Yacht*, 43.

22. Karr, *Canotage*, 191.

23. Frédéric Lecaron, "Rapport fait à l'assemblée générale de la Société des régates parisiennes année 1858, 17 décembre 1858," Paris, 1859, 9, in AA Fêtes Publiques, 1833–59, 5.I.², in Fêtes publiques, 1833–69, 5.I.²–5.I.⁴.

24. Maupassant, "Mouche or Reminiscences of a Rowing Man," in *Short Stories*, 357. The owner of one of the three floating wash houses along the Argenteuil promenade registered a complaint against the boaters in a letter to the department prefect. He claimed, "les canotiers de la Seine causent de fréquents dommages à mon bateau lavoir et à d'autres établissements de cette nature placés le long de la rive droite du fleuve d'Argenteuil." He demanded that boating be banned for 500 meters from the pedestrian bridge. Of course, that did not happen. (AA Letter to mayor of Argenteuil from department prefect, 22 October 1863, in Règlement de la navigation de la Seine, 1820–1916. 31.O.¹.)

25. Wildenstein dates *Sailboats in the Boat Rental Area* to 1872 (DW.I, 212). However, the broad, painterly style of the work is inconsistent with the flatter, more delicate handling of most paintings of that year. Even *The Boat Rental Area* (W. 226), with its evident looseness, does not approach the bravura of the San Francisco picture. Further evidence supports the later dating. Robert Herbert has noted that the boats in the foreground are in fact the same as those that appear in Manet's 1874 portrayal of boaters, *Argenteuil*. While it might be argued that the same boats were moored in Argenteuil over the two year period, Herbert has also observed that in Manet's view *Monet working in his Floating Studio* of 1874 (fig. 81), Monet is in the process of painting the San Francisco view. A drawing

from Monet's Marmottan sketchbooks (fig. 85) supports a date of 1874. Clearly related to *Sailboats in the Boat Rental Area*, it follows several sheets in the same carnet that without doubt are preparatory studies for Monet's *Regatta from Gennevilliers* of 1874 (fig. 77). Finally, the picture's iconography is inconsistent with works from 1872, as no painting from the first year in Argenteuil represents as graphically the contrasting city–country sides of the town. On all of these counts, therefore, a date of 1874 is more reasonable.

26. Eugène Chapus, "La Vie à Paris: La Grenouillère et son bain de rivière," *Le Sport*, 28 August 1867, 3; repeated in Chapus, "La Vie à Paris: Bougival," *Le Sport*, 26 July 1876, 2–3.

27. Y., "Un dimanche d'été," *La Vie Parisienne*, 3 July 1875, 375. Also see Y., "Le Parisien et la nature," *La Vie Parisienne*, 25 September 1875, 431.

NOTES TO CHAPTER 5

1. Eugène Chapus, "La Vie à Paris: Le Caractère de la société parisienne actuelle; les maisons de la campagne," *Le Sport*, 5 September 1860, 2–3.

2. *Ibid.*

3. Jules Janin, *La Normandie*, 3rd ed., Paris, 1862, 503.

4. Chapus, *Le Sport*, 5 September 1860, 2–3.

5. Gustave Flaubert, *Sentimental Education*, trans. Robert Baldick, Harmondsworth, 1976, p. 76.

6. Bachaumont, "La Vie à Paris: Vente de la Malmaison," *Le Sport*, 26 May 1877, 2.

7. "Rapport fait au Conseil Municipal 14 avril 1856," in AA Chemins ruraux. Affaires Générales, 1817–1920, 17.O.², in Chemins ruraux. Etat des reconnaissance, 17.O.

8. Minutes of Municipal Council meeting, 6 April 1845, in AA RDCM, 1844–46.
 On the number of public establishments see AYSO Statistiques commerciales et industrielles; AYSO Census 1872 and 1876; and letter to mayor of Argenteuil from department prefect, 22 March 1877, denying authorization for another café-bar on grounds that 95 were more than sufficient for the town's population, in AA Correspondance (de la maire), 1871–80, 4.D.⁸. On the new pigeon shoot see "Tir aux pigeons d'Argenteuil," *Le Sport*, 2 October 1864, 2.

9. G.B., "En Villégiature," *L'Illustration*, LXX, 13 October 1877, 231–34. The author goes on to ask, "A quelle classe de la société appartient un pareil homme? . . . Bien avisé qui pourrait le

dire. Parmi les savants, parmi les politiques parmi les industriels, parmi les désoeuvrés, on en rencontre de tels. Nous en avons connu aux quatre coins de la France et même à l'étranger où ils ne sont pas rares."

10. A. Houssaye, "Les Poèmes du Salon," *L'Artiste*, LXXIX, 15 June 1866, 207.

11. J. Claretie, "Les Premières Fleurs par M. Adrien Moreau," *L'Illustration*, LXIII, 11 April 1874, 234.

12. Bachaumont, "La Vie à Paris: La Villégiature aux environs de Paris," *Le Sport*, 28 July 1875, 2.

13. "Le Matin—graveur d'après M. Becker," *L'Illustration*, LXV, 27 March 1875, 207.

14. Emile Zola, "Mon salon: IV. Les Actualistes," *L'Evénement Illustré*, 24 May 1868.

15. Théodore Duret, *Les Peintres Impressionnistes*, Paris, 1878, 19.

16. George Rivière, "L'Exposition des impressionnistes," *L'Impressionniste*, I, 6 April 1877, 2–6, as cited in Barbara White, ed., *Impressionism in Perspective*, Englewood Cliffs, 1978, 9.

17. Flaubert, *Bouvard and Pécuchet*, trans. A. J. Krailsheimer, 1978, 173.

18. Eugène Chapus, "Ça et là: La Vie des eaux est passée dans nos moeurs," *Le Sport*, 19 August 1874, 3.

19. Flaubert, *Bouvard and Péchuchet*, 173.

20. A. Piedagnel, "Millet chez lui—Souvenirs de Barbizon," *L'Artiste*, XLVII, May 1876, 288.

21. Edmond Duranty, *La Nouvelle Peinture: Propos du groupe d'artistes qui expose dans les Galeries Durand-Ruel*, Paris, 1876.

22. Cited in Linda Nochlin, *Realism*, Harmondsworth, 1977, 63.

23. G. Brandes, "Japanesik og impressionisti kunst," as cited in DW.I, 276.

24. Société des études, *Assainissement de Paris. Des eaux d'égouts et des vidanges: Leur utilisation à l'agriculture par irrigation dans leurs parcours jusqu'à la mer*, Paris, 1875, 33.

25. *Ibid.*, 13ff; Robert Quinot, *Gennevilliers, evocation historique: I. Dès origines à la fin du XIX^e siècle*, Gennevilliers, 1966, 242; and Société des agriculteurs de France, *Utilisation agricole des eaux d'égout rapport présenté au nom de la 5^e section*, Paris, 1876, 7–36.

26. On these deux proposals see Société des études, *Assainissement de Paris*, 41ff; *Assainissement de la Seine*, Paris, 1876, III (Documents administratifs), 157–88; and *Mémoire sur l'avant projet de déviation des eaux d'égout de la ville de Paris*, Saint-Germain-en-Laye, 1876, 5–47; *Rapport de la Commission chargée de proposer les mesures à prendre pour remédier*

à l'infection de la Seine aux abords de Paris, Paris, 1875.

27. Minutes of Municipal Council meeting, 9 November 1875, in AA Assainissement de la Seine. Déversement des égouts dan la Seine, 1874–1909, 66.I.[3], in Surveillance des eaux, des écoles. Vaccination, 66.I.–69.I. And AA Extrait du Registre des Délibérations du Conseil Municipal de la Ville d'Argenteuil Séance du 17 mai 1876: Eaux des égouts de Paris, in *ibid.*

28. *Mémoire sur l'avant projet*, 45.

29. On proposals for a second railroad see Arrêté, 24 February 1877, in AA RAM, 1854–83. On the plans for the expansion of the railroad plaza see Arrêté, 2 April 1876, in *ibid.*; on the new street that opened next to Monet's house see Avenue de la Gare, Chapter 2, note 28. On the third iron works see Chapter 6, note 12.

30. Monet to de Bellio, Argenteuil, 20 June 1876, cited in DW.I, 430.

NOTES TO CHAPTER 6

1. John Rewald, *The History of Impressionism*, revised ed., New York, 1961, 432. Douglas Cooper and John Richardson in their catalogue to the Monet exhibition of 1957 in Edinburgh also identified the work as Vétheuil, 1878 (49–50).

2. Minutes of Municipal Council meeting, 15 February 1877, in AA RDCM, 1876–81, I.D.[24]

3. The house on the right was built by M. Fabre, a Parisian who moved to Argenteuil in the early 1850s. He bought a large tract of land now defined by the rue Verte and the avenue du Petit Marly and constructed ten to twelve houses that were later referred to as the colonie Fabre. See AA Minutes of Municipal Council meetings, 6 August 1853 and 21 August 1855, in RDCM, 1853–59, I.D.[21]; also see AA Cadastre de la ville d'Argenteuil.

4. On the replanting of the Champs de Mars near the Route Nationale see Minutes of Municipal Council meeting, 9 November 1875, in AA RDCM, 1870–76, I.D.[24]

 On the alignment of the rue du Port see Rue du Port, 1834–1900, in AA Dossiers des Rues Pe.–Pu., 4.O.

5. Located at the western limits of Argenteuil, close to the neighboring town of Bezons, the Château du Marais was a sizeable estate with formal gardens and an impressive house dating from the mid-eighteenth century. Occupied briefly by Mirabeau, it was subsequently owned by the Duc de Creds, Madame de Beaumetz, the

Comte Ressequier and the Marquis d'Anglade. The Marquis and his descendants held the estate until the late 1860s or early 1870s. During Monet's years at Argenteuil, it seems to have been used very little, although the residents of the area cited the Marquis as an important inhabitant of the neighborhood when they wrote the mayor asking for more street lights. See Chapter 2, note 17.

For other information on the chateau see Edmond Réthoré, *Argenteuil et son passé*, Saint-Gratien, 1868, I, 247–69; Réthoré, "Le Château du Marais," *Le Vieil Argenteuil*, 18, 1952–63, 29–53; and Avenue du Marais, 1833–82, 4.O., in AA Dossiers des Rues L.–Mo., 4.O.

6. Cézanne had brought Victor Chocquet to Monet's house in Argenteuil in February 1876. This appears to have been Monet's first contact with this patron of many of the Impressionists. See letter from Monet to Chocquet, 4 February 1876, as cited in DW.I, 430.

7. Rodolphe Walter, "Le Parc de Monsieur Zola," *L'Oeil*, CCLXXII, March 1978, 18–25. Bachaumont claimed that the Parc Monceau offered "la promenade la plus merveilleuse peut-être de la capitale ne ressemblant en aucune façon en son genre aux jardins du Luxembourg et des Tuileries." ("La Vie à Paris: Le Parc Monceau," *Le Sport*, 19 September 1877, 2–3.) On the history of the park see in particular A. Alphond, *Les Promenades de Paris*, Paris, 1867–73.

8. On this commission see DW.I, 88ff.

9. On 17 January 1877 Monet wrote the well-known editor Charpentier informing him that "Je suis à peu près installé 17 rue Moncey." (DW.I, 431.) By March Monet had already sold several views of the station, three to Hoschedé alone. In the third Impressionist exhibition which opened in April, Monet showed thirty works, eight of which were of the railroad station. See DW.I, 84.

10. Baron Grimm, "Lettres anecdotiques: Les Impressionnistes," *Le Figaro*, 5 April 1877.

11. Georges Rivière, "L'Exposition des impressionnistes," *L'Impressionniste*, I, 6 April 1877, 2–6, as cited and trans. in Barbara White, ed., *Impressionism in Perspective*, Englewood Cliffs, 1978, 10.

12. The plaster concerns rose from 295 employees in late 1876 and early 1877 to 320; the crystal factory, which had dropped in late 1876 to only 15 employees (from 130 in 1875), rose to 70 in the third quarter of 1877 and over 200 in the last quarter. The sawmill was up to 30 workers from a mid-1877 low of 18, and the two major embroidery concerns, which had employed 50

people in 1876 were employing 85 by late 1877. All employment figures are from AA Statistiques commerciales et industrielles, 1858–1929, 6.F., in Commerce et Industrie 3.F.–6.F. and AN SICSO.

On the third iron works that opened in front of Monet's house see AA Rues des Charretiers, 1865–1912, 4.O., in Dossier des Rues Ca.–Cha., 4.O.

In April 1875 Ambrose Thomas wrote the mayor of Argenteuil a spirited letter protesting the noise caused by the second iron works founded in 1874 in his neighborhood: "le martèlément des grosses pièces, qu'on n'entend que trop souvent, est vraiment intolérable." (AA DEA, 7.M.) Monet must have suffered similar inconvenience.

13. On the proposals for the second railroad see Chapter 5, note 29; the Minutes of the Municipal Council meeting, 4 March 1877, and for a full review of the situation the Minutes of the Municipal Council meeting, 19 December 1877, both in AA RDCM, 1876–81, I.D.[25]

14. For the establishment of the tramway from Mantes to Argenteuil see Minutes of the Municipal Council meeting, 14 August 1877, and for the line from Paris to Argenteuil see the request made by M. le Baron de Coelln as transcribed in the Minutes of the Municipal Council meeting, 6 April 1877, both in AA RDCM, 1876–81, I.D.[25]

15. On Bouts's rental see Minutes of Municipal Council meeting, 11 July 1877, in *ibid*. On the land purchase see Minutes of Municipal Council meeting, 23 May 1877, in *ibid*. In a letter to the mayor of Argenteuil protesting the establishment of the second iron works in 1874, one resident wrote: "The area of the Porte aux Engrais is admirably situated on the banks of the Seine at the end of Argenteuil's principal promenade across from a charming island [the Ile Marante]. It offers you one of the most beautiful views in the suburbs of Paris. It is here that the municipal government wants to build a boiler-making factory. But in a few years when political calm will be reestablished and the real estate market will resume its upward spiral, it is not for 10 francs a meter that the city will be able to sell the land but rather for twenty-five or thirty."

The land for the road the city intended to build in the area in 1876 cost twenty francs a meter, close to the resident's prediction.

16. On the new distillery and the reopening of the chemical plant see AA DEA.

17. Census figures from AYSO.

200

18. Letter from mayor of Argenteuil to department prefect, 8 October 1878, in AA Correspondance (de la maire), 1871–80, 4.D.⁸.

19. A. C. Chevalier, "Hygiène publique—Les Chiens morts," *Journal d'Argenteuil*, 29 March 1863, 2.

20. Minutes of Municipal Council meeting, 10 October 1855, in AA RDCM, 1853–59, I.D.²¹.

21. Chevalier, "Hygiène publique," 2.

22. Letter from mayor of Argenteuil to department prefect, 23 July 1872, in AA Correspondance (de la maire) 1871–80, 4.D.⁸.

23. Letter from the Directeur de la Compagnie des Ponts d'Asnières et Argenteuil, 12 June 1873, in AA LIVRP, 1808–1922, 63.I.

24. Letter from mayor of Argenteuil to M. Foulard, Ingénieur pour la ville de Paris, 4 June 1874, in AA Correspondance (de la maire), 1871–80, 4.D.⁸. In November 1874 the Municipal Council sent a formal protest to the department prefect, the president of the National Assembly, and the minister of public works outlining the state of the Seine and demanding action. The protest is worth quoting in full. "Vu l'état d'infection toujours croissant de la Seine, état reconnu par une commission administrative spéciale et tellement évident qu'ils suffit de le signaler. Considérant que la Seine est devenue le réceptacle des immondices de toute nature amenées non seulement par l'égout collecteur mais encore par les égout de St. Denis et de Colombes; considérant que le bassin d'Argenteuil, n'ayant qu'un très faible courant à cause de la retenue du barrage de Bezons, devient d'autant plus facilement le dépôt des matières et que son envasement prochain n'est pas douteux; considérant que la santé de la population (10,000 habitants) est sérieusement compromise par l'alimentation de ces eaux malsaines ainsi que par les émanations d'un fleuve boueux incessamment agité par le passage des bateaux; considérant d'autre part que, si cherchant la purification de la Seine

dans l'utilisation agricole des eaux d'égout, la ville de Paris met à exécution son projet de déverser toutes les eaux du grand collecteur dans la plaine de Gennevilliers, une telle affectation donnée à cette vaste plaine est de nature à préjudicier à la ville d'Argenteuil et à légitimer les craintes les plus vives; considérant enfin qu'il est tout à fait inadmissible que la ville de Paris cherche l'assainissement de la Seine dans l'application de moyens insuffisants et dans le seul but de retarder la dépense que nécessiterait un moyen efficace mais onéreux; considérant de plus que c'est un devoir étroit pour le conseil de solliciter l'intervention d'un gouvernement, afin de contraindre le département de la Seine à appliquer immédiatement un moyen certainement efficace qui ferait disparaître les dangers présents et à venir et mettre un terme aux inquiétudes justifiées des populations. Delibere: Il y a lieu de se pourvoir auprès de l'Assemblée Nationale de M. le Ministre des Travaux publics à l'effet d'obtenir que la ville de Paris et le département de la Seine soient mis en demeure de conduire leurs eaux d'égouts jusqu'à un point où elles cesseront d'avoir des inconvénients pour la salubrité publique." (AA Minutes of Municipal Council meeting, 9 November 1874, in RDCM, 1870–76, in I.D.²⁴.)

25. Letter from mayor of Argenteuil to M. Panhart, avocat au Conseil d'Etat, 9 February 1878, in AA Correspondance (de la maire), 1871–80, 4.D.⁸.

26. Guy de Maupassant, "Mouche, or Reminiscences of a Rowing Man," in *Selected Short Stories*, trans. Roger Colet, Harmondsworth, 1980, 357–58.

27. Letter from Monet to Chocquet, 25 October 1877, as cited in DW.I, 432.

28. DW.I, 89.

29. Letter from Monet to Eugène Murer, 1 September 1878, as cited in DW.I, 433. On Vétheuil, see Annuaire de Commerce, Arrondissement de Mantes, Vétheuil, as cited in DW.I, 92.

Bibliography

CLAUDE MONET

PRIMARY SOURCES

Archives Durand-Ruel, Paris.
Bibliothèque Nationale, Cabinet des estampes, Paris.

SECONDARY SOURCES

Butor, Michel. "Claude Monet ou le monde renversé," *L'Art de France*, I, 1963, 277–301.
Chatillon-Josse, Jacqueline. "Par monts et par vaux: Le Fief de Villebon. Sur les pas de Guy de Maupassant et de Claude Monet," *Bulletin de la Société des amis de Meudon-Bellevue*, CXIX, May–August 1969, 1799–1801.
Chevalier, Frédéric. "Les Impressionnistes," *L'Artiste*, XXV, May 1877, 329–33.
Cooper, Douglas and Richardson, John. *Claude Monet*. Exhibition catalogue. London: Arts Council of Great Britain, 1957.
Duranty, Edmond. *La Nouvelle Peinture: À propos du groupe d'artistes qui expose dans les Galeries Durand-Ruel (1876)*. Foreword and notes by Marcel Guerin. Paris: 1946.
Duret, Théodore. *Les Peintres Impressionnistes: Claude Monet, Sisley, C. Pissarro, Renoir, Berthe Morisot*. Paris: Heymann & Perois, 1878.
Fels, Marthe de. *La Vie de Claude Monet*. Paris: Gallimard, 1929.
Geffroy, Gustave. *Claude Monet: Sa vie, son oeuvre*. 2nd ed. 2 vols. Paris: G. Crès, 1924.
Gimpel, René. *Dairy of an Art Dealer*. Trans. Joseph Rosenberg. New York: Farrar, Strauss, & Giroux, 1966.
Goldwater, Robert. "Symbolic Form: Symbolic Content," in *Acts of the Twentieth International Congress of the History of Art*. Princeton: 1963, 4, 111–21.
Herbert, Robert. "Method and Meaning in Monet," *Art in America*, LXVII, September 1979, 90–108.
House, John. *Claude Monet*. London: Phaidon, 1978.
———. "Claude Monet: His Aims and Methods, *c.* 1877–1895," doctoral thesis, Courtauld Institute of Art, 1976.
Isaacson, Joel. *Monet: Le Déjeuner sur l'herbe*. New York: Viking Press, 1972.
———. "Monet's Views of Paris," *Allen Memorial Art Museum Bulletin*, XXIV, Fall 1966, 5–22.
———. *Observation and Reflection: Claude Monet*. Oxford: Phaidon, 1978.
Lefevre Gallery and Denys Sutton. *Claude Monet: The Early Years*. Exhibition catalogue. London: Lefevre Gallery, 1969.
Levine, Steven. "Décor/Décorative/Décoration in Claude Monet's Art," *Arts Magazine*, LI, February 1977, 136–39.
———. "Monet's Pairs," *Arts Magazine*, XLIX, June 1975, 72–75.
———. *Monet and his Critics*. New York: Garland Press, 1976.

BIBLIOGRAPHY

Levine, Steven. "Window Metaphor and Monet's Windows," *Arts Magazine*, LIV, November 1979, 98–104.

Musée Marmottan. *Monet et ses amis*. Paris: 1971.

———. *Monet et ses amis, nouveaux enrichissements*. Paris: 1972.

Needham, Gerald. "The Paintings of Claude Monet, 1859–1878," doctoral thesis, Institute of Fine Arts, 1971.

Rewald, John. *The History of Impressionism*. 4th revised ed. New York: Museum of Modern Art, 1973.

Rivière, Georges. "L'Exposition des impressionnistes," *L'Impressionniste*, 6 April 1877.

Roskill, Mark. "Early Impressionism and the Fashion Print," *Burlington Magazine*, CXII, June 1970, 391–94.

Sabbine, C. *Science and Philosophy in Art*. Philadelphia: 1886.

Seiberling, Grace. "The Development of an Impressionist," in *Paintings by Monet*. Exhibition catalogue. Chicago: Art Institute of Chicago, 1975.

———. "Monet at Argenteuil," master's thesis, Yale University, 1967.

Seitz, William. *Claude Monet*. Exhibition catalogue. St. Louis: City Art Museum, 1957.

———. *Claude Monet*. New York: Abrams, 1960.

———. *Claude Monet: Seasons and Moments*. Exhibition catalogue. New York: Museum of Modern Art, 1960.

Walter, Rodolphe. "Emile Zola and Claude Monet," *Cahiers Naturalistes*, XXVI, 1964, 51–61.

———. "Saint-Lazare, l'impressionniste," *L'Oeil*, CCXCII, November 1979, 52–55.

———. "Les Maisons de Claude Monet à Argenteuil," *Gazette des Beaux-Arts*, LXVIII, December 1966, 333–42.

Wildenstein, Daniel. *Claude Monet: Biographie et catalogue raisonné*. 3 vols. (1840–1881) (1882–1886) (1887–1898) Peintures. Lausanne–Paris: Bibliothèque des Arts, 1974–78.

NINETEENTH-CENTURY FRENCH ART AND ISSUES

Arnaud, Arsène, [Jules Claretie]. *L'Art et les artistes français contemporains*. Paris: Charpentier, 1876.

Baudelaire, Charles. *The Painter of Modern Life and other Essays*. Trans. and ed. Jonathan Mayne. London: Phaidon, 1964.

Becker, Georges Joseph. *Paris and the Arts, 1851–1896, from the Goncourt Journals*. Ithaca: Cornell University Press, 1971.

Berhaut, Marie. *Gustave Caillebotte: sa vie et son oeuvre*. Paris: Bibliothèque des Arts, 1978.

Blunden, Maria and Blunden, Godfrey. *Impressionists and Impressionism*. Geneva: Skira, 1970.

Boas, Georges. "Il faut d'être de son temps," *Journal of Aesthetics and Art Criticism*, I, 1941, 52–65.

Brookner, Anita. *The Genius of the Future*. London: Phaidon, 1971.

Champa, Kermit. *Studies in Early Impressionism*. New Haven and London: Yale University Press, 1973.

Chesneau, Ernest. "Le Japon à Paris," *Gazette des Beaux-Arts*, XVIII, 1878, 385–97, 841–56.

Clark, T. J. *Images of the People*. London: Thames and Hudson, 1973.

———. *The Absolute Bourgeois*. London: Thames and Hudson, 1973.

George, Albert Joseph. *The Development of French Romanticism: The Impact of the Industrial Revolution on Literature*. Syracuse: Syracuse University Press, 1955.

Goldwater, Robert. "The Glory that was France," *Art News*, LXV, March 1966, 40–50.

Grana, César. *Fact and Symbol: Essays in the Sociology of Art and Literature*. New York: Oxford University Press, 1971.

Hauser, Arnold. *The Social History of Art*. 4 vols. New York: Viking Press, 1957.

Herbert, Robert L. *Barbizon Revisited*. Exhibition catalogue. Boston: Museum of Fine Arts, 1962.

———. "City vs. Country: The Rural Image in French Painting from Millet to Gauguin," *Artforum*, VIII, February 1970, 44–50.

———. *Jean François Millet*. Exhibition catalogue. Paris: Musées Nationaux, 1975.

Ives, Colta Fella. *The Great Wave: The Influence of Japanese Woodcuts on French Prints*. New York: Graphic Society, 1974.

Jacquemart, Albert. "L'Art japonais au Palais de l'industrie," *Gazette des Beaux-Arts*, VII, 1873, 281ff, 446ff.

Japonisme: Japanese Influence on French Art, 1854–1910. Exhibition catalogue. Cleveland, Ohio: Cleveland Museum, 1975.

Klingender, Francis, D. *Art and the Industrial Revolution*. Revised ed. Frogmore: Paladin, 1975.

Lethève, Jacques. *Impressionnistes et symbolistes devant la presse*. Paris: Armand Colin, 1959.

Nochlin, Linda, ed. *Impressionism and Post-Impressionism, 1874–1904: Sources and Documents*. Englewood Cliffs: Prentice-Hall, 1966.

——. *Realism*. Harmondsworth: Penguin, 1977.

——. ed. *Realism and Tradition in Art, 1848–1900: Sources and Documents*. Englewood Cliffs: Prentice-Hall, 1966.

Piedagnel, A. "Millet chez lui: Souvenirs de Barbizon," *L'Artiste*, XLVII, 1, 1876, 287ff.

Poulain, Gaston. *Bazille et ses amis*. Paris: Renaissance du Livre, 1932.

Riverside Department of the History of Art. *The Impressionists and the Salon, 1874–1886*. Exhibition catalogue. Riverside: University of California, 1974.

Rosenthal, Léon. *Du romantisme au réalisme: Essai sur l'évolution de peinture en France de 1830 à 1848*. Paris: H. Laurens, 1914.

Schorske, Carl E. *Fin-de-siècle Vienna*. New York: Vintage Books, 1981.

Shapiro, Meyer. "The Nature of Abstract Art," *Marxist Quarterly*, I, January–March 1937, 77–99.

Varnedoe, J. Kirk T. and Lee, Thomas P. *Gustave Caillebotte: A Retrospective Exhibition*. Exhibition catalogue. Houston: Museum of Fine Arts, 1976.

Varnedoe, J. Kirk T. "Artifice or Candor: Impressionism and Photography Reconsidered," *Art in America*, LXVIII, January 1980, 66–78.

Venturi, Lionello, ed. *Les Archives de l'impressionnisme*. 2 vols. Paris and New York: Durand-Ruel, 1939.

White, H. C. and White, C. A. *Canvases and Careers: Institutional Change in French Painting*. New York: Wiley, 1965.

White, Barbara, ed. *Impressionism in Perspective*. Englewood Cliffs: Prentice-Hall, 1978.

Zola, Emile. *Salons*. Ed. F. W. J. Hemmings and R. J. Niess. Geneva: E. Droz, 1959.

NINETEENTH-CENTURY PARIS AND THE SUBURBS

PRIMARY SOURCES

Archives Nationales. Cartes, plans et profils de chemins de fer, 1826–95 (F^{14} 10330–10332).

——. Etat des dommages causes aux chemins de fer par la guerre de 1870–71: états des destructions, réflexions, travaux, plans, rapports, 1870–73 (F^{14} 9235).

——. Ponts de Seine-et-Oise, rapports, mémoires, correspondances, devis, plans, An III–1883.

——. Situation industrielle de Seine-et-Oise, 1869–1887 (F^{12} 4538).

——. Usines métallurgiques: authorizations, Seine-et-Oise, 1811–67, 1790–1867 (F^{14} 1273, F^{14} 4484).

SECONDARY SOURCES

Allem, Maurice. *La Vie quotidienne sous le Second Empire*. Paris: Hachette, 1948.

Alphand, Adolphe. *Les Promenades de Paris*. Paris: Rothschild, 1867–73.

Anonymous. "Un dimanche d'été," *La Vie Parisienne*, XIII, 3 July 1875, 375.

——. *Exposé sommaire de la différence existant entre Le Sport Nautique de la Seine (Société d'encouragement pour la navagation de plaisance) et La Société des régates parisiennes*. Paris: 1867.

——. *L'Eté à Paris*. Paris: L. Curmen, 1843.

——. *Impressions and observations of a young person during a residence in Paris*. 3rd ed. Paris: A. & W. Galignani, 1845.

——. *Journal of a party of pleasure to Paris in the month of August 1802*. London: Cadell, 1814.

——. *Nouveau manuel universel et raisonné du canotier par un loup d'eau douce*. Paris: Librairie Encyclopédique de Robert, 1845.

——. "Le Parisien et la Nature," *La Vie Parisienne*, XIII, 25 September 1875, 545.

——. *Scenes de Paris*. Paris: Guéry & Cie., 1829.

Archives Nationales. *Le Parisien chez lui au XIX^e siècle, 1814–1914*. Exhibition catalogue. Paris: Archives Nationales, 1976.

Audiganne. *Paris dans sa splendeur*. 3 vols. Paris: Henri Charpentier, 1861–63.

Bibliography

B.-R. *Le Guide du promeneur aux barrières et dans les environs de Paris*, Paris: Librairie populaire des villes et des campagnes, 1856.

Bachaumont. "La Vie à Paris: Paris qui part et Paris qui reste," *Le Sport*, 10 July 1878, 2.

———. "La Vie à Paris: La Villégiature aux environs de Paris," *Le Sport*, 28 July 1875, 2.

Benjamin, Walter. "Paris—Capital of the Nineteenth Century," *New Left Review*, XLVIII, March–April 1968.

Bonnemère, Eugène. *Histoire des paysans depuis le fin du moyen âge jusqu'à nos jours, 1200–1850*. 2 vols. Paris: 1856.

Briffault, Eugène. *Paris dans l'eau*. Paris: J. Hetzel, 1844.

Bury, John Bagnell. *The Idea of Progress*. London: 1921.

Cans, A. "L'Accroissement de la banlieue parisienne et la dépopulation des campagnes en Seine-et-Oise," *Revue de l'histoire de Versailles et Seine-et-Oise*, 1929, 329ff.

Chapman, J. M. and Chapman, Brian. *The Life and Times of Baron Haussmann: Paris in the Second Empire*. London: Weidenfeld & Nicolson, 1957.

Chapus, Eugène. *Le Sport à Paris*. Paris: Hachette, 1854.

———. "La Vie à Paris: Bougival, son port, son bal des canotiers et son restaurant des canotiers," *Le Sport*, 26 July 1876, 2–3.

———. "La Vie à Paris: La Campagne et Paris," *Le Sport*, 30 April 1856, 3.

———. "La Vie à Paris: Les Campagnes des environs de Paris," *Le Sport*, 22 June 1859, 3.

———. "La Vie à Paris: Le Caractère de la société parisienne actuelle; les maisons de campagne," *Le Sport*, 5 September 1860, 2–3.

Charlton, D. G. *Positivist Thought in France, 1852–1870*. Oxford: Clarendon Press, 1959.

Chevalier, Louis. "Les Fondements économiques et sociaux de l'histoire politique de la région parisienne, 1848–1870," thesis, University of Paris, 1951.

———. *La Formation de la population parisienne au XIXᵉ siècle*. Paris: Presses Universitaires de France, 1949.

Clapham, J. H. *The Economic Development of France and Germany, 1815–1914*. Cambridge: Cambridge University Press, 1961.

Clément, A. *Nouveau guide du voyageur dans les environs de Paris par les chemins de fer*. Paris: Chaumont, 1851.

Cochin, Augustin. *Paris, sa population, son industrie* (Mémoire read at the Académie des sciences morales et politiques, 18 and 25 June 1864). Paris: 1864.

Copping, Edward. *Aspects of Paris*. London: 1858.

Daly, C. *L'Architecture privée au XIXᵉ siècle sous Napoléon III: Nouvelle maisons de Paris et des environs*. 3 vols. Paris: 1864–72.

Daryl, Philippe. *Le Yacht, histoire de la navigation maritime de plaisance*. Paris: Maison Quantin, 1890.

Delvau, Alfred. *Les Plaisirs de Paris: Guide practique et illustré*. Paris: Faure, 1867.

———. *Du Pont des Arts au Pont de Kehl, Reisbilder d'un Parisien*. Paris: Faure, 1866.

DuCamp, Maxime. *Paris: Ses organes, sa fonction et sa vie dans la seconde moitié du XIXᵉ siècle*. 6 vols. Paris: Hachette, 1869–76.

Dulaure, J. A. *Histoire physique, civile, et morale des environs de Paris*, 2 vols. Paris: Guillaume, 1825.

Dupont, Pierre. *Chants et chansons, poesie et musique*. 3 vols. Paris: Alexandre Houssiaux, 1852–54.

Esquiros, Alphonse. "Les Chemins de fer des environs de Paris," *Revue de Paris*, III, 1845, 374–79.

———. *Paris ou les sciences, les institutions et les moeurs au XIXᵉ siècle*. 2 vols. Paris: Imprimeurs amis, 1847.

Frédéric. "Le canotage et les canotiers," *Le Sport*, 12 March 1856, 3.

Fournel, Victor. *Paris nouveau et Paris futur*. Paris: Lecoffre, 1865.

Gastineau, Benjamin. *Histoire des chemins de fer*. Paris: Hachette, 1863.

Gourdon, Edouard. *Physiologie des diligences et des grandes routes*. Paris: Hachette, 1842.

Green, F. C. *A Comparative View of French and British Civilization, 1850–1870*. London: Dent, 1965.

Guillemin, Amédée. *Les Chemins de fer*. 3rd ed. Paris: Hachette, 1869.

Janin, Jules. *Almanach du plaisir, sport, chasse, théâtres, jeux gastronomie, eaux, et bains de mer, voyages, fêtes. . . .* Paris: Garnier, 1852.

———. *La Normandie*. 3rd ed. Paris: Ernest Bourdin, 1862.

———. *Guide du voyageur de Paris à la mer*, Paris: Ernest Bourdin, n.d.

———. "Les ruines des Tuileries," *L'Artiste*, XLVIII, 1 February 1877, 73–77.

Joanne, Adolphe. *Les Environs de Paris illustrés*, Paris: Hachette, 1868.

Joanne, Adolphe. *De Paris à Saint-Germain à Poissy et à Argenteuil*. Paris: Hachette, 1856.

———. *Paris illustré en 1870*. Paris: Hachette, 1870.

Karr, Alphonse. *Le Canotage en France*. Paris: Jules Taride, 1858.

Labédollière, Emile de. *Histoire des environs du nouveau Paris*. Paris: Gustave Barba, 1861.

———. *Le Nouveau Paris*. Paris: Gustave Barba, 1860.

Lachambeaudie, Pierre. *Fables de Pierre Lachambeaudie*. 10th ed. Paris: Pagnerre, 1852.

Lacombe, Paul. *Bibliographie parisienne: Tableaux de moeurs, 1600–1880*. Paris: P. Rouquette, 1887.

Lambeau, Lucien. *Histoire des communes annexées à Paris en 1859*. Paris: E. Leroux, 1910–23.

Lavergne, Léonce de. *Economie rurale de la France depuis 1789*. 3rd ed. Paris: Guillaumin et Cie., 1866.

Lebeuf, Abbé. *Histoire de Paris et ses diocèses*. Paris: 1749.

Leers, Jules de. "La Vie aux eaux," *Le Sport*, 13 August 1869, 3.

Lefranc, Georges. "The French Railroads, 1823–1842," *Journal of Economic and Business History*, II, 1930, 299–331.

Lemoine, H. "Le Département de Seine-et-Oise de l'an VIII à 1871," *Revue de l'histoire de Versailles et Seine-et-Oise*, I–II, January–June 1940, 22–48; July–December 1942, 95–108; July–December 1943, 1–8.

Luchet, Auguste. *Les Moeurs d'aujourd'hui*. Paris: Coulon-Pineau, 1854.

Martin, A. *Les Environs de Paris: Region de l'ouest*. Paris: A. Hennuyer, 1892.

Merlin, Pierre. *Les Transports Parisiens (Etude de geographie économique et sociale)*. Paris: Masson & Cie., 1967.

Mulhall, Michael G. *Balance Sheet of the World for Ten Years, 1870–1880*. London: Edward Stanford, 1881.

Musée de l'Ile de France, Château de Sceaux. *Les Parisiens à la campagne*. Exhibition catalogue. Sceaux: 1938.

O'Farrell, Horace H. *The Franco-German War Indemnity and its Economic Results*. London: Harrison & Sons, 1913.

Oudiette, Charles. *Dictionnaire topographique des environs de Paris*. Paris: J. G. Dentu, 1812.

Perignon, E. "Yachting: Un yacht de plaisance à Paris il y a deux siècles," *Le Sport*, 21 November 1866, 3.

Pinkney, David H. "Migrations to Paris during the Second Empire," *Journal of Modern History*, XXV, 1953, 1–12.

———. *Napoleon III and the Rebuilding of Paris*. Princeton: Princeton University Press, 1972.

Quinot, Robert. *Gennevilliers, evocation historique: I. Dès origines à la fin du XIXe siècle*. Gennevilliers: 1966.

Richardson, Joanna. *La Vie parisienne, 1852–1870*. London: Hamish Hamilton, 1971.

St. John, Bayle. *Purple Tints of Paris: Character and Manners in the New Empire*. New York: Riker, Thorne & Co., 1854.

Simond, Charles. *Paris de 1800 à 1900 d'après les estampes et les mémoires du temps*. Paris: Librairie Plon, 1900.

Société des études. *Assainissement de Paris. Des eaux d'égoûts et des vidanges: Leur utilisation à l'agriculture par irrigation dans leurs parcours jusqu'à la mer*. Paris: Société des études, 1875.

Textier, Edmond. *Tableaux de Paris*. Paris: Paulin & Le Chevalier, 1852.

Veuillot, Louis. *Les Odeurs de Paris*. Paris: Palmé, 1867.

Weber, Adna. *The Growth of Cities in the Nineteenth Century*. New York: Macmillan, 1899.

Williams, Raymond. *The Country and the City*. New York: Oxford University Press, 1973.

ARGENTEUIL

PRIMARY SOURCES

Archives Nationales. Plan des rues, places, quais, ports, ruelles, et impasses de la ville d'Argenteuil, 1840 (F^{1a} 2002^{320}).

Archives Départementales. Police Municipale, Arrêtés, 1866–1938.

———. Etablissements dangereux, insalubres, ou incommodes, An VIII–1940.

———. Pont d'Argenteuil, 1871–74.

———. Recensement, canton d'Argenteuil, 1818–81.

———. Statistiques commerciales et industrielles, canton d'Argenteuil, 1818–81.

———. Voirie urbaine, rue alignements, terrains, travaux.

Archives d'Argenteuil. Agriculture (7.F.–12.F.).

———. Berges de la Seine, 1874–99 (34.O.).

BIBLIOGRAPHY

Archives d'Argenteuil. Biens communaux. Echanges. Locations (6.N.–7.N.).
———. Cadastre de la ville d'Argenteuil.
———. Chemins de halage, An XII (1804)–1910 (34.O.).
———. Chemins vicinaux ordinaires (16.O.).
———. Commerce et Industrie (3.F.–6.F.).
———. Contentieux (15.D.–16.D.).
———. Correspondance (de la maire) 1818–80 (4.D.).
———. Dossiers des rues A–Z (4.O.).
———. Eclairage. Gaz. (5.O.–12.O.).
———. Etablissements dangereux, insalubres et incommodes (65.I.).
———. Fêtes publiques, 1833–85 (5.I.).
———. Logements insalubres. Visites, rapports, plaints, 1808–1922 (63.I.).
———. Marchés. Baux et traités, 1868–96 (17.F.).
———. Registre des arrêtés du maire, 1822–83.
———. Registre des délibérations du Conseil Municipal, 1818–80.
———. Règlement de la navigation de la Seine, 1820–1916 (31.O.).
———. Routes Nationales (18.O.).
———. Sinistres. Inondations (19.I.).
———. Surveillance des eaux, des écoles. Vaccination. (69.I.).
———. Trafic et amenagements du port à marchandise, 1826–1922 (67.I.).
Archives du Musée du Vieil Argenteuil.

SECONDARY SOURCES

Anonymous. *Les Allemands en France, huit jours dans Seine-et-Oise*. Paris: Librairie générale, 1872.
———. "Les Environs de Paris: Argenteuil, Porte de Clippers," *L'Illustration*, XXXII, 30 October 1858, 278.
———. "Excursion sur la fête d'Argenteuil," *Journal d'Argenteuil*, 7 June 1863.
———. *Rapport de la Commission chargée de proposer les mesures à prendre pour remédier à l'infection de la Seine*. Paris: A. Wittersheim & Cie., 1875.
Beaujanot, Jules. "Promenade autour d'Argenteuil, La Butte d'Orgemont," *Journal d'Argenteuil*, 13 April 1862. 1.
———. "Viaduc de chemin de fer d'Argenteuil," *Journal d'Argenteuil*, 21 September 1862, 2.
C.P.D. "Les Environs de Paris: Argenteuil," *L'Illustration*, LIV, 25 September 1869, 208.
Chevalier, A.-C. "Hygiène publique—Les Chiens morts," *Journal d'Argenteuil*, 29 March 1863, 2.
———. "Le Progrès," *Journal d'Argenteuil*, 20 April 1862, 2; and 4 May 1862, 2.
Chevalier, Etienne-Olivier. *Notices sur la commune et sur l'hospice d'Argenteuil*. Saint-Denis: A. Moulin, 1859.
Collas, Claude. "Sur le nouveau chemin de fer d'Argenteuil," *Journal d'Argenteuil*, 28 June 1863, 2.
Commission municipale d'histoire locale. *Argenteuil: Images d'histoire*. Argenteuil: Maury, 1977.
Coornaert, Monique and Harlaut, Claude. *Ville et quartier: Argenteuil*. Paris: Institut de sociologie urbain, 1965.
Desjardins, Gustave. *Tableau de la guerre des allemands dans le département de Seine-et-Oise, 1870–1871*. Paris: Léopold Cerf, 1892.
Lebeuf, F. "Ouverture de la nouvelle gare d'Argenteuil," *Journal d'Argenteuil*, 7 June 1863, 2.
———. "Le Pont du chemin de fer d'Argenteuil," *Journal d'Argenteuil*, 30 March 1862, 1.
Leheu, Paulette. "Le Développement d'une banlieue, Argenteuil," *Urbanisme et Habitation*, July–December 1954, 195–220.
M.V. "Le Nouveau Pont d'Argenteuil—Jonction des lignes du nord et de l'ouest. Section d'Ermont. (System tubulaire)," *Le Monde Illustré*, XIII, 29 August 1863, 140.
Réthoré, Edmond. *Argenteuil et son passé*. 3 vols. Saint-Gratien: 1968–72.
Tissier, Louis. "Argenteuil et les grandes industries parisiennes," *Journal d'Argenteuil*, 3 May 1863, 2.
———. "La Poésie de l'industrie," *Journal d'Argenteuil*, 20 July 1862, 2; and 27 July 1862, 2.
Worms, P. "Une promenade à Argenteuil," *Journal d'Argenteuil*, 30 March 1862, 2–3.

Index

INDEX